The British Museum Book of
FLOWERS

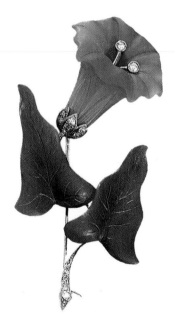

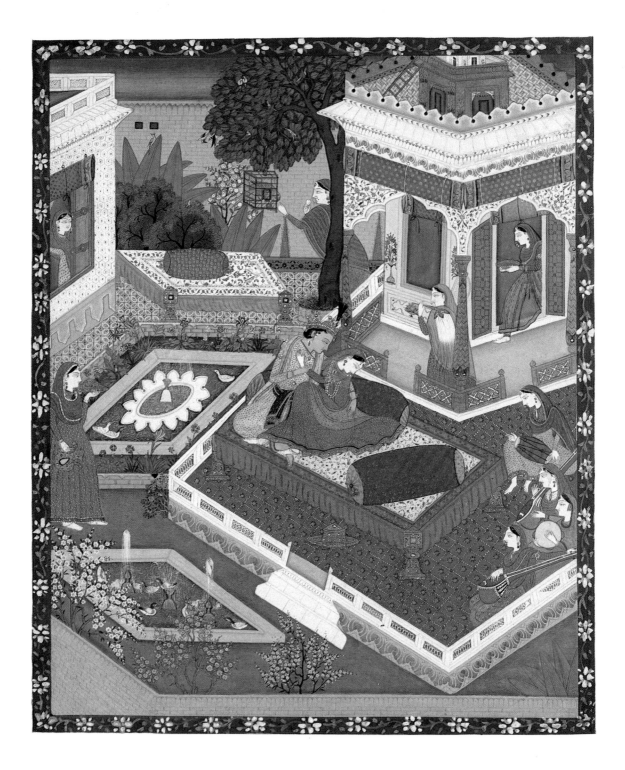

The British Museum Book of
FLOWERS

Anne Scott-James
Ray Desmond & Frances Wood

Published for the Trustees of the British Museum
by British Museum Publications

Half-title page Brooch in the shape of a morning glory flower. Stained chalcedony and nephrite, mounted in white gold set with diamonds. Perhaps German, *c.* 1930

Title page Radha and Krishna in a garden. India, Pahari school, Kangra style, *c.* 1840.

© 1989 The Trustees of the British Museum
Published by British Museum Publications Ltd
46 Bloomsbury Street, London WC1B 3QQ

British Library Cataloguing in Publication Data
Scott-James, Anne, *1913–*
The British Museum book of flowers.
1. Visual arts. Special subjects. Flowering plants
I. Title II. Desmond, Ray, *1925–*
III. Wood, Frances
704.9′434

ISBN 0–7141–1700–5

Designed by Behram Kapadia
Typeset by Wyvern Typesetting Ltd, Bristol
Printed in Singapore
by Imago Productions Ltd

Contents

Introduction

In the summer of 1979 the British Museum mounted a memorable exhibition on flower painting accompanied by an excellent book on *Flowers in Art from East and West* by Paul Hulton and Lawrence Smith. The enormous field of floral decoration on sculpture, ceramics, jewellery and other three-dimensional works of art was deliberately excluded both from the exhibition and the book. *The British Museum Book of Flowers*, which is concerned mainly with floral decoration, can perhaps be viewed as a companion volume to the earlier book. Most of the objects which are described or illustrated have been selected from the British Museum's collections.

Designers and decorators have always consulted the plant kingdom for ideas and themes for the embellishment of buildings and the decoration of rooms and their contents, finding imagery in the infinite shapes of flower and leaf, copying or adapting them, manipulating their flexibility, and exploiting their innate rhythms. Clothes and personal accessories flaunt floral patterns, both naturalistic and abstract. Without doubt, plant forms are the most common motif in ornament. An observant stroll along any street or a visit to public buildings, especially churches, will confirm their universality: they appear on architectural mouldings, on lamp posts and railings; seldom does any ornamental metalwork escape their pervasive influence. They symbolise national identity on flags, coins and postage stamps.

Floral decoration is almost as old as civilised man although it would appear that Palaeolithic art was confined to powerful images of animals such as the horse, bison and ox. Primitive man was a hunter; it was not until he began to cultivate plants for food or medicine that he scratched on some slivers of bone a few lines that could conceivably have been his crude representation of a plant. The delineation of animals and figures preceded plant forms in the East

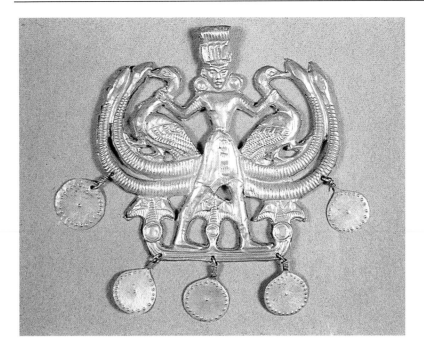

1 A Minoan gold pendant showing a nature god standing amongst lotus flowers and holding a water-bird in each hand. From Aegina, *c.* 1700–1500 BC.

as well as in the West. As settlements grew into towns, personal ornaments became more sophisticated, frequently borrowing from natural forms. The tombs of the second Early Minoan period, *c.* 2800–2400 BC, contained gold jewellery of daisies, lilies, roses and
1 sprays of olives. The lotus was seldom absent from New Kingdom necklaces in Ancient Egypt.

2 Plants have always been symbolic of spiritual and secular concepts. The Egyptians linked the lotus with the sun-god Horus, as a symbol of regeneration; in association with Isis it symbolised fertility. In Hindu iconography it represents both Brahma and Lakshmi; for Buddhists it is a sacred emblem of purity. The Madonna lily (*Lilium candidum*), one of the oldest cultivated flowers, was adopted as a royal flower by the Minoans; Christians made it a symbol of the Virgin Mary. Another symbol of the Virgin Mary, the fleur-de-lis, a stylised lily, was incorporated in the royal arms of France in the twelfth century. The cypress tree which Persians and Mughals always planted in their gardens was a hopeful reminder of immortality. The 'Four noble plants' in Chinese paintings – plum, orchid, chrysanthemum and bamboo – denoted the four

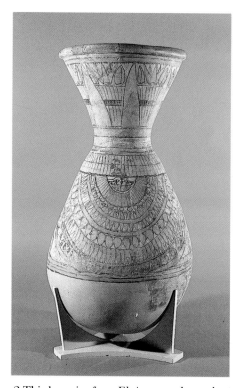

2 This large jar from El-Amarna shows the craftsman's consummate skill in adapting a tiered design to a curved shape. The ground is painted with pale blue lotus petals, with flower-heads and their accompanying buds round the rim.

seasons. In nineteenth-century England the symbolic language of flowers was a frivolous means of communication between lovers.

The American scholar W. H. Goodyear propounded a universal symbolism in *The Grammar of the Lotus* (1891), convinced that the solar symbolism of the lotus was disseminated from Egypt to other civilisations eastwards, eventually reaching Greece where it was transformed into the well-known ornamental device, the palmette. This theory was disputed by his contemporary the Austrian art-historian Alois Riegl, whose painstaking researches on the gradual evolution of ornamental borders of acanthus, lotus and palmette were expounded in *Stilfragen* (1893).

It was a species of acanthus, for example, which evolved into one of the most common ornamental features in European decorative art. Its formalised leaves distinguish the capitals of the Corinthian and Composite Orders in Greek and Roman architecture. The leaf underwent subtle changes in Gothic and Renaissance architecture. Rarely was it out of fashion. It was generously carved on furniture – table and chair legs sometimes terminated in scrolls of acanthus leaves. The wood-carver Grinling Gibbons was a proficient exponent of the acanthus scroll. A repeating border of acanthus leaves often provided a dignified frame to tapestries. A fresh interpretation of this traditional ornament was given by William Morris with his 'Acanthus' wallpaper.

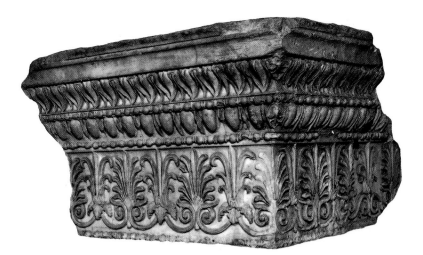

3 One of the earliest examples of the acanthus-leaf pattern, from the Erechtheion at Athens, 420–410 BC. The acanthus leaves are linked with alternating palmettes.

4 The inside of a footed basin painted underglaze in cobalt blue. The flowers in the diamond-shaped panels are the Turkish potter's interpretation of the standard Chinese lotus design. Turkey, Iznik, early 16th century.

4

107

Turkish Iznik ware offers another instance of the cross-fertilisation of ornamental styles, usually the result of trade or conquest. Chinese motifs such as the peony and lotus were adapted by sixteenth-century Turkish potters, who sometimes substituted their own vibrant colours for the classical Chinese blue. They invented fantastic flowers by freely adapting the shape of the Chinese lotus. As Jessica Rawson observed in her book, *Chinese Ornament: the Lotus and the Dragon* (1984), 'the ramifications of the influence of the Chinese lotus patterns are surprisingly wide'. The floral tiles designed by William de Morgan in the late nineteenth century owe a great deal to the Iznik style.

Jewellery is one of the oldest of all the decorative arts. Palaeolithic hunters adorned themselves with perforated shells, stones and animal teeth. The wearing of ornaments – artefacts or flowers – fulfils a basic human need to beautify the body, to enhance the wearer's personality or to proclaim status. Floral shapes have always been an important component in the jeweller's vocabulary, as is abundantly evident in the British Museum's extensive collections from Europe and the Middle East.

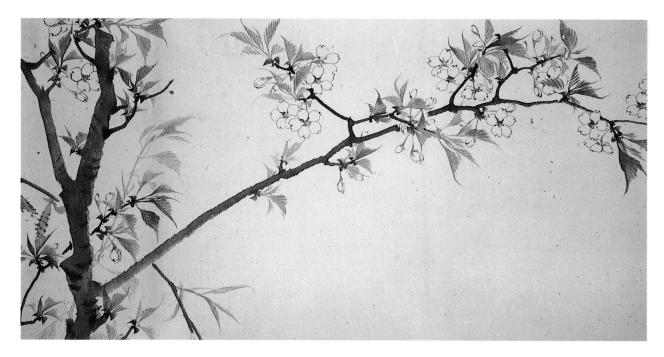

5 Japanese mountain cherry (*Prunus yamasakura*), from a handscroll by the Japanese artist Matsumura Keibun (1779–1843).

Philosophical and aesthetic considerations often governed the craft of gardening during the cultural maturity of most civilisations. Formal gardens surrounded the great temples and palaces of the Egyptians; Babylon was famous for its raised or 'hanging' gardens; Roman families relaxed in the privacy of their villa gardens; they were a refuge for quiet contemplation for the Chinese; for the Persians and Mughals they offered a foretaste of paradise; and for the English they are a national obsession. Gardens and flowers reflect the whims of fashion. During the Tang dynasty when the Chinese were captivated by the peony their porcelain bowls were embellished with its florid blooms. Japanese paintings and textiles confirm the nation's love of prunus blossom. When the Dutch and the Turks succumbed to tulipomania, this prized flower became an ubiquitous decorative motif. Some plants have retained their popularity: the lotus, for example, or the bamboo; or the rose, beloved by the Romans, adopted by the Christian Church, incorporated into heraldic arms, and a favourite with all flower painters.

Flowers speak a universal language; they proclaim a love of nature; they are resonant with symbolism; their diversity of form and colour inspires the artist and craftsman. It is fitting that they should adorn common objects in daily use as well as cherished works of art.

1

The Ancient World

Anne Scott-James

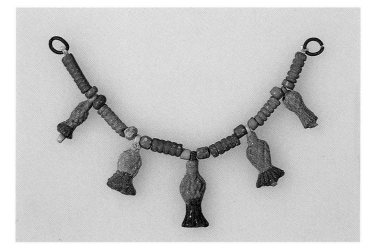

6 A string of cornflower pendants, from
the New Kingdom period in Egypt.

Egypt

The Egyptians were among the first and finest farmers in the ancient world. Blessed with eternal sunshine and a rich alluvial soil replenished every year by the flooding of the Nile, Egypt provided a lush home for wild plants and an invitation to a clever people to cultivate plants to an exceptional standard. Egypt entered documentary history in about the year 3000 BC, and from a very early date the Egyptians were improving native plants and importing foreign species, until their range of trees, shrubs, fruits, vegetables, cereals, vines and all manner of plants for food, drink, clothes and medicine far exceeded that of any other country until the heyday of the Roman Empire. The Israelites, grumbling, as was their wont, on the journey from Egypt to the Promised Land, complained 'we remember the fish, which we did eat in Egypt freely; the cucumbers, and the melons, and the leeks, and the onions, and the garlick', and without accepting the Book of Numbers as reliable history, it is clear that the Egyptian standard of living was famous among neighbouring peoples.

The Egyptians were not only practical cultivators of useful plants; they were also great lovers of flowers, and the two qualities do not always go hand in hand. The Romans, for example, were farmers, landscape architects, formal gardeners and students of natural history, but not passionate flower lovers, and modern British farming is ruled by chemistry to the detriment of wild flora. To the Egyptians, flowers were an important element in life. Flowers were symbols of religion and the tribute of kings. They were massed as decoration at processions and feasts, they were worn as crowns and garlands, they were arranged in bowls and carried as bouquets. A lady would hold a single lotus on her way to an assignation, and a labourer would thread a garland round the horns of his ox. And flowers were a frequent motif in Egyptian art, from temple columns fashioned in the

7 Pavements as well as walls were often painted with scenes from nature. This fragment from El-Amarna, the city in Middle Egypt which was briefly the capital under the monotheist King Akhenaten, husband of Queen Nefertiti, is somewhat carelessly painted with a marsh scene, with papyrus and wildfowl.

[12]

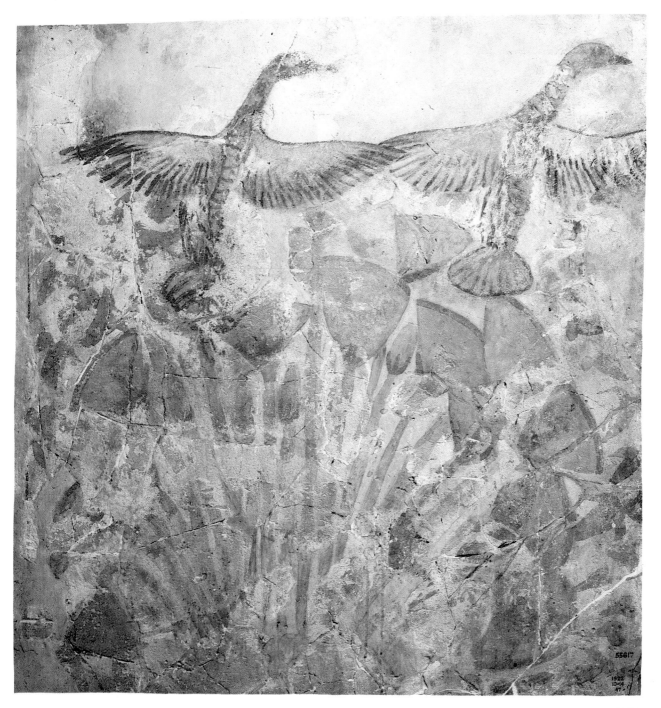

[13]

CHRONOLOGY

Early Dynastic Period c. 3100–2686 BC
Dynasties I–II

Old Kingdom c. 2686–2160 BC
Dynasties III–VIII

First Intermediate Period c. 2160–2040 BC
Dynasties IX–X

Middle Kingdom c. 2133–1786 BC
Dynasties XI–XII

Second Intermediate Period c. 1786–1567 BC
Dynasties XIII–XVII

New Kingdom c. 1567–1085 BC
Dynasties XVIII–XX

Late Dynastic Period c. 1085–343 BC
Dynasties XXI–XXX

Persian kings 343–332 BC
Macedonian kings 332–305 BC

Graeco-Roman Period
Ptolemaic kings 305–30 BC
Roman emperors after 30 BC

shape of a papyrus to necklaces strung with beads imitating corn-flowers, lotus buds, palm leaves, poppy petals and daisies. Fruit and vegetables, too, were often the theme of ornaments; glass and faience were shaped like pomegranates, and wooden boxes like cucumbers. The Egyptians had an affectionate feeling for the whole natural world – perhaps their mystical relationship with flowers can be compared with that of the Japanese.

The evidence we have of the importance of flowers in Egypt comes from many sources. The most valuable is the tombs, for the Egyptians attached enormous importance to life after death. The rich and powerful, especially the kings, built their tombs while alive and stocked them lavishly with food and furniture, treasure and jewellery, mystical paintings and objects of beauty, to support them magically in the style to which they were accustomed between death and the Day of Judgement, and afterwards through Eternal Life. Visual representations of flowers and gardens as well as real dried fruit and seeds have been found in plenty in the tombs of nobles, priests, priestesses and civil servants, the upper classes of Egyptian society. There is also the evidence of temple architecture and sculpture, of secular papyri, and, in the later years of the Egyptian empire, of historians like Herodotus. Many of the wall-paintings, papyri, sculpture and funerary offerings have been excellently preserved.

Although the history of ancient Egypt is immensely long – more than 3,000 years of documented history and many earlier centuries of civilisation – it is extraordinary how little the Egyptian way of life and the conventions of art seem to have changed until the country was influenced by the Greeks. The conventions were strict, the style impersonal – the craftsman-artist was portraying ritual subjects, rarely looking at the world with his own fresh vision. Ancient Egyptian art is basically two-dimensional, and perspective is not attempted. Human beings are idealised, usually shown beautiful and young. All figures are seen in profile, except for the torso, which is turned towards the viewer, and important people are shown at large scale, while less important ones are smaller, although the wife of a great man is often shown only slightly inferior in size to her husband. Everyday subjects, like the trees and flowers which concern us here, are portrayed as symbols without botanical detail, which makes some of the plants difficult to identify. It is not until the New Kingdom (*c.* 1567–1085 BC) that there are signs of artistic change,

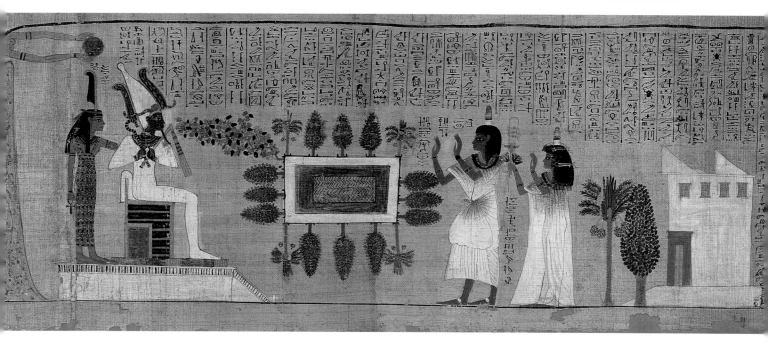

particularly in painting, the artist sometimes allowing himself to express affection, humour or romance. It was during the New Kingdom that Egypt reached her artistic zenith, and most of the floral art described in this chapter belongs to that period.

It is impossible to say with any certainty how many plants in the Egyptian flora were indigenous and how many were foreigners, or when the latter were introduced. Even the papyrus, usually accepted as a native, has been thought by some botanists to have come from Nubia in the south. Certainly the Egyptians were importing plants, especially valuable trees, such as cedar, from a very early date, and there are paintings of boats laden with whole trees, roots and all, which must have been a considerable feat of gardening to transplant.

Every Egyptian house of quality had a garden raised above the level of the Nile floods. In the case of a royal or temple property this would be very large indeed, with architectural colonnades and rows of sacred trees as well as pools and areas for fruit-trees, vines and herbs.

More typical were the many gardens of the rich sited round luxurious houses outside the towns. These were surrounded by walls

8 A papyrus painting illustrating the fine garden of the scribe Nakhte, who is seen leaving the house in the morning with his wife to greet the god Osiris. There is a formal pool surrounded by a row of trees with a date-palm at each corner. The house is raised on a platform as protection from floods.

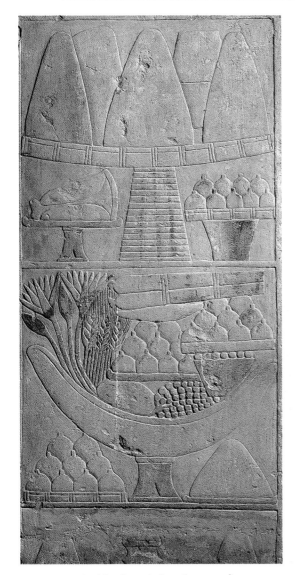

9 The blue lotus is found among funerary offerings as early as the Fifth Dynasty. This stone false door from a tomb at Saqqara is carved with a footed bowl of lotus flowers and buds, heads of grain, cucumbers, grapes and figs to please the dead.

as protection against enemies, animals and winds, and were entered through imposing gates approached by water. Inside, as is natural in a flat country, especially in the Near and Middle East, where aesthetic tastes tend to the formal, all was planned geometrically. There were straight canals, lines of trees, trellises of vines and rectangular pools.

The most important requisites of an Egyptian garden were shade and water, and tall palms and other fruit-trees lined the walks and were planted in rows round the pools. Water for the garden was provided by every known method of irrigation: canals and ditches, wells, ponds, and mud banks and ridges with plants at their base, where the soil would tend to retain moisture. Some of the pools were highly ornamental, surrounded by fruit-trees and pergolas of vines, stocked with fish and ducks, and planted with lotus and papyrus. Often there was a summer-house, in the cool of which the owner could take his meals while contemplating his beautiful and productive garden. Drawn without perspective from a bird's-eye-view, 8 the pools are the subject of many papyrus paintings.

In the towns, there were smaller gardens with perhaps no more than a well, a tree and a few vines, vegetables and herbs, but these would be just as precious to their middle-class owners as were their grand properties to the rich, providing water, a few plants, and protection from the ever-burning sun.

Of the many flowers the Egyptians grew and celebrated in art, two were especially beloved, the lotus and the papyrus. Both are water plants, revered as denizens of the watery chaos from which, according to some creation myths, the world emerged. Two species of lotus, or water-lily, grow throughout Egypt, both certainly native: the blue lotus, *Nymphaea caerulea*, the sacred flower of the Nile, which has pointed petals, spotted sepals, and an entire, peltate leaf, and is sweetly scented and aphrodisiac; and the white lotus, *Nymphaea lotus*, with rounded petals and a sharply toothed leaf. The blue lotus closes at night and opens in the morning and was revered as a symbol of the rising sun: according to one myth, the Sun-god, Re, entered the flower at night, when the petals closed upon him, and was reborn in the morning. The white lotus opens in the afternoon and closes in the morning. The blue lotus is the most common floral motif in Egyptian art of all periods, like the rose in the modern world.

We find the blue lotus as early as the Old Kingdom (*c.* 2686–2160 BC), carved on tomb doors and stelae. On a vast stone door of the

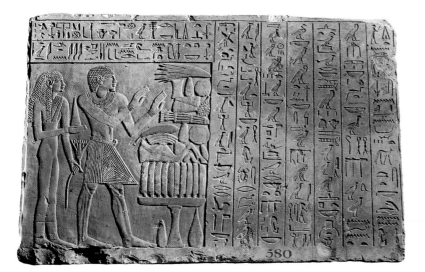

10 A Middle Kingdom stela showing the importance of flowers and vegetables in religion and the after-life. A high official and his wife stand before an offering table with palms raised in a gesture of reverence. The table is piled with meat, bread, vegetables and fruit, topped by a cos lettuce. The woman holds a blue lotus.

9 Fifth Dynasty, found at Saqqara, scenes of funerary offerings include a bowl piled with blue lotus (the original blue paint still clear), heads of grain, cucumbers, grapes and figs. From the Middle Kingdom (*c.* 2133–1786 BC) come fine carved stelae with figures holding lotus flowers in the hand. One, a relic of the Lady Khu of the Twelfth Dynasty, who had two husbands, shows her with each; an attendant carries a lotus and two buds and an offering table is piled with vegetables and fruit. On another stela, a high official and his wife 10 stand before a loaded offering table topped with a cos lettuce, the wife carrying a lotus on a long stem. The text on the stela is a hymn to the god Osiris, and the sculpture is a moving piece of work, both man and wife holding out hands with upraised palms in a gesture of reverence.

Perhaps the loveliest lotus designs are those of later, New Kingdom date, to be found in the funerary murals and papyri painted with scenes of a great man's life and possessions, which were enclosed in his tomb so that he might enjoy his earthly pleasures for ever. Distinguished women were also accorded this blessing. The finest group of murals comes from the late Eighteenth Dynasty tomb of a Theban official called Nebamun, a man who delighted in hunting, fishing and feasting when he was not engaged in his official work of counting cattle and crops and assessing taxes. His standard of living 11 was luxurious. His house had a productive and ornamental garden.

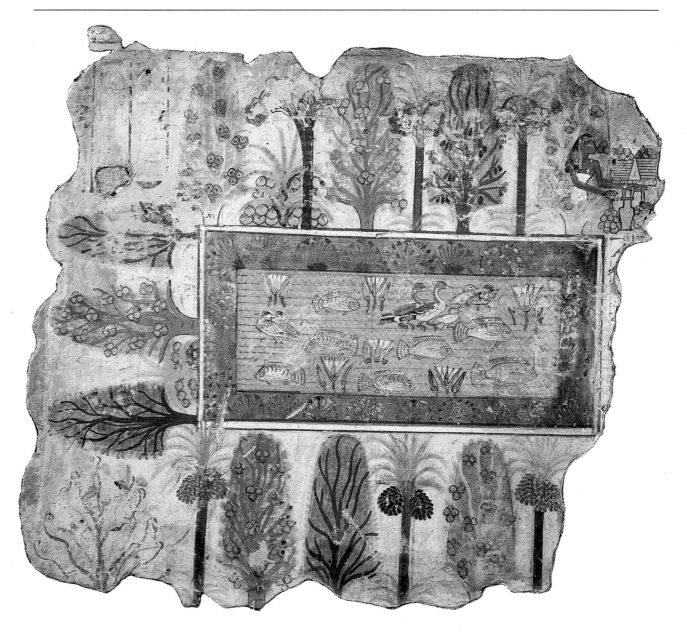

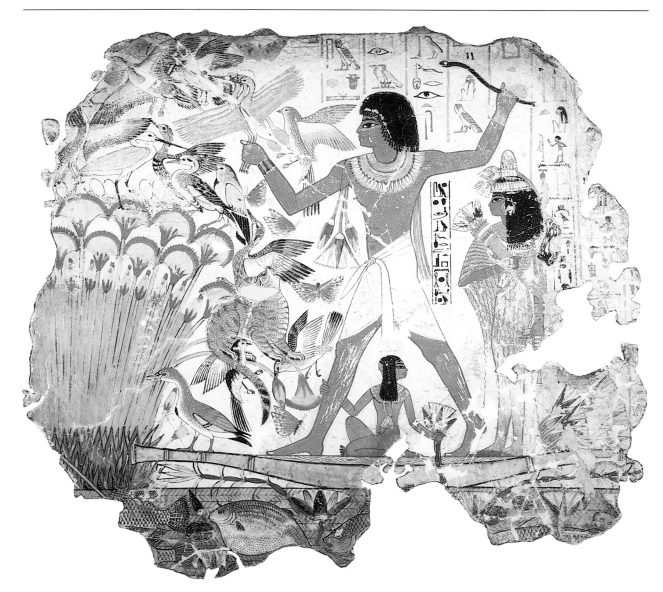

11 (*opposite*) A typical rich man's garden – that of the Theban official Nebamun – with a rectangular pool planted with lotus and many fruit-trees, notably dates, sycamore figs and mandrakes. The goddess of the sycamore inhabits the tree in the top right-hand corner.

12 The plants of the Nile form the background of this mural from the tomb of Nebamun, an official at Thebes during the Eighteenth Dynasty. Nebamun is hunting in the marshes thick with papyrus. He has a stem of lotus over his arm, and his wife and daughter wear lotus-petal collars.

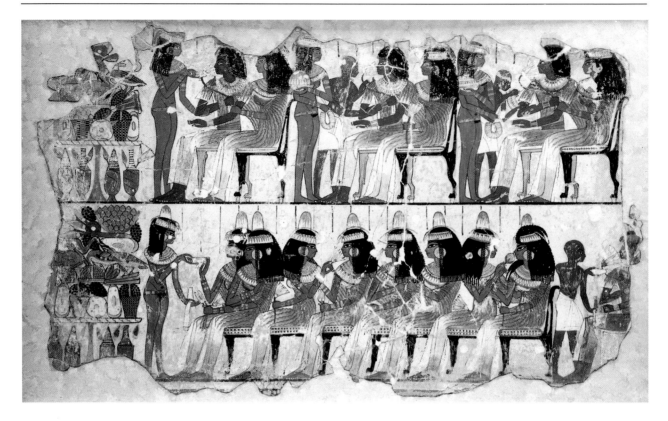

13 Flowers and perfumes were a luxurious feature of banquets. The ladies wore chaplets over their wigs and flowery collars, and carried stems of the scented blue lotus. The cones on their heads were also scented, melting slowly as the evening passed. Wall-painting from the tomb of Nebamun at Thebes.

He hunted in marshes rich in game birds and fish, accompanied by a beautiful wife and daughter. Richly dressed men and women attended his banquets, married couples sitting together and un-married women sitting in a separate row. Throughout the whole sequence of paintings there are lavish clumps or groups of flowers, the lotus always holding the honoured place. In a hunting scene 12 Nebamun has a lotus and two buds draped over his arm, his wife clasps an open lotus flower and wears blossoms on her head, and his daughter, otherwise naked, wears a collar of flowers and a lotus pendant. In a banqueting scene the ladies wear chaplets of lotus 13 flowers over their wigs, and one elegant guest, wearing a flowery collar on a long, gracefully pleated dress, holds a lotus to the nose of the lady next to her to sniff, a touching gesture of kindness.

In another part of the feast scene there is a stand of wine jars garlanded with three tiers of flower petals. Flower arrangements in

Egypt were elaborate enough to please the most exacting member of the modern flower-arranging movement. Sometimes a few lotus blossoms were placed simply in a pot, but other bouquets were rich and complicated, piled to a considerable height. Sometimes a long, narrow sheaf was placed in a dead person's coffin: it was made of leaves folded round a papyrus stalk, stitched into place, and then filled with multi-coloured flowers.

The painted funerary papyri are as beautiful as the murals, founded on the magic texts of the traditional Book of the Dead, but adapted to each man's status and desires and sealed into his tomb, never to be seen again. Among the finest is the papyrus of a royal scribe called Ani, who is shown in one vignette kneeling in judgement before Osiris. Many lotus flowers ornament this scene, which includes a group of the four sons of Horus standing on a lotus, it being their duty to guard the entrails of the dead person. Rows of lotuses fill other corners of the painting, some arranged in three-tiered vases. In another scene of the same series a lion sniffs a lotus with apparent interest, and in yet another a hippopotamus-goddess stands on a dais with towering bouquets of lotus flowers and buds at her feet.

Lotus patterns can also be seen on exquisite New Kingdom pottery and in small household objects. A glorious bowl made of
14 aquamarine-blue glazed composition is painted with a design of a

14 This fine New Kingdom bowl of brilliant blue glazed composition (or faience) is decorated on the inside with swirling lotus and papyrus flowers. The central square represents a pool.

[21]

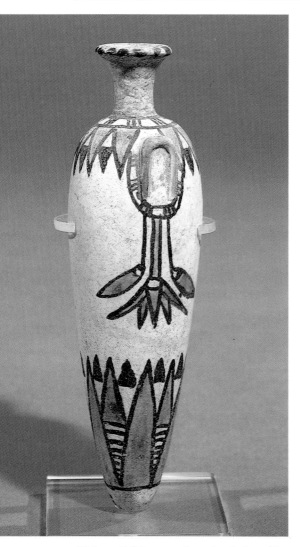

15 A small faience perfume bottle found in Upper Nubia, showing the art of the New Kingdom at its best. It is glazed white with applied decoration in blue and black. A blue lotus flower flanked by two buds hangs below each handle, lotus petals circle the shoulder and an open lotus surrounds the base.

garden pool surrounded by swirling lotus and papyrus flowers. A cosmetic vessel is decorated with a fringe of lotus petals from which hang pendant lotus flowers with their buds. A very large buff-coloured jar from El-Amarna is painted all over with pale blue lotus garlands and petals in a design beautifully adapted to its curving shape. A highly glazed faience bowl has the less common white lotus painted on the underside. There are lotus cups and moulded goblets, cosmetic boxes and ointment spoons. The Egyptians revelled in scents, unguents and cosmetics, especially scented oil for the hair and eye-paint, which was made (perhaps dangerously for the skin) of green pounded minerals and kohl.

Jewellery naturally drew much inspiration from flowers. There are many New Kingdom necklaces and collars consisting of semi-precious beads in floral shapes, usually painted in nature's colours — blue lotus and cornflower, green palm leaves, white lotus and daisies. One of the most spectacular pieces of jewellery, of Late Dynastic date, is a pair of gold bracelets inlaid with blue glass showing the infant Horus emerging naked from a lotus, with his finger in his mouth, flanked by a pair of royal cobras. Jewelled floral collars were also painted on the effigies on mummy cases.

The other plant of particular aesthetic importance to the Egyptians was the papyrus (*Cyperus papyrus*), which was of great use as well as beauty. It was abundant from the most ancient times in the delta of the Nile and in the marshy verges all along the river.

The papyrus is a tall plant, up to some five metres in height, with large fluffy umbels of yellow-green flowers and green bracts at the top of triangular stems: the leaves clasp the base of the stalks, which are otherwise bare. The papyrus form was much used in temple architecture, roofs being supported by columns in the shape of bunched papyrus stems with capitals of papyrus flowers or lotus-buds. The vast hypostyle hall at Karnak was built round a colonnade of carved and painted pillars of huge diameter, crowded too closely together to charm those accustomed to the airier temples of Greece. The carvings at Karnak include exotic plants, such as the arum lilies of Syria.

Lighter and more charming are the papyrus clumps in tomb paintings and papyri, where the plant is always a setting for scenes of happiness — in the painting of Nebamun hunting on the Nile, coveys of game birds burst out of a papyrus thicket. There are also cheerful scenes of birds and papyrus painted on the walls and floor of a palace

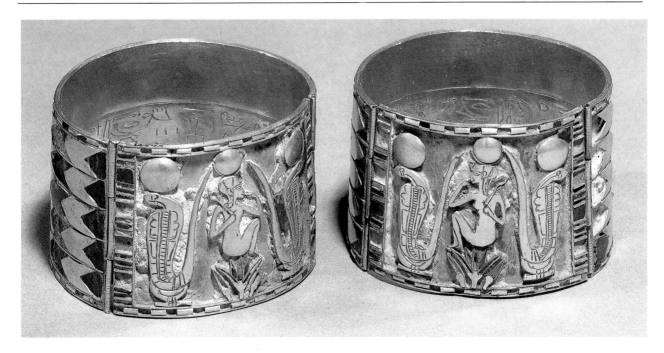

at El-Amarna, the city built between Memphis and Thebes by the monotheist pharaoh Akhenaten of the Eighteenth Dynasty. The papyrus form was used for small objects by carvers of ivory as well as potters, and one attractive little kohl container is shaped like a pair of papyrus buds. The representation is always stylised and the flowers perfect, though in nature the papyrus is an untidy plant.

If the lotus and papyrus were the most spectacular flowers in ancient Egypt, the flowers of the field were also well loved. White daisies (an *Anthemis* species) were chosen for necklace beads, and sometimes daisies were painted in place of nipples on mummy cases. Tiles painted with stylised daisies were used at El-Amarna. Other wild flowers chosen for jewellery were cornflowers (*Centaurea depressa*), sometimes misnamed corn-cockle, and poppies (*Papaver rhoeas*); and palm-leaves, pomegranates, mandrake, figs and bunches of grapes were other favourite motifs.

One more flower must be mentioned as part of the Egyptian flora, although it is mysterious and cannot be exactly identified: a flower used as a heraldic emblem of Upper Egypt called the Lily of the South. It is possibly a *Kaempferia*, possibly a *Silphium*, or possibly

16 Flowers were often the central motif of jewellery. This pair of gold bracelets of Twenty-second Dynasty date shows the infant Horus emerging naked from a lotus, with his finger in his mouth. The bracelets are inlaid with lapis-lazuli and blue glass.

[23]

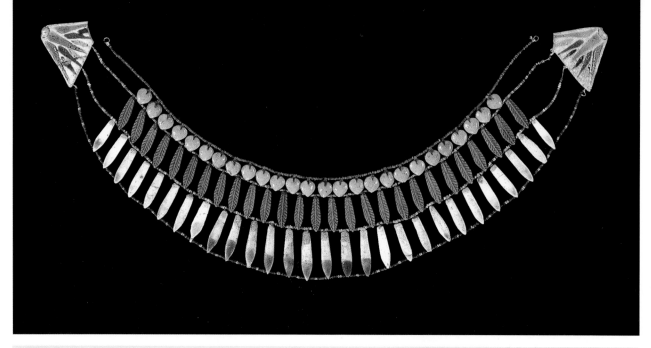

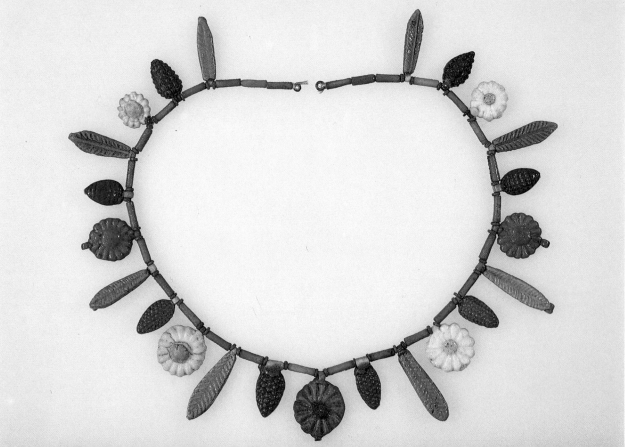

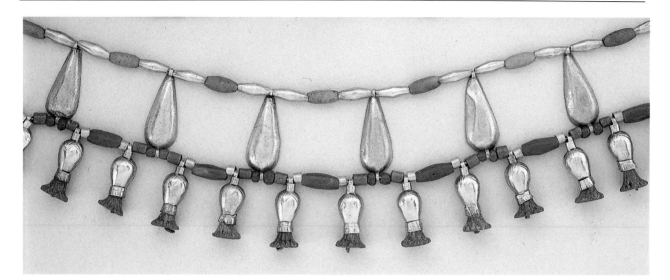

an iris, if, indeed, it is a real flower at all and not just a symbol. But from the early days of the Old Kingdom it occurs prolifically on sculptures, and at Karnak there are heraldic pillars representing the Papyrus of the North and the Lily of the South.

Indigenous trees were few in Egypt, particularly hard-wood trees, which had to be imported for buildings, furniture and coffins. The most probable natives were *Acacia nilotica*, *A. albida*, a willow (*Salix subserrata*), the thorny *Ziziphus spina-christi*, which has edible fruits, one conifer (*Juniperus phoenicea*), an oil-producing tree, *Balanites aegyptiaca*, and the doum-palm (*Hyphaene thebaica*), which has a forked stem, unlike the loftier date-palm, and is of harder wood. The date-palm (*Phoenix dactylifera*) is probably of Mesopotamian origin, but grew throughout Egypt in prehistoric times. Other trees were introduced very early and cultivated with typical Egyptian skill, including the fig (*Ficus carica*), with fruits growing singly on the branches; the sycomore fig (*Ficus sycomorus*), with large fruits in bunches and a very hard wood; the olive (*Olea europea*), which was planted in groves near temples; the carob (*Ceratonia siliqua*), a delicacy in cooking; the pomegranate (*Punica granatum*); the persea tree; and, from prehistoric times, the vine (*Vitis vinifera*). Woods imported as timber included the highly prized cedar of Lebanon, cork oak, the reddish-black African ebony, ash, yew, cypress and pine.

17–19 A well-to-do woman of the New Kingdom period would have had a large collection of bead necklaces in gold, semi-precious stones, glazed composition or glass, with many of the beads in the realistic shapes of flowers or fruit. Some necklaces consisted of several tiers, perhaps as deep as collars, and had elaborate clasps. Blue and white lotus, daisies, cornflowers, poppies, grapes, mandrake and pomegranates, as well as petals, buds and leaves, were usually made in their natural colours.

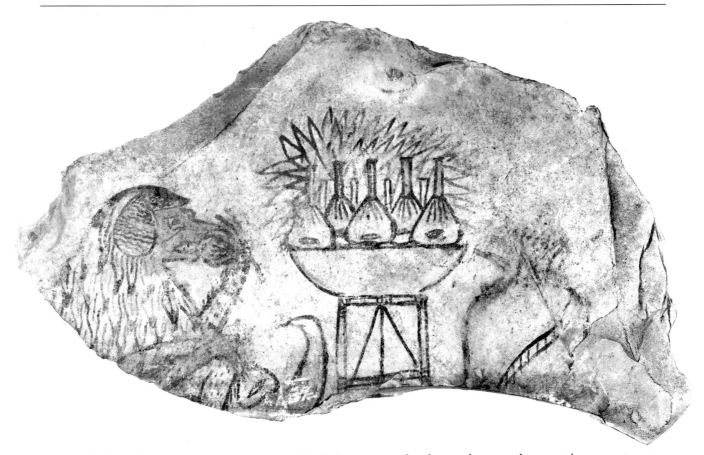

20 A spirited drawing on an ostracon, or potsherd, showing a sacred baboon eating a fig from a bowl filled with fruit and lettuces. The drawing is in black with accents in red wash.

Of all these trees, the date-palm was the most important, every part of the tree being useful for fresh and dried fruit, wine, honey, preserves and medicine, while the large leaves were used for baskets, mats, cords, nets and boats, the fronds for rods, the filaments of the trunks for brushes, and so on. It was the most popular of all the trees as a subject for art, and can be found in numerous sculptures and paintings.

Palms were the model for noble columns and capitals from as early as the Third Dynasty. They appear in garden scenes, and many charming objects were made in palm shape, such as cosmetic containers. Palmettes as well as palm fronds were motifs for jewellery and formal decoration, a palmette being a stylised pattern probably derived from the leaf of the tree.

21

Many other fruit-trees grew in Egyptian gardens. Vines were known in prehistoric times, and there are many paintings of vine-gathering and wine-making, and others showing vine trellis used as a garden feature. Though beer, made from fermented barley-bread, was the universal drink of all classes, wine was widely used by royalty and the noble and professional classes. Fig-trees and sycomore-figs also appear frequently in paintings (and provided a favourite food for the sacred baboons), and pomegranates were a model often chosen by craftsmen because of their sensuous shape.

Though they are not strictly 'floral', many surviving household objects remind us of the importance to the ancient Egyptians of the vegetable world. The greatest of all is papyrus paper. This was exquisitely made from the earliest times by slicing and pressing strips of the pith of the papyrus stalk, laid vertically and horizontally, into a sheet. Flax, the only textile fibre, was abundant, and used to make linen clothing; sandals and baskets were made of palm, papyrus, reeds and rushes.

The remains of real food also have been found in tombs, including grapes, *Zizyphus* fruit, dried figs and palm fruits, pomegranates and emmer wheat, the desiccated survivors of thousands of years in the funerary store-cupboard.

21 Opaque moulded glass was used for artefacts during the New Kingdom, though the glazing of pottery was known at a much earlier date. This container for eye make-up, made in blue glass patterned in yellow, is in the shape of a palm-tree.

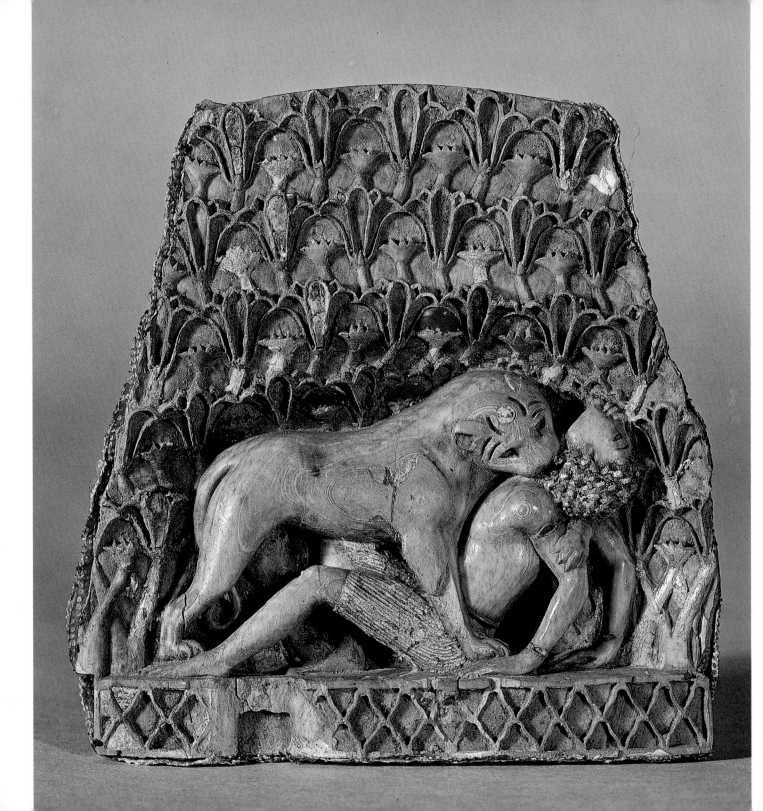

The Bible Lands

While the Egyptians were developing from a nomadic to a settled civilisation, and then, with the invention of writing, entering the realms of history, another culture was evolving in Mesopotamia, between and beyond the rivers Tigris and Euphrates. Indeed, these two ancient societies pursued a largely parallel course, and were by no means isolated from each other. The powerful motive of trade inspired a friendly relationship long before the still more powerful motive of conquest brought the first clash.

But the Mesopotamians were very different people from the Egyptians. More prone to aggression, and the fluctuations of conquest and defeat, their ancient history has not the continuity of that of Egypt. Between the two great rivers, civilisations rose and fell, often lasting for fewer than two hundred years – Sumerians, Akkadians and Babylonians in the marshy south and then Assyrians in the rolling plains of the north conquered their neighbours, had their glorious hour, and fell in turn into obscurity. Of these, the Assyrians excelled in war and from small beginnings in the second millennium built a vast empire from the tenth to the seventh centuries BC which dominated western Asia, overrunning Palestine and Egypt in the west and extending to the borders of Persia in the east; it fell in the end to an alliance of neo-Babylonians and Medes. The conquered included, of course, the Jews, whose morally intense and stormy story is inextricably interwoven with that of the Mesopotamians: there had been an early westward migration from Mesopotamia to Palestine, and later many Jews were deported eastward to Assyria as prisoners. The 'Bible Lands', with which this chapter deals, are taken to mean the area of Asia which stretches from the Mediterranean to Persia.

Artistic depictions of the gardens, flowers and plants of the Bible Lands fall into two groups. Firstly, from very ancient times, there

22 A Phoenician ivory showing a startling scene of sudden death in an exquisite background of flowers. A lioness mauls a negro in a formalised meadow of lilies and papyrus, the whole overlaid with gold leaf and inlaid with carnelian and lapis-lazuli. From Nimrud, 8th century BC.

MESOPOTAMIAN CHRONOLOGY

Early Dynastic (Sumerian)	2800–2330 BC
Akkadian and Neo-Sumerian	2330–2000 BC
Old Babylonian	2000–1600 BC
Kassite	1600–1350 BC
Middle Assyrian	1350–1000 BC
Assyrian Empire	1000–612 BC
Ashurnasirpal II	884–859 BC
Sargon II	722–705 BC
Sennacherib	705–681 BC
Ashurbanipal	669–627 BC
Neo-Babylonian	612–539 BC
Nebuchadnezzar II	605–562 BC

survive from Mesopotamia and neighbouring countries objects such as jewellery, seals and ivories, which give glimpses of the joy of plants, especially trees, in a torrid climate. If any one theme emerges, it is the sacred nature of trees, especially palm-trees, but probably also pomegranates and pines. In Assyria, the kings, in their capacity as high priests of the god Ashur, were shown officiating at possibly mythical ceremonies centred on trees, tended by winged and sometimes eagle-headed genies, whose magic equipment included a large pine-cone and a bucket. (Some botanists have suggested that the genies in these scenes were propagating the trees, but since the pine-cone held by the genie often touches a king's head it seems possible that the process was one of anointing the king with a sacred juice tapped from the tree's trunk. This explanation was put forward by the French historian, A. Parrot.) One of the heathen practices castigated by the Lord God of Israel was that of celebrating rites 'under every green tree'.

Secondly, there are the great Assyrian bas-reliefs of the ninth to seventh centuries, which are of a narrative nature, vaunting the exploits of the Assyrian kings in war and in the hunting field, much as the heroic feats of the Normans were recorded in the Bayeux Tapestry. Since the Assyrian reliefs are documentary, and the campaigns of the kings took place in far-apart and diverse territories,

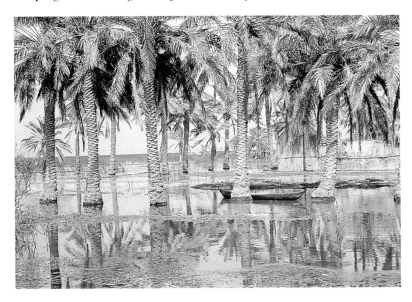

23 Typical marsh landscape on the Lower Euphrates, southern Iraq.

the backgrounds and the vegetation vary, too, and the scenes of carnage, pillage, enslavement, victory and the hunt occur in landscapes of mountains, rivers, marshes, parks and gardens, some rich in trees, flowers and fruit, some thick with reeds and rushes. It must be confessed that most Mesopotamian sculptors reached the peak of their powers in portraying animals rather than plants. The animals are realistic and forceful, the plants naive or so stylised as to be mere patterns, but they are plentiful enough to explain why Mesopotamia, with its lacing of rivers and streams, was regarded as a paradise of shade and coolness by all the peoples of western Asia, including the creators and guardians of the Biblical tradition.

Some of the earliest Mesopotamian depictions of 'flowers' come from the Royal Cemetery at Ur of the Chaldees, the Sumerian city a few miles west of the lower Euphrates where, according to Biblical tradition, Abraham was born. This civilisation lasted for about four hundred years, from early in the third millennium BC. The territory round Ur was flat and fertile, blessed by annual river floods and rich in crops and pasture, while between the Euphrates and the Tigris was 23 a vast stretch of permanently marshy country thick with giant reeds which provided material for houses, boats, mats, fodder and fuel and 24 cover for wild pig and water-fowl. This giant reed (*Phragmites australis*) has been described with intimate knowledge by Wilfred Thesiger in his book *The Marsh Arabs*. Thesiger lived in these marshes for some seven years in the 1950s, and believed that the way of life had changed little over five thousand years: 'This giant grass, which looked like a bamboo, grew in the dense reed-beds to a height of more than twenty-five feet. The stems, each terminating in a tasselled head of palest buff, were so thick that the marshmen used them as punt-poles.' This reed is tolerant of salt winds and brackish water and often grows in companionship with bulrushes.

The Sumerians were a creative and imaginative people, whose religious figure sculptures are among the glories of ancient art. They were also fine goldsmiths, and made magnificent bowls, cups, daggers, animal models and jewellery of gold and semi-precious stones. A splendid woman's head-dress, for example, is made of 25 latticed strips of gold like a Juliet cap with a double circlet of gold leaves to go round the brow, the whole being finished with a topknot 26 of three stylised flowers. Even more spectacular is a model of a goat feeding on a flowering shrub, made of gold, silver, lapis-lazuli, shell and red stone in about 2600 BC. The goat was one of a pair, and two

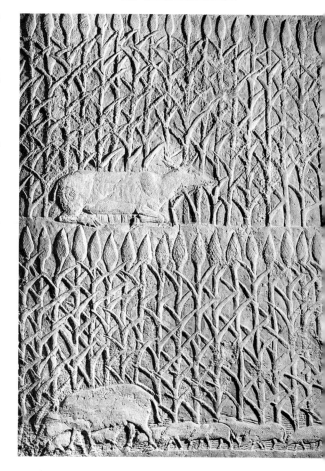

24 Stylised reeds standing in stiff battalions represent a marsh near Nineveh. A deer takes cover in the swamp and a wild sow leads her litter. Relief from Sennacherib's palace, *c.* 700 BC.

[31]

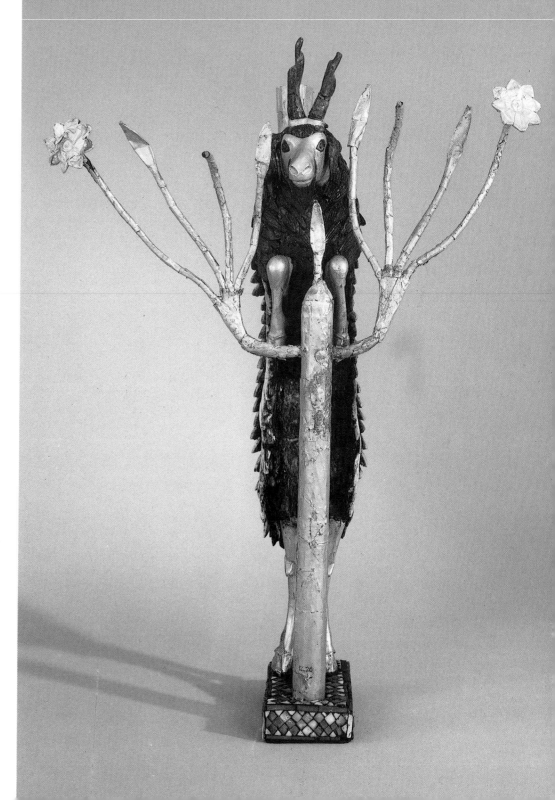

25 (*opposite*) According to Biblical tradition, the Sumerian city of Ur, near the Lower Euphrates, was the birthplace of Abraham. Flowers and leaves were frequent motifs in Sumerian jewellery, as in this latticed woman's cap with daisies on the crown and leaves around the brow. Third millennium BC.

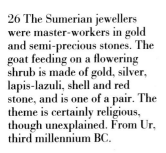

26 The Sumerian jewellers were master-workers in gold and semi-precious stones. The goat feeding on a flowering shrub is made of gold, silver, lapis-lazuli, shell and red stone, and is one of a pair. The theme is certainly religious, though unexplained. From Ur, third millennium BC.

goats on either side of a shrub or tree was a frequent theme in Mesopotamian art, with a religious significance not yet understood, but usually explained in that non-committal phrase 'fertility rites'. The shrub is completely stylised and cannot be identified.

The Akkadian empire, established by the warrior king Sargon I, succeeded the Sumerian and lasted for about two hundred years. Now we begin to see the love of gardens which later became a marked feature of Assyrian art, and clues can be found in some of the cylinder seals of the period. The most celebrated is the post-Akkadian 'Temptation Seal', of the late third millennium, so called because the subject has an affinity with the story of Adam and Eve. In the centre of the design is a tree: a horned god sits on one side and a woman on the other, with a serpent rearing behind each. Another seal shows a man and a woman sitting drinking wine by trees in a garden, and a Babylonian seal has a design of a man worshipping a tree.

A number of carved ivories, mostly Syrian or Phoenician and of later date, include flowers in their designs. In one ivory of Egyptian inspiration, dating from the ninth to eighth century BC, a young man stands holding a long-stemmed lotus taller than himself, and a fine Syrian ivory bed-head of the eighth century is carved with genies holding their pine-cones and buckets, attending to their trees, with lilies growing round about. The madonna lily (*Lilium candidum*) is

27 The Assyrian love of gardens is revealed in art as early as the third millennium BC. The 'Temptation Seal' of this period, so called because the subject is akin to the story of Adam and Eve, shows a horned god and a woman seated on either side of a sacred tree, with a rearing serpent behind each.

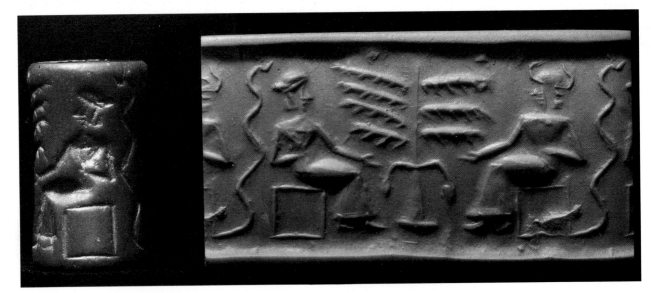

the one flower which is instantly recognisable in western Asiatic art, clearly as beloved in the gardens of Asia as was the lotus in Egypt. Clay tablets also yield information: one lists plants grown in the royal garden of the neo-Babylonian king Marduk-aplaiddina II in the seventh century. Sixty-seven varieties are grouped into fifteen sections, and these include onions, garlic, leeks, cress, lettuce, several pulses, gourds, and a variety of herbs and spices.

Admittedly, these early flower and plant depictions are mixed in their subject, place of origin and date, and somewhat scanty in number. They prove little more than that trees were plentiful and gardens cherished in Mesopotamia and the surrounding lands, and continued to be so throughout antiquity. The famed hanging gardens of Babylon were artificial hills, terraced and irrigated and richly planted with trees. There are differing accounts of their origin and date, and no traces have been found, but they were probably made in the sixth century by Nebuchadnezzar II.

The Assyrian reliefs tell a fuller and more coherent story. Their subjects are war, the rewards of war, and the sport of lion-hunting. Among the rewards of war are the splendid buildings and fine gardens which the kings were able to create with their stolen wealth and slave labour. The first Assyrian capital was at Ashur, of which but little remains, but various kings built themselves new capitals, at Nimrud on the Tigris (Ashurnasirpal II in 879), at Khorsabad in rocky country away from the river in the north of Assyria (Sargon II in 710), and at Nineveh by the Tigris (begun by Sennacherib in 700, it reached its peak under his grandson, Ashurbanipal), and from the walls of their palaces vast and awe-inspiring stone reliefs (originally painted) have been excavated, of which the finest collection in the world is in the British Museum.

It is thought by archaeologists that the royal gardens were of two kinds. First, there were gardens within the complex of palace buildings, where feasts were held and where the royal family could retreat among trees and make use of a colonnaded pavilion or summer-house; here there were palm-trees, pines and fruit-trees, vines, tame animals, including lions, and wild and cultivated flowers. Then, outside the city walls and connected to the palace by a gate, there were large and spectacular park-gardens landscaped as thoughtfully as any picturesque garden in eighteenth-century England. There would also have been orchards and nursery gardens for the cultivation and propagation of vegetables and fruits, including

28 Carved ivory, as well as stone, bears witness to the love and worship of plants in the Near and Middle East. In this ivory in the Phoenician style, made in the 9th or 8th century BC, a young man holds a stylised lotus with its customary pair of buds.

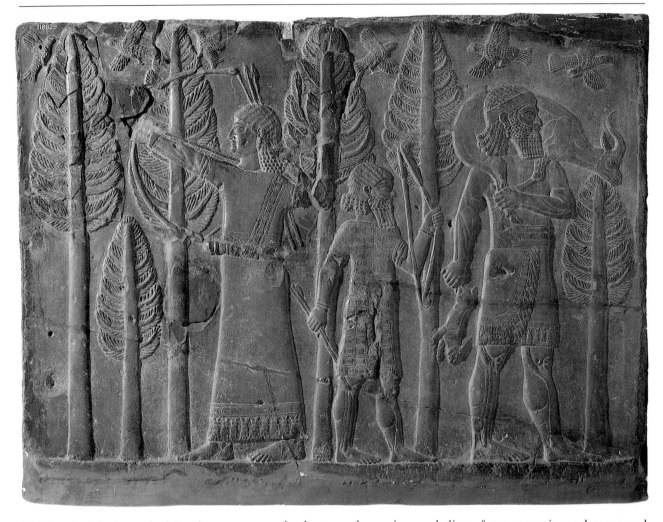

29 Khorsabad, in the north of Assyria, was the capital in the 8th century BC, before the rebuilding of Nineveh. A relief in black stone from the palace of Sargon II shows a hunting scene in wooded country thick with pine-trees.

exotic plants, such as spices and olives, from countries to the east and west.

Sennacherib, founder of Nineveh, made a splendid park-garden 31 outside the city which is recorded both in his own annals and in the Assyrian reliefs. It was both pleasure ground and nature reserve, combining the qualities of a botanic garden and a modern safari park, a true paradise garden where man dwelt in harmony with wild creatures. Sennacherib brought water from the river and planted reeds, as cover for wild pigs, deer, other animals and water-birds,

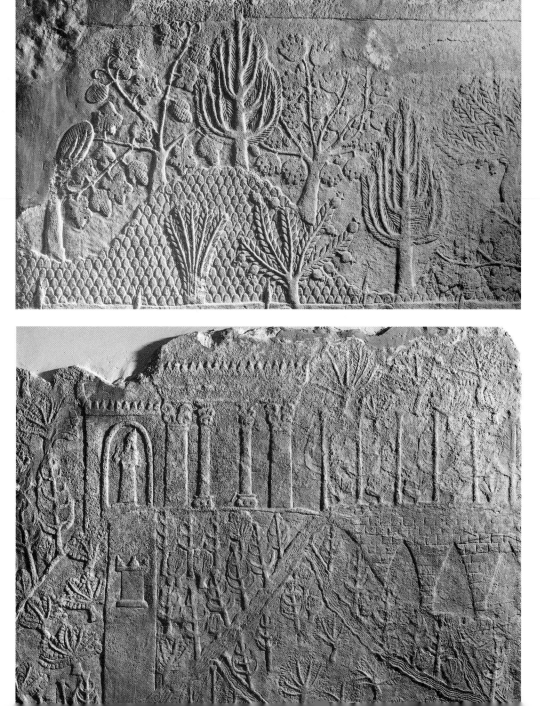

30 Near Sennacherib's city of Nineveh were important stone quarries fringed by orchards with a variety of trees. In this relief, pines, figs, pomegranates and vines are clearly depicted. The scallop pattern represents hilly country.

31 Sennacherib's paradise-garden outside Nineveh, made in the 7th century BC. A summer-house built on columns overlooked a landscaped park with winding paths and many trees, watercourses fed from an aqueduct and a swamp planted with reeds which was a refuge for wild pig and water-birds. At the top left is a stela of the king. Relief from Ashurbanipal's palace at Nineveh.

[37]

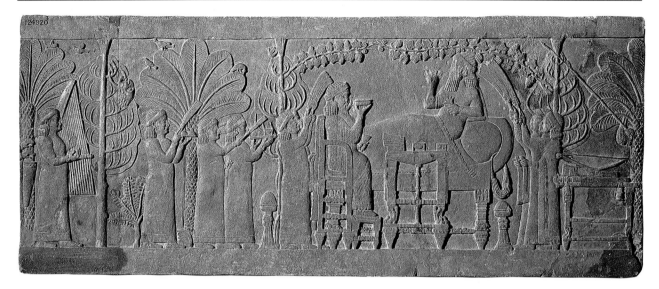

32 King Ashurbanipal and his queen feast in a garden at Nineveh among palms, pines, vines and fruit-trees, while servants bring wine and food and play the harp and drum. The idyllic nature of the scene is somewhat marred by the head of the conquered king of the Elamites hanging from a tree. The relief dates from *c.* 645 BC.

and was particularly pleased that the imported herons nested and increased. 'Above the city and below the city I laid out parks. The wealth of mountain and all lands, all the herbs of the land of Hatti [Syria], myrrh-plants, among which fruitfulness was greater than in their [natural] habitat, all kinds of mountain-vines, all the fruits of all lands, herbs and fruit-bearing trees I set out for my subjects ... I made a swamp and set out a cane-break within it. *Igiru*-birds, wild swine, beasts of the forest, I let loose therein.' All, the annals continue, throve exceedingly, and the beasts 'brought forth young in abundance'.

Sennacherib's grandson, Ashurbanipal, was a plant collector, and had saplings, cuttings and seeds brought from many parts of his empire, which often grew better in his skilled gardeners' hands than in their native homes. A number of beautiful panels in the reliefs show garden scenes from Nineveh during his reign. One probably depicts his grandfather's park-garden and, though drawn without perspective, the plan is clear. At the top of the panel there is a stela of the king set against an open summer-house standing on graceful columns. This overlooks a landscaped park with winding paths, water-courses and many trees, both native and foreign introductions; an aqueduct with pointed arches supplies water for the plants and swamp. This park-garden may have been fenced to lead into one of the king's hunting-parks, where wild lions roamed, for lion-

31

hunting was a royal sport, the king apparently achieving great feats of heroism. He usually shot his prey with arrows and finished it off at close quarters with a spear, and there are many scenes of lions dying in agony, always carved with exceptional vigour and gusto. The sculptors showed a close observation of the bodies and movements of animals, which unfortunately they did not apply to plants.

32 Another striking panel from sculptures from the palace at Nineveh shows Ashurbanipal and his queen feasting in their garden in 645 BC. The garden is full of beautiful trees and trained vines, and the king reclines on a couch, facing his queen on a throne, in the shade of tall palm-trees, fruit-trees and pines. They drink wine from cups and eat delicious onions to the music of harp and drum and the song of birds, while servants ply fans to create a breeze. But the scene is not so idyllic as it seems at first glance, for from the branch there dangles the severed head of the king of the Elamites, whom Ashurbanipal has just slain in battle. This is a startling work of art revealing the

33 An unusually serene garden scene shows lions resting under a pine-tree hung with vines. The madonna lily on the right is more realistic than most Assyrian plant carvings, the daises by the tree being characteristically stylised. Nineveh, 7th century BC.

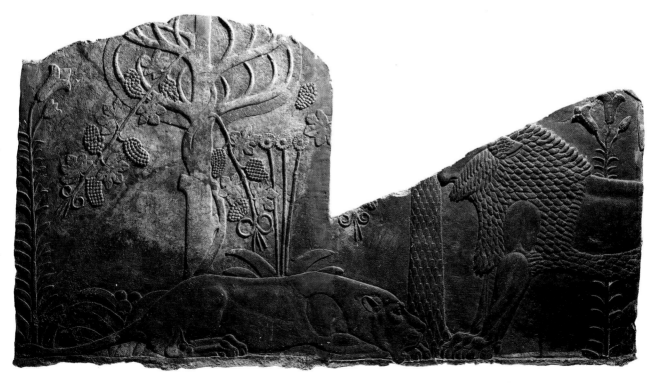

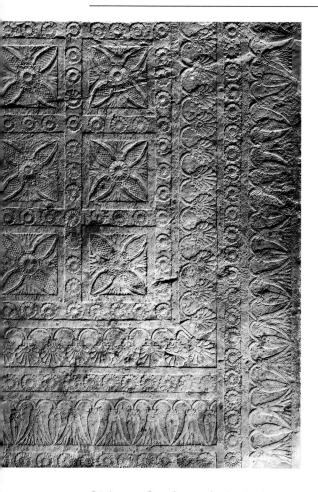

34 A stone floor from Ashurbanipal's palace at Nineveh, carved in the Egyptian manner with linked lotus flowers and buds, and inner borders of rosettes and palmettes.

Assyrian joy in conquest. The French writer and art critic, André Malraux, has written of the 'narrative magnificence of Assyrian bas-reliefs and their sinister pageantry'.

Another garden scene from Nineveh is more serene. A tame lion 33 and lioness rest among pines and palm-trees hung with trailing vines, and the garden is planted with madonna lilies and with stylised wild flowers which look like marguerites. Unfortunately a piece of the panel is missing, but the vegetation in the surviving part is perfectly clear and the carving of the lilies is almost naturalistic.

Before passing from the gardens of Mesopotamia to individual trees and flowers, one more relic of Nineveh must be noted, though it is in quite a different style from that of the reliefs – a large fragment of a stone floor from Ashurbanipal's palace carved with a formal 34 plant pattern. The carpet has an outer border of lotus and buds in the Egyptian manner, joined by curving stalks. Inside is another flower border of rosettes, and inside this a border of linked palmettes, while the centre of the carpet consists of squares filled with lotuses and rosettes. All, like other Assyrian sculptures, would have been painted.

The earlier reliefs from the ninth-century palace of Ashurnasirpal II at Nimrud on the upper Tigris contain no garden scenes, but magnificent panels show sacred ceremonies with kings and beneficent genies with formalised trees. In one awe-inspiring scene from the king's throne-room, the king stands in front of a sacred palm-tree (*Phoenix dactylifera*), his stiff figure shown in duplicate on either side of the tree. The tree itself is completely stylised, consisting of a trunk topped with palm-leaves and with side branches finishing in palmettes, and over the tree there hangs a sacred winged disc. Behind both figures of the king stand winged genies with cones and buckets. Another scene shows a winged, eagle-headed genie touching a tree, and in another a genie carries a deer in one arm and in the other hand 35 holds a palm-branch divided into five shoots.

The sculptures from Nimrud are of ritual scenes but later sculptures, which are narratives of war, are set among a variety of plants. Some of these record wars in countries far west of Mesopotamia, others record victories in the marshes of southern Iraq. Across the great sequence of sculpture there pass processions of grim conquerors, agonised victims and melancholy captives in the varied landscapes of western Asia, the poignancy of their misery enhanced by the beauty of the settings.

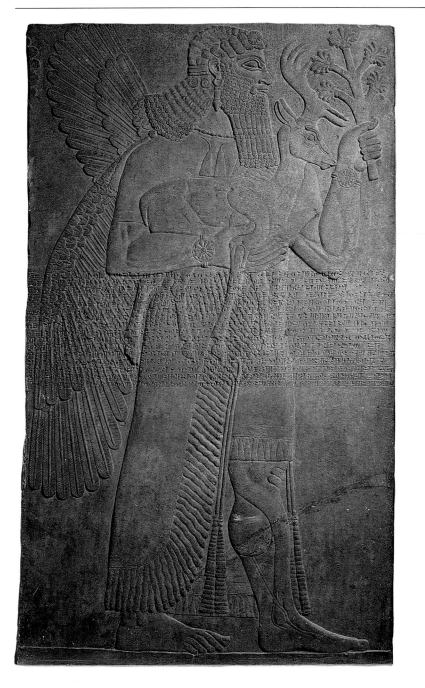

35 The winged genies in the reliefs at
Nimrud are usually seen celebrating rites in
connection with sacred trees. This genie
carries a branch in one hand and a deer in
the other, and is from Ashurnasirpal's
palace of the 9th century BC.

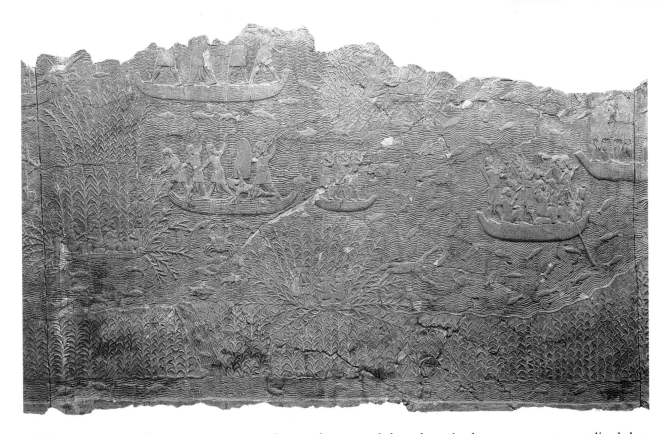

36 The marshy nature of lower Mesopotamia is vividly illustrated in this relief of Chaldeans in a boat hiding from their Assyrian conquerors. The same species of reed, *Phragmites australis*, still provides tall, thick cover in the marshes today. From Sennacherib's palace at Nineveh, *c.* 700 BC.

It must be stressed that plants in these scenes are so stylised that identification must be largely guesswork. Date-palms and pine-trees are usually recognisable, the palm trunks being carved with a scalloped pattern to indicate their roughness and some palms carrying hanging bunches of dates. Smaller trees with short trunks breaking into from three to nine feathery branches are usually fruit-trees: often they bear clearly carved pomegranates or figs, sometimes two of a kind on the same tree, and in scenes near the Mediterranean there would be olives. Vines, with their deep-cut leaves and bunches of grapes are easily identified. Pollarded trees would be willows or poplars, probably the latter on high ground, though there might be streams in the mountains to provide essential moisture for either. Tall reeds with pointed heads are usually *Phragmites australis*. There are standard symbols to represent features in the landscape. Mountains or hills are indicated with an all-over diamond pattern and wavy lines represent water, sometimes alive with fishes and crabs. In one moving panel from Nineveh, defeated Chaldeans crouch in a reed-boat in the marshes of southern Iraq hoping to be hidden from the enemy by the tall reeds. While the conquering

36

Assyrians seem always grim and devoid of feeling, the fear and depression of the conquered are often more sensitively expressed.

So far in this chapter we have been more closely concerned with Mesopotamia than with the countries of Palestine, which we associate more readily with the Bible. This is because we have so much hard, tangible evidence from the east, while the Biblical tradition is largely oral until a much later date. But from as early as the ninth century BC the Assyrians had been encroaching on land towards Lebanon and Palestine, and in the following century and a half there was both intermittent conflict and, on the other hand, alliances. The most exciting archaeological and artistic evidence of war in the Bible Lands is a series of sculptures in the British Museum showing the fall of Lachish, in Judah, to Sennacherib, in 701 BC; these come from Sennacherib's palace at Nineveh, and were discovered by the Victorian archaeologist, Henry Layard, who made beautiful drawings of many panels on the spot before their removal to London.

Both the sculptures and Layard's drawings reveal much about the landscape of Palestine and its plants. The country near Lachish is rocky, every hill covered with its stylised diamond pattern. There are plenty of trees, always shown in conventional isolation, not grouped or overlapping, probably olives and pollarded willows or poplars, and there are orchards with figs, pomegranates and vines clearly identifiable. In one panel a pathetic procession of Jewish prisoners and their families, with oxen and other possessions, is being marched through a rocky landscape with stylised trees in the background, which in that country might well have been olives. In a Layard drawing Sennacherib sits on a throne near Lachish surveying his booty while the defeated kneel before him. In the background are orchards in fruit with mountains behind dotted with olives and pollarded poplars.

The examples illustrated are but a small selection from the long processions of reliefs which depict the countryside of the Assyrian empire. The reader must add from his imagination the thousands of wild flowers which are native to western Asia – daisies, poppies, anemones, crocuses, lilies, and others – many of which are mentioned in the Bible.

37 This copper peg surmounted by a young bull in a reed marsh was part of a foundation deposit, buried in a box to mark the corner of a newly built temple. Sumerian, *c.* 2100 BC.

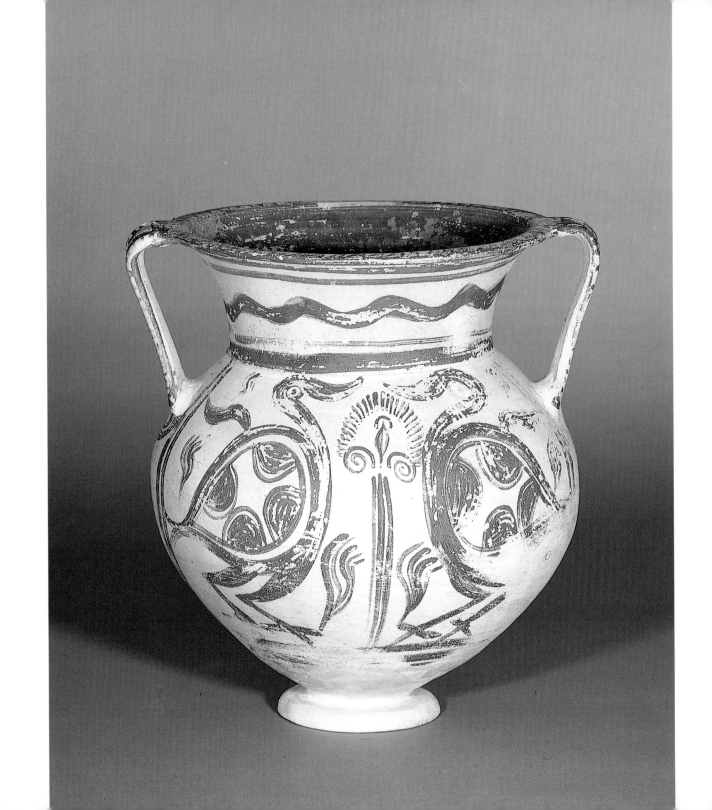

Greece and Rome

So great is its physical beauty that all Greece is a garden. With its mountain ranges, herb-scented valleys, natural springs and dramatic coastline, all fostering thousands of species of wild flowers and shrubs, a cultivated private garden seems almost superfluous. It was the desert-dwellers of antiquity who pioneered the art of gardening.

As far as we know, the private decorative garden was not important to the Greeks until Hellenistic times, but they were intensely aware of the beauty of their landscape and its wild flowers, particularly in the Bronze Age, when their feeling for nature was explicit in literature and art. From Knossos, in Minoan Crete, there are surviving frescoes painted in the early second millennium BC with roses, the first representation of a rose so far discovered. From Crete and other Aegean islands we have vases and bowls painted almost naturalistically with grasses, crocuses or lilies, and from Mycenae on the mainland pottery decorated with stylised trees or flowers.

In Homer, the landscape pervades the poetry. Trees, caves, magical herbs, springs of water and the capricious sea are the background of the wars of the *Iliad* and the travels of the *Odyssey*, and flowers are mentioned by name in a charming passage of the *Iliad* where Zeus, inflamed with desire for his wife, Hera (who in fact had other plans in her mind), lies with her on Mount Ida on a mattress of flowers:

> Then the son of Kronos caught his wife in his arms, and underneath them the sacred earth brought forth fresh-sprouting grass and dewy clover and crocus and hyacinth, thick and tender, which raised them above the ground. There they lay and covered themselves in a beautiful golden cloud, from which shining dewdrops fell.

Of a more sombre nature was the asphodel which grew in the meadows of the underworld where the shades of the dead wandered

38 In the flower-loving Bronze Age, vases and bowls were often painted with crocuses, lilies, trees or other plants. This Minoan vase found in Cyprus has a design of ducks and a papyrus-like flower, and dates from 1300–1200 BC.

in fretful melancholy, and where, in the *Odyssey*, the suitors slain by Odysseus joined the heroic ghosts of Achilles and Agamemnon.

There is just one glimpse in the *Odyssey* of an orderly and cultivated garden – the only account until the Hellenistic age – that of Alcinous, king of Phaeacia, whose palace had an enclosed garden full of apples, vines, pomegranates, olives, figs and beds of herbs, with two springs of water, one of which was for the use of the townspeople; the fruit-trees and herbs had the magical gift of being perpetually in fruit or flower. But most of the gardens in Homer are semi-wild paradise gardens, like that of Calypso who lived in a cave in an island naturally blessed with streams and trees, vines, violets and parsley. The whole mythology of the Greeks is permeated with an awareness of wild flowers. Daphne, pursued by Apollo, was changed into a laurel. Narcissus, in love with his own reflection, killed himself and his blood was changed into a flower, as was the blood of Hyacinthus by Apollo, after Zephyrus had killed him with a discus. Persephone, daughter of Demeter, was gathering flowers when she was carried away by Hades. Prometheus, stealing fire from heaven, brought it to earth in a hollow fennel-stalk. The oak was sacred to Zeus, the olive to Athene, the laurel to Apollo. Aphrodite, associated in many myths with apples, was usually imagined among fruit-trees and shrubs in a garden paradise.

Though named or recognisable flowers are found in the arts of the Bronze Age, after the fall of Mycenae in about 1100 BC the manifest joy of the Greeks in plants fades away. In life, their decorative function was confined to wreaths and garlands hung on doors and altars and the chaplets worn at feasts and by victors at the games, made of olive, laurel, parsley or pine according to the locality. Chaplets in the early times were green, usually made of shoots of trees or shrubs, and flowers were a later refinement.

In literature, there are only rare references to gardens, and in visual art, plants and gardens take a subordinate place. When Greece re-emerged from the Dark Ages in the eighth century, the first pottery was plain, then geometric, to be followed by a great period of figure-painted pottery with centres in Athens, Corinth, some of the islands and southern Italy. The subjects were usually mythological and heroic, with occasional scenes of homely life, but the use of plants was confined to formal borders, usually circling the neck of a vase or filling in space round the handle. The representation of the plants was completely stylised, often a lotus-and-palmette pattern of

Egyptian origin, or palmettes alone, or a ring of ivy leaves, or a
scattering of rosettes. One charming Athenian black-figure jug of the
39 sixth century BC shows a lion appearing to sniff a palmette, the
background scattered with large rosettes, and many vase paintings
illustrate the wearing of formal chaplets and wreaths. But only rarely
does a plant take a central role, as in the splendid sixth-century vase
40 showing men and boys gathering olives.

Plant motifs can also be found on coins and jewellery, and there is
41 some early gold jewellery fashioned into rosettes. Most famous of the
flower coins are those from Rhodes, dating from the early fourth
42 century, stamped with a rose and buds, but other coins from other
islands and cities bear a fig-leaf or a celery stalk, a silphium plant or a

39 (*left*) Formal flowers are used with
unusual and charming freedom on this
Athenian black-figure jug of the 6th
century BC. A lion seems to sniff a
palmette, and rosettes are scattered over
the background.

40 An Athenian vase with a scene of men
harvesting olives. Two men beat the tree,
while a boy climbs it to knock the fruit
from the branches. Another picks the fruit
up from the ground. 6th century BC.

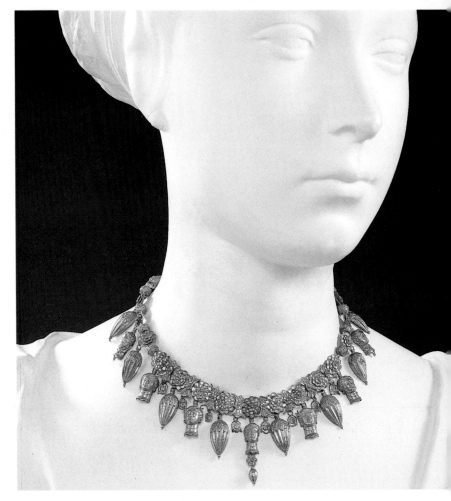

41 Rosettes and flower-buds used as motifs in a gold necklace from the Greek city of Tarentum in southern Italy, dating from the 4th century BC.

bunch of grapes, and some Athenian coins bear Athene's owl and a sprig of olive. However, except for the roses of Rhodes, flower coins were not common.

In sculpture, as in pottery, plants take only a minor and formal place, especially in the fifth century, when the Greek genius for portraying the idealised human form, particularly the nude, reached its zenith. However, one plant innovation in fifth-century sculpture was that of the acanthus leaf, used first on capitals inside the temple at Bassae and in an architectural border of lotuses, palmettes and acanthus leaves on the Erechtheion at Athens. This was the first appearance of the leaf which was later to adorn a myriad Corinthian

capitals and Roman paintings and ornaments. The only decorative blossom which the Greeks seem to have valued in this flower-barren century was the rose, which Herodotus claimed grew wild in a sweet-smelling, sixty-petalled form in Macedonia.

Though we know little about private gardens in Greece until a later date, one can assume that they were simple and utilitarian, for the Greek soil is thin and poor, and water is scarce, and then, as now, herbs and shrubs were most easily grown in pots. But we can without too much difficulty imagine the shady groves cultivated near temples and shrines, and the public park-gardens of the gymnasia outside Athens where athletes trained and philosophers taught. If there was no water near a shrine, Plato laid down that it must be conducted to the spot, for every sacred precinct must have trees and fountains, but in view of the water shortage in summer one wonders how often, except in Athens itself, the playing of fountains was practicable. In the agora at Athens, where all men met, they walked in the shade of plane-trees and poplars to the music of fountains.

Shade-giving trees were also the joy of the gardens of the gymnasia – there were avenues and groves of olives, myrtle, laurel, cypress, oaks, ilex, poplars and planes – and that of the Academy was famous for its beauty. Aristotle had his own garden, tended by many gardeners, in the grounds of the Lyceum, which he bequeathed in his will to his pupil, Theophrastus, whose *Enquiry into Plants* was the first encyclopedic book of botany, herbalism, agriculture and horti-culture. Aristotle's enormous resources for research included reports from the team of scientists who accompanied Alexander of Macedon to the east, and from this time a scientific approach to plants and a knowledge of exotic plants succeeded the homely Greek lore of earlier centuries. Theophrastus' monumental work included many plants from Egypt, Libya and Asia. The first garden made inside the city itself was created by the philosopher Epicurus, who bequeathed it to his Society, but we know nothing of its design or planting.

Before this, however, from the closing years of the fifth century, plants as ornament had been taking an increasingly important place in Greek life. Pottery, our chief source of evidence, had become both more florid and more floral, with strength of draughtsmanship giving way to grace. The drawing of plants had become more naturalistic, and they were given a larger share of the composition. Increasingly, a garden would be the main subject of a vase painting, often as a setting for one of the ancient myths. One important vase made just

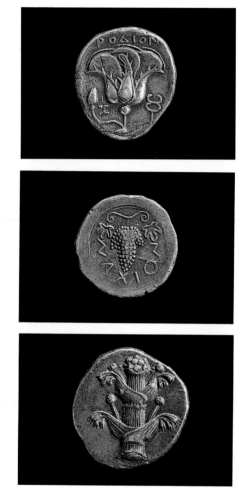

42–4 Most celebrated of Greek flower coins are the rose coins of the island of Rhodes, minted from about 400 BC. Other plant motifs on coins were the grapes of Naxos (461 or 463 BC) and the celery plant of Selinus, Sicily (480–466 BC).

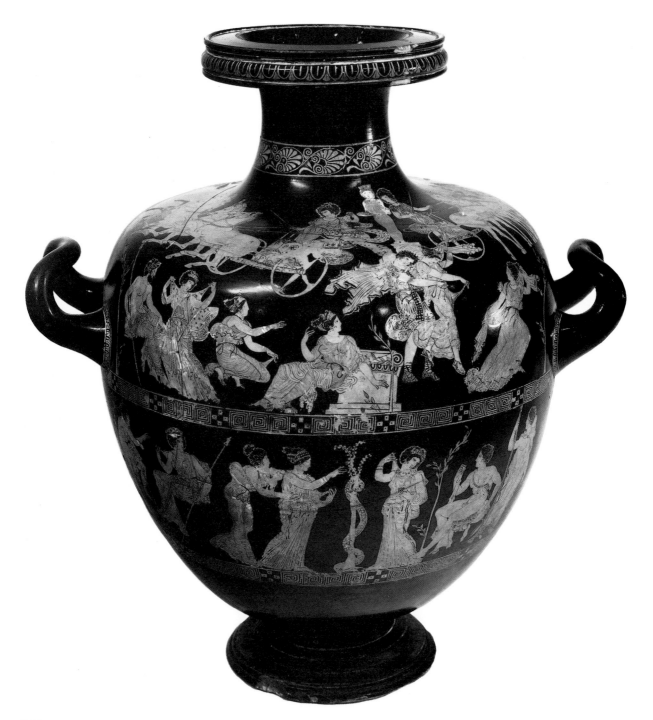

45 before 400 BC is painted with two such scenes: in the upper zone is the rape by Castor and Polydeuces of the daughters of Leucippus while they were gathering flowers in the sanctuary of Aphrodite, and below is Heracles in the Garden of the Hesperides, with its serpent-guarded tree of golden apples. This vase was painted by the celebrated 'Meidias painter', whose world is sweet and peaceful and lacks the old sense of conflict – the rape seems to please all parties, and Heracles is quite relaxed about his Labour. Following the Meidias painter, Aphrodite in a paradise garden, often in company with Eros, was a favourite subject for vase paintings.

46 By the middle of the fourth century, wreaths and swags of myrtle and ivy, friezes of fruiting vines, flowery garlands and curling stems of leaves and flowers were central features of painted pottery of the highest elegance. Soon after came a fashion for moulded pottery, much of it in fussy imitation of metalware, and three-dimensional decoration succeeded the finer, more austere painted style. Moulded terracotta figurines, a speciality of Tanagra in Boeotia, now reached a technical and artistic peak, and chic terracotta ladies, wearing flowery head-dresses or carrying garlands, smiled on a placid world. The Hellenistic style, with its prettiness and reviving use of nature as a model, was in full swing.

After Alexander's conquests, Hellenism swept into the cities of the east, and also west into Italy, where there had already been Greek colonists for centuries and were soon to be many more. Greek art, architecture, philosophy, decoration and language penetrated the more accessible centres of population and took much from the orient as well as giving, including an advanced and luxurious concept of the pleasure garden, long known to the potentates of the Near and Middle East. The grander gardens of the great Hellenistic cities such as Alexandria and Antioch were an elaborate welding of the Asiatic tradition of well-watered timbered parks with a Greek love of stone statuary and architectural ornament, to which were added new triumphs of engineering and expanding collections of exotic plants. Gardens became centres of social life rather than sacred or philosophic enclaves, and their rich owners, including the Ptolemaic kings, were proud of their garden banqueting halls and complicated waterworks – thanks to new mechanical skills, fountains played music and artificial birds trilled songs.

In Rome, Hellenistic thinking was so well established by the second century BC that Cato the Censor felt it his duty to denounce

45 This water-jar of the late 5th century, attributed to the Meidias painter, has two idyllic garden scenes. Above, a bland version of the rape of the daughters of Leucippus and, below, Heracles in the garden of the Hesperides. Athens, 410–400 BC.

Greek decadence, condemning all things Greek from women's dress to doctors. But he was swimming against an inexorable tide. Among the many Greek imports into Italy was the Hellenistic style of domestic architecture, including the elaborate pleasure garden, which attracted the Roman man of fashion.

The Roman attitude to gardens was quite different from that of the Greeks of classical times, who were gregarious dwellers in cities, with no great attachment to the countryside. In a mountainous terrain fertile land was scarce, and through most of Greece agricultural produce was won with toil and hardship. The Romans enjoyed an easier climate. In many districts of Italy there are great rivers and lakes, plenty of rainfall and abundance of fertile soil, which, combined with the realism and practical gifts of the Italians, made them skilful and enthusiastic farmers. Even in the closing years of the Republic, with Hellenistic sophistication an established influence on Italian life, a Roman aristocrat was proud to own a country farm, and the great men of literature wrote about farming with intimate knowledge. Virgil, the son of a yeoman, was born on a farm near Mantua and in the *Georgics* turned technical advice into poetry in a way never equalled since. Horace was born in Apulia and later, when he was a celebrity in Rome, divided his time between the city and the Sabine farm given him by his patron, Maecenas. Cicero believed that farming was the only form of commerce fit for a gentleman.

By the middle of the first century BC, this pastoral heritage, merged with a growing taste for luxury, had blossomed into an enthusiasm for ornamental gardening, and townsmen as well as countrymen had their private gardens, their pot gardens on the roof, their covered garden rooms; and Rome itself was famous for its gardens and flowers. When a swelling population required the building of blocks of flats, the tenants had gardens on their balconies.

Since the resources of garden owners varied according to their taste, wealth and available land, there were Italian gardens of at least two different kinds. An old-fashioned house, built round an *atrium*, or central hall, and lit from within, would have a useful *hortus* around the house. This would be loosely planted with trees and shrubs, many of them grown in pots, with plots for fruit, vegetables and herbs, of which the Italians grew a wide range for cooking, medicine and scent. A gardener of the old school would stick to well-known plants and resist luxurious innovations: Cato, in his *De Re Rustica*, repeatedly stressed the importance of cabbages.

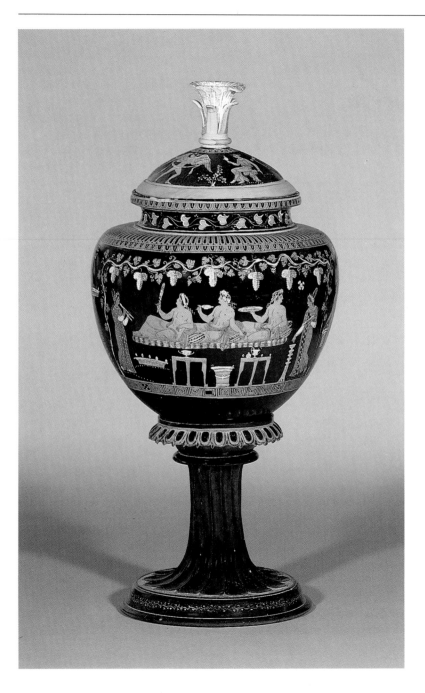

46 Fourth-century vases in Greece and southern Italy had lost their earlier austerity. This red-figured wine-bowl found in Apulia is painted with banqueters crowned with flowery chaplets and with swags of grapes and ivy. It dates to *c*. 350 BC.

But from the second century BC the rich and *avant-garde* had been building more modern houses (or converting old ones) in the Hellenistic manner. These houses looked outwards rather than inwards, on to gardens which were admired places of beauty or true pleasure gardens. Indeed, the whole house tended to move outwards and to embrace the open air. Beyond the *tablinum*, or main reception room, an important new feature was a rectangular peristyle, an open decorative courtyard surrounded by covered arcades and rooms which were larger and airier than those of more old-fashioned houses. The peristyle would be adorned with both architectural features and plants, and often a terrace led from the main house into the garden, linking the two together. Some of the new gardens, like those of the country mansions of Lucullus in the first half of the first century BC, were of legendary luxury and size, with statuary, fountains and wonderful new plants – Lucullus is credited with having introduced peaches and cherries from Asia Minor. Some of these princely estates ate up so much agricultural land that the country poor were forced into the towns and there was a serious shortage of produce in the markets of Rome.

Town gardens, in Rome or elsewhere, were necessarily more modest in size. They were always formal in shape, with straight paved walks, rectangular beds and pools of rectangular or other geometric shape, though sometimes, where the site allowed, the strictness was tempered by an awareness of the landscape beyond the walls. The town gardens we know most about are those of Pompeii and Herculaneum, since abundant archaeological and pictorial evidence has been revealed by excavation of the ruins which were overwhelmed in AD 79 by the eruption of Vesuvius. The country garden where we feel most at home is that of Pliny the Younger in Tuscany, for he described it inch by inch in a letter to a friend in about AD 100.

Pompeii was a prosperous provincial town near Naples in the lovely district of Campania, where many rich Romans had built country houses in the first century BC – Cicero had large estates there – and the small towns on or near the sea were centres of Hellenistic art and craftsmanship as well as popular resorts. In Pompeii there were public parks, private gardens large and small, orchards, nurseries and a vineyard, so that in the hot summers there was plenty of refreshing green.

The small houses of the artisans were of the old-fashioned kind,

with traditional gardens simply planted, and even where these were of pocket-handkerchief size there was usually a full-sized tree for shade. But the larger gardens were highly elaborate, even ostentatious, with a peristyle an important feature. A rich householder might have several peristyles, either in different places, as dictated by the site, or leading from one to another. A small peristyle would have formal beds planted with low-growing evergreens such as box and ivy and a small pool, but a large one would include soft fruits, vines and olives and was likely to be crowded with architectural

47 This fantasy wall-painting from the villa of the Empress Livia near Rome includes many characteristic features of Roman gardens. A low boundary fence encloses a luxuriant garden planted with pines and fruit-trees and rich in flowers and birds. 1st century BC. Rome, Museo delle Terme.

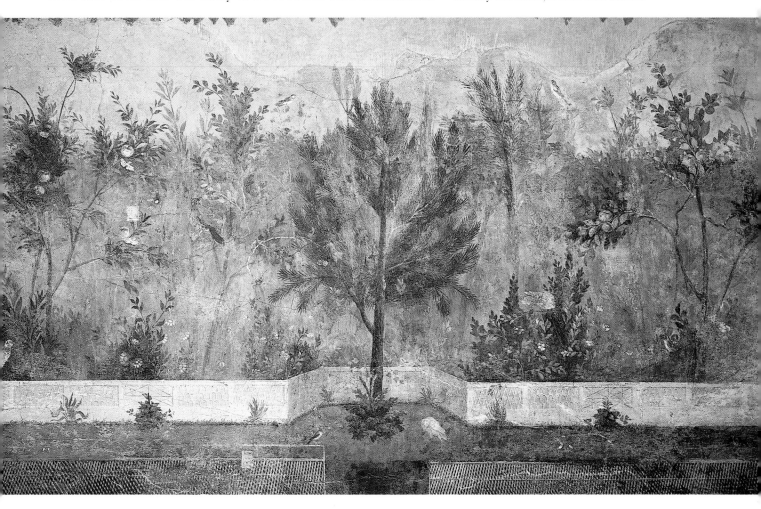

ornaments: the satirist Martial quipped that a rich man's garden was so stuffed with statues and plants that there was no room to eat or sleep. Marble fountains and statues were *de rigueur*, there were pools and fountains, marble tables and couches, niches for busts, herms or vases, columns and porticoes, trellis for vines, and pots of shrubs, including lemons, in rows, and, towards the end of the heyday of Pompeii, mosaics. If the site permitted, the garden might be planned round a long central canal lined with marble or cement painted blue. Often there was an aviary to give the charm of wild-life. Sometimes the architect contrived to build terraces above the garden rooms to give a view over the sea.

Always there would be shade provided by large trees, especially planes (*Plantanus orientalis*), fruit-trees trained to walls, clipped hedges and perhaps topiary, a fashion which came in at the time of Augustus. The colour of the garden plants would be mostly green, the green of trees, ivy, box, laurel, acanthus, arbutus, myrtle and rosemary, but there would certainly be roses and other scented plants, perhaps a few lilies, irises, violets, narcissus, jasmine or lavender. In this preference for evergreens, the Romans showed unexpected good taste, for the lavish quantities of statuary would be tolerable only in a green setting, and stone, water and green plants have been the fundamentals of Italian gardens to this day.

One new garden feature of importance, found both at Pompeii and Herculaneum, was the painting of garden walls. There was a long tradition of wall painting in Italy inherited from the Etruscans, and in the first century BC this changed its character from straight representation to fantasy painting, or even to deceptive *trompe-l'oeil* painting, creating an illusion of depth and distance on a flat surface. In great mansions, interior walls were painted with false columns, cornices, masks and elaborate mouldings, like a stage-set in the theatre, with romantic landscapes which seemed to carry the eye outside the house to scenes in the distant country. Some of these scenes were of sacro-idyllic subjects, such as Pan among the nymphs or Europa with the bull, or Venus or Mercury, but often they were of a rustic nature, a fashion introduced, according to Pliny, by the painter Studius in the time of Augustus. Subjects were country villas, rocks and woods, harbours and seascapes, or pictures of men fowling, fishing, or herding goats, a link between the modern extravagance of Rome and her practical past; and sometimes there were representations of gardens. The covered garden room of the

48

47 Empress Livia at Prima Porta, near Rome, had every wall covered with fantasy painting. The base of each wall was painted with a low boundary fence, with a luxuriant garden beyond planted with pines and other trees and alive with birds and flowers. A wall-painting found at Herculaneum has an elaborate trellis fence, trellis arches, fountains, posts supporting elegant vases and some delightful storks. There are no human beings in these paintings – nature is tamed and loved for its own sake.

This fantasy painting came to be extended from the inside to the outside of the house, a gift to the owner of a small garden who wished by illusion to exaggerate its size, and painted garden walls, usually the walls at the end of the garden, were a popular fashion at Pompeii. The subjects were as various as those of the paintings in the house, and sometimes repeated them: there were scenes of gods and heroes, also many simpler pictures of the animal and plant life of Campania. At the bottom of the fresco there was always a trellis fence. Beyond this there might be trees and flowers, or birds drinking at a fountain,

48 Landscape with villa. Roman wall-painting from a villa at Boscoreali, near Pompeii. 1st century AD.

or a heron eating a lizard, or a domestic animal, perhaps the family dog. Sometimes the birds and plants were local, such as herons and doves and the wild flowers of Campania, but sometimes, more incongruously, they were exotic – wild peacocks or rampant lions.

This fusion of luxury with a love of the land was not confined to the town garden. It was strongly evident in the gardening style of Pliny the Younger, whose career was at its peak in the reign of Trajan, and who owned at least two country estates as well as his town house, one at Laurentum, on the sea near Rome, and a larger one in Tuscany. Pliny's taste was characteristically Roman. He loved landscape and an open view, but was not innocent of ostentation. He liked formality of design and statuary in unashamed quantities, and had no particular feeling for flowers, except as a source of scent, but he cared deeply for scenery. At Laurentum, he had a garden room with a view over the sea, and in Tuscany his vast formal garden led into a semi-wild garden with groves and meandering walks beside a stream, leading in turn into the mountainous country beyond, which could be viewed from the house and from vantage points in the garden.

The main garden near the house was filled with horticultural tricks. There was architectural ornament everywhere – porticos, pavilions, obelisks, fountains, seats, columns and trellises. Rows of trees, clipped with military precision, were linked by festoons of trained ivy. Fruit-trees were trained espalier-fashion. Topiary was ubiquitous, sometimes clipped into animal shapes or letters of the alphabet: Pliny's name and (charmingly) that of his gardener were cut out in box. Indeed, plants were used as a material, like brick or stone. In general, the Romans grew plants for utility rather than beauty. They grew them for scent or shade, to eat or to flavour food, to make wine and chaplets, for dyes and aphrodisiacs, beauty preparations and perfumes, and to cure every known ailment from boils to asthma, from menopausal pains to snakebite, but they did not love flowers as did the Egyptians, or appreciate their manner of growth.

The Roman style of garden in the early centuries AD extended far outside Italy into many parts of the Empire, especially North Africa, and it was also brought to Britain. At Fishbourne, in Sussex, a large Roman villa was excavated in the 1960s, and for the first time the archaeologists explored the garden as well as the buildings from the beginning of their work. They found a large peristyle formally planted, piped water bubbling in basins of Purbeck marble, alcoves

49 Country scenes are occasionally depicted on Roman cameo glass. The Portland Vase shown here was made during the reign of Augustus (27 BC – AD 14). The subject of the scene is disputed: some believe it to represent the wedding of Peleus and Thetis.

51 (*opposite*) Acanthus stems and a central leafy rosette decorate the side panel of a mosaic pavement from a large town-house in North Africa.

50 A pottery jug with a relief pattern of vines and grasshoppers. Italy, 1st century AD.

for statues and seats, clipped hedges and, most exciting of all the revelations, traces of a painted wall.

An interest in nature, in abeyance in Greece for many centuries after the Bronze Age, had revived strongly in the Hellenistic period, and was readily inherited by the country-loving Romans. Their taste was of course reflected in Roman art. As well as the wall-paintings with their fantasy landscapes, the themes of decorative sculpture, pottery, silver, glass and mosaics were often pastoral or sporting. With the Empire, art became more official and vainglorious, with human portraiture dominant, and the fantasy element gradually faded away, but decoration and infill were still inspired by the gifts of

nature, and trees, flowery arabesques, sprigs and sprays, leaves and fruit, animals, birds and insects, are found in almost every artistic medium until the fall of the Empire, to be revived in the Renaissance. Of all the plant motifs used by artists and craftsmen, the acanthus leaf was the most important, the round-leaved *A. mollis* being the commonly chosen species and more rarely the spiky *A. spinosus*.

49 Scenes of figures in the open air, either mythical or pastoral, were frequent subjects of decorated glass, pottery and mosaics. The Portland Vase, made in the late first century BC, is the most celebrated of all Roman glasses. Dark blue, with a raised cameo design in white, the scene is possibly the marriage of Peleus and Thetis, the parents of Achilles. Thetis reclines on a plinth in the shade of a tree. Dionysus and Ariadne in a garden, with a goat and a dog, are the subject of a cameo panel of similar technique in the Naples Museum.

Moulded pottery also favoured outdoor scenes, and a characteristic terracotta lamp in the British Museum shows the Tityrus of Virgil's first *Eclogue* tending his sheep and goats beneath a tree. (Glass, pottery and silverware had since early Hellenistic times tended to be decorated in relief.)

Country scenes in mosaic are usually of later date, and mosaics retained their quality through late antiquity after other Roman arts had fallen into decadence. Mosaic paving was a local craft practised throughout the Empire, and it was made out of whatever pieces of stone were locally available. The central subjects were usually figurative, representing either mythological characters or the grandees who commissioned the work, but there was plenty of space for incidental decoration or borders in the form of leaves, flowers or

51 fruit, always formalised, with the acanthus leaf the most popular motif. A splendid North African mosaic in the British Museum, dated AD 200, has four busts of the Seasons set in a swirling background of arabesques of leaves and flowers. Another fine mosaic has a side panel of a giant acanthus in a pot. At the Romano-British palace at Fishbourne there were mosaics of several dates, but the best, of the Flavian period, had a central circular panel bordered by rosettes and beautiful stylised leaves.

Hunting scenes were another favourite subject, and in the British Museum there is a late but lively mosaic from North Africa, of the fifth or sixth century AD, depicting the landowner on horseback roping a stag, with growing plants and sprays of flowers dotted

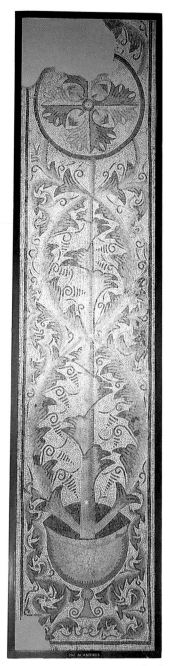

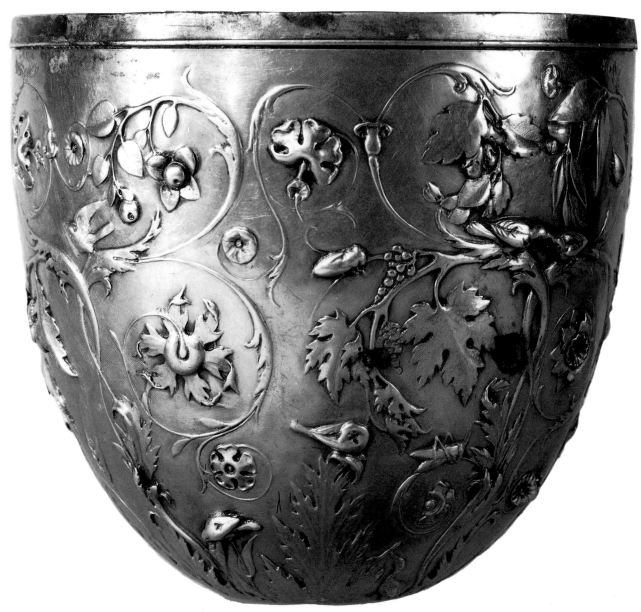

52 The relief work characteristic of the Hellenistic age became increasingly popular with Roman
craftsmen. This silver cup, one of a pair, is richly decorated with scrolls of flowers,
vines and acanthus leaves. 1st century BC or AD.

throughout the landscape. Mosaics of hunting scenes, featuring dogs, wild boar, deer, birds and even ostriches, flattered the provincial owner's self-esteem and proved his prowess as a country gentleman. The pavement would decorate the main reception room of his villa and would impress his guests and clients with his aristocratic tastes.

Acanthus, vines and leafy scrolls were common motifs in other Roman crafts. One moulded jug in the British Museum is patterned with vine-leaves and grasshoppers. Silverware cups are networked with curling plant sprays. Formal borders of acanthus edge the base and rim of the fourth-century masterpiece, the Lycurgus Cup, which shows Lycurgus being killed by Dionysus. By an accomplished technique, the glass shows red when light passes through it, but is green in reflected light.

Though Roman sculptors were commissioned to turn out inordinate quantities of statues and busts, either copies of Greek originals or contemporary portraits of wealthy citizens, there was much decorative sculpture based on themes from nature, especially plants. One of the great legacies of the late Hellenistic and the Roman world is the Corinthian capital, which was used on columns throughout the Empire on temples and public buildings, especially from the time of Augustus, when marble was increasingly the chosen building material instead of limestone. In the fifth century BC, at Bassae, the column with the first known Corinthian capital was built inside the temple beside the cult statue. Later Corinthian capitals were used on the outside as well as the inside of buildings and the proportions of the columns varied, as did the capitals: the acanthus leaves were sometimes narrow and upright, sometimes broad or reflexed, sometimes had elongated stalks terminating in flowers. The acanthus pattern was not confined to the capitals of columns, but was also used on smaller pieces of sculpture, such as altars, fountains or candelabra. A first-century marble fountain found in a garden at Tivoli (not Hadrian's villa) is elaborately carved with an acanthus base from which rises a column wrapped by olive, ivy and other foliage

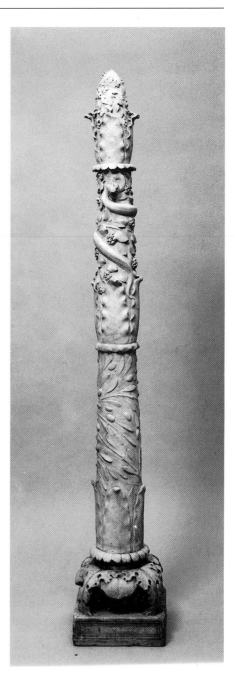

53 A marble fountain found in a garden at Tivoli, carved with an acanthus base and a column wrapped by olive and ivy foliage and a serpent, with flowers at the apex. 1st or 2nd century AD.

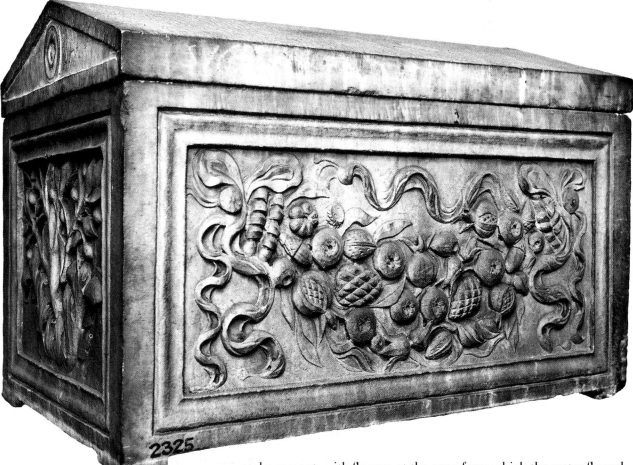

54 Rich sculpture of fruit and foliage was characteristic of the early Empire. This child's cinerary urn in marble, probably of the early 2nd century AD, is carved with realistic pomegranates, apples, grapes and nuts. On the short end, an olive tree grows out of an acanthus, a funerary symbol.

and a serpent, with flowers at the apex from which the water flowed. An altar to Ceres of the same date is richly decorated with acanthus, corn and fruit, and a fine marble cinerary urn of the second century AD, used to inter a child, is carved with realistic pomegranates, apples, grapes and nuts, with olive trees on the short ends. 54

A distinguished line of plant historians, from Pliny onwards, provides literary proof of the intense interest taken by the citizens of the Roman Empire in the vegetation of the natural world. This is complemented by much artistic evidence, of which this chapter quotes only a fraction, of the pride which the Romans took in their gardens, trees, flowers, foliage and fruit.

2
Western Art

Ray Desmond

55 Jan van Huysum (1682–1749): *Adonis, Lilium pyrenaicum,*
Chrysanthemum coronarium and peony(?). Watercolour and bodycolour.

The Search for Nature

The Middle Ages is an abstract concept whose birth and demise cannot be precisely defined; aspects of it survived beyond the Renaissance and the Reformation. The way for it was prepared with the disintegration of the Roman Empire. Some scholars postulate the dawn of the Middle Ages in the year AD 313 when the Edict of Milan established Christianity as a state religion; others, including many art historians, favour Charlemagne's enthronement by the Pope in AD 800 and the formation of the first Germanic empire. It was not, however, until the Church and its teaching permeated the life and thought of Europe that medieval art, inspired and nurtured by the Christian faith, evolved its own ethos. When the skills of craftsmen – illuminators, painters, sculptors, wood carvers and embroiderers – were enlisted to disseminate theological doctrine, the church and monastery inevitably became the focal point of artistic endeavour.

In the botanical manuscripts produced in the so-called Dark Ages – that obscure period between the demise of the Roman Empire and the onset of the Middle Ages – drawings of flowers through repeated copying from other manuscripts had become stylised, lifeless and remote from nature. There were a few notable exceptions like the magnificent *Codex Vindobonensis* of Dioscorides, compiled in the classical tradition at Constantinople in AD 512. Artists were usually content to copy earlier drawings, no matter how debased, apparently feeling no compulsion to study the living plant. Plants employed in ornamentation were also stylised. The Anglo-Saxon cross-shaft found at East Stour in Dorset is incised with formalised plant scrolls, clusters of grapes, acanthus and palmettes with exaggerated leaves. Palmettes also decorated the illuminated manuscripts of the Win-

56 Fragment of a limestone cross-shaft from East Stour, Dorset, decorated with vine and foliate scrolls. It has been described as 'by far the most elaborate and well preserved carving of plant scrolls from Wessex'. Anglo-Saxon, early 10th century.

56

chester School based upon the New Minster, which became an important centre for painting in the maturity of the Anglo-Saxon period. Miniatures in these manuscripts were usually framed in borders of acanthus or interlaced foliage. Across the English Channel illustrators embellished large initial letters with this ubiquitous leaf.

The Castle joined the Church as patrons of artists who now found new outlets for their skills as painters, gold- and silver-smiths and carvers in stone, wood and bone. Some distraction from the monumentality of Romanesque architecture was provided by Biblical stories carved on the capitals of pillars. In this didactic sculpture can occasionally be found a flourish of curving leaves and twisting stems, revealing a perception of natural forms and a hint of a revival of a direct observation of nature.

In early Norman buildings foliage tended to be restricted to a surface decoration of capitals and impost blocks. By the thirteenth century, deeply cut ornamental leaves had replaced the former solidity and restraint of capitals, and there emerged a distinctive Gothic style which endured until the Renaissance, a style characterised by a nervous energy, exuberant yet controlled, organic yet abstracted. The Gothic sculptor disdained the narrative scenes of earlier capitals, substituting large sprays of foliage, at first stiff and inflexible. Very soon not only capitals but also windows and woodwork in screens and choir stalls were smothered in an abundance of plant decoration. The transept doors at Chartres Cathedral are adorned with hawthorn, holly, ivy and rose; the west door of Notre-Dame-de-Paris has a frieze of what looks like watercress. Sculptural evidence of an acute observation of natural forms can be discerned in Rheims Cathedral, the Sainte-Chapelle in Paris, Nuremberg Cathedral, Lincoln Cathedral and York Minster; its finest expression in this country is in the octagonal Chapter House at Southwell Minster in Nottinghamshire. The anonymous sculptor or sculptors at Southwell had obviously looked at plants, observing their structure and form before skilfully interpreting their vitality and suppleness in stone. In the canopy of foliage that covers capitals, tympana and roof bosses can be identified the characteristic shapes of hawthorn, ivy, maple, potentilla and rose. Yet the sculptor, notwithstanding his adherence to natural forms, made no attempt to carve them to scale, treating them rather as components in a decorative composition.

In an age which generally subordinated botanical accuracy to the requirements of formal ornamentation, these instances of naturalism

were uncommon and localised: lily-of-the-valley and seedpods of the poppy can be seen in the carvings that survive in the ruins of Corcomroe Abbey on the west coast of Ireland. The urge to decorate surfaces extended even to concealed misericords in the choir stalls, where the oak leaf was the most popular foliage with the wood-carver. It has been calculated that plants amount to about half the subjects depicted on British misericords, usually as supporters flanking the central subject.

The rose, a symbol of love and beauty in the classical world, was adopted by the Christian Church to represent both human and divine love. The rose window in Chartres Cathedral must surely be the largest design ever inspired by any plant. About the same time that realistic leaves were being carved at Southwell, York and elsewhere, a similar trend was taking place in the rendering of leaves in painted glass. The gradual change can be perceived in the foliage grisaille in the Five Sisters Window in York Minster. In the fourteenth century some glass painters reached a commendable standard of naturalism with the familiar plants of the countryside. Regional schools evolved

57 Ivory liturgical comb with animal heads, figures and stylised foliage. English, first half of the 12th century.

58 Floral decoration on the back of one of the Lewis chessmen. Walrus ivory. Probably Scandinavian, mid-12th century.

59 Gilt-bronze crozier-head with foliage decoration, set with gems and nielloed silver plaques; the knop is of rock crystal. The technique and the style of the foliage ornament suggest the work of Hugo of Oignies or one of his associates. Mosan, c. 1230.

their own floral styles: Norwich glass, for example, often included a motif of holly-like leaves twisted around a vertical pole.

Decoration was not confined to the fabric of the church. The crozier of a bishop or abbot, for example, would sometimes terminate in an ornamental flower. The British Museum possesses a particularly fine crozier head set with gems and nielloed plaques with a knop of rock crystal. Its foliage decoration suggests the work of one of the best goldsmiths of the thirteenth century, Hugo of Oignies, or a member of his circle. Smaller objects also received the attention of the craftsman's nimble fingers. The British Museum's liturgical comb, used by the celebrant of the Mass for the ritual tidying of his hair, has interlaced scrolls of foliage. It is probably made of walrus ivory, as elephant tusks were scarce in Europe during the twelfth century. Certainly the twelfth-century chessmen found on the Isle of Lewis in the Outer Hebrides, and now in the British Museum, were fashioned from walrus ivory, probably in Scandinavia. They, too, display finely carved leafy scrolls.

The gittern, the medieval forerunner of the modern guitar, survives in a unique fourteenth-century specimen in the British Museum. It once belonged either to Queen Elizabeth or her favourite, Robert Dudley, Earl of Leicester. A vine descends from the neck of the monster carved at the head of the instrument. The body of the gittern is carved with scenes of huntsmen among friezes and panels of hawthorn leaves and other foliage. This foliage is in the spirit of similar early decorated embellishment in the choir stalls in Winchester Cathedral and on the capitals in the crypt of St Stephen's Chapel, Westminster.

Because of the ease with which its form and sinuous lines could be manipulated to fit the limitations of the page, foliage had always been a favourite motif with the decorators of manuscripts. The twelfth-century illustrator generously enveloped his large initial letters in twisting plant tendrils and leaves of uncertain provenance. By the late thirteenth century, luxuriant ivy or vine-leaf borders with diminutive leaves carefully picked out in gold became fashionable, especially in Books of Hours. These were the personal prayer books of the wealthy, whose patronage encouraged the growth of workshops or studios in France and the Low Countries where scribes and illustrators worked primarily in the production of these exquisite volumes. By the 1470s Flemish illustrators in Bruges and Ghent had abandoned the leafy border for a gold frame which served as a kind

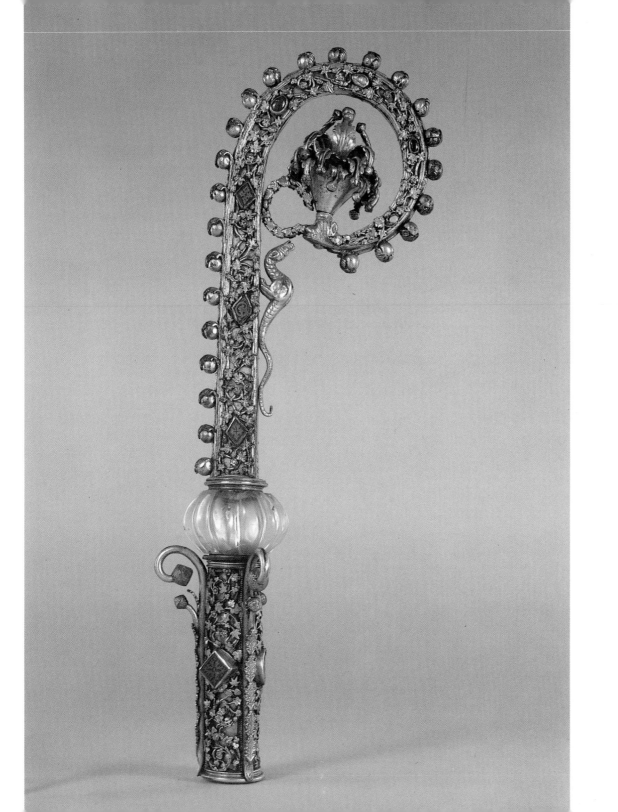

of window through which to view the miniature. On the gold background insects and the heads of flowers that were common in the garden or countryside were scattered in a casual profusion – daisies, pansies, pinks, primroses and violets – and the artists achieved a brilliant *trompe l'oeil* effect by deftly adding a faint shadow behind each flower and insect.

Flowers formed part of the composition of these miniatures and also of large canvases because they were the means of expressing moral concepts: the lily-of-the-valley for purity, for example, or the violet for humility. The aquilegia symbolised the Holy Ghost, the trilobed clover the Trinity and the blue iris the Madonna. Whether or not the flowers in medieval and Renaissance art had this symbolic role, they could still be painted with an honest regard for accuracy. Some thirty species of flowers can be recognised in Sandro Botticelli's *Primavera*. Walter Pater, in his *Studies in the History of the Renaissance* (1873), wrote of Botticelli that he 'lived in a generation of naturalists and he might have been a mere naturalist among them. There are traces enough of that alert sense of outward things which in the pictures of that period fills the lawns with delicate living creatures, and the hillsides with pools of water, and the pools of water with flowering reeds.'

The medieval artist readily found the floral subjects for his paintings or carvings in neighbouring fields or in the gardens of the cloister and castle. The gardens themselves have long since disappeared, and information about their design and the plants they grew has to be sought in archives, in the few plans that have survived, and in the tantalising glimpses of them in oil paintings and miniatures. Many gardens, matching the splendour of the buildings to which they were attached – royal, monastic, collegiate and private – existed for pleasure as well as for utility. The more modest was just a flowering mead: a lawn sown with low-growing flowers such as periwinkles, primroses, violets and gillyflowers. Such a floral carpet was lovingly painted by the brothers Jan and Hubert van Eyck in their *Adoration of the Lamb* (Ghent, Church of St Bavon). The larger gardens had tunnel arbours covered with ivy, vines or roses, with paved walks and flower borders of roses, irises, lilies and herbaceous plants.

This evident enjoyment of nature found an echo in the furnishings of medieval houses. The tapestries which hung on the walls projected a background of clusters of flowers known as *millefleurs*. More than a hundred different plants were woven in the celebrated Unicorn

60–61 An ancestor of the modern guitar, this gittern is the only surviving major English musical instrument of the medieval period. The back, sides and neck are intricately carved from a single piece of wood with a profusion of foliage: hawthorn, oak, vine and ivy. English, early 14th century.

tapestries (in the Cluny Museum, Paris, and the Cloisters Collection, New York) and were executed with such painstaking exactitude that most of them can be named with confidence. Floral patterns were also embroidered on beds, cushions and dresses.

Flowers and scrolls of foliage were embroidered, too, in fluent compositions on English ecclesiastical vestments of the late thirteenth and fourteenth centuries: this accomplished needlework was renowned throughout Europe as *Opus Anglicanum*. Pope Urban IV employed an English gold-embroiderer, and Pope Innocent IV, an admirer of English embroidered vestments, remarked, 'England is for us surely a garden of delights, truly an inexhaustible well; and from there where so many things abound, many may be extorted.' He requested that such embroideries, especially those made with gold thread, be sent to Rome. The English monk and historian Matthew Paris laconically observed, 'The command of my Lord Pope did not displease the London merchants who traded in these embroideries and sold them at their own price.'

Low-cut bodices in the middle of the fifteenth century encouraged the wearing of necklaces and pendants, which sometimes incorporated floral motifs. In 1467 Sir John Howard presented his wife with a collar of thirty-four roses, and jewellery with enamelled foliage and flowers formed part of a hoard deposited at Fishpool in Nottinghamshire during the 1460s. From monumental sculpture to exquisite jewels, the decorative arts in the late medieval period responded to a genuine and deep-felt appreciation of natural beauty.

There is no precise dividing line between the Middle Ages and the Renaissance, which has been defined as 'the intellectual, moral, spiritual and artistic rebirth of Europe'. A consensus of opinion agrees that it owed its origin to the rediscovery of Greek and Latin literature in Italy in the fourteenth century, but there had always been a few medieval scholars familiar with classical texts. It has also been defined as 'a revival of naturalism', but the foundations for this had been firmly laid by those anonymous medieval craftsmen who confidently drew or carved the plants and animals they knew. There was, however, one important change. The Renaissance artist emerged as an individual serving a patron, whereas his medieval counterpart expressed the collective needs of a community.

The progress towards modern natural history received an impetus when the artist left his studio for the fields. The Flemish artists who illuminated their manuscripts with flowers that seem to lie lightly on

62 English or Flemish silver-gilt spoon. Both sides of the bowl are enamelled with flowers. The spoon can be unscrewed into three separate pieces for housing in a leather case. 15th century.

the page must surely have found their models out of doors. Jean Bourdichon (1457–1521), court painter to three French monarchs, produced a spectacular Book of Hours (*Grandes Heures*) for the French queen in the early years of the sixteenth century. He drew over 300 plants for its floral borders, and so confident was he of their accuracy that he did not hesitate to add their French and Latin names.

One would expect the same consideration for objective truth to be found in herbals, which described plants especially for their medicinal properties. Most plant portraits in the old herbals were, surprisingly, little more than an exercise in geometrical symmetry, admirable for decoration but useless for identification. This tradition of meaningless stylisation was not broken until the new schools of medicine demanded reliable texts. In the thirteenth century, Platearius, one of the leading figures at the medical school in Salerno near Naples, the first to be established in Europe, compiled a manual of plant drugs known as the *Liber de Simplici Medicina*. The earliest surviving illustrated copy of this manuscript, now in the British Library, heralds the dawn of a new realism in plant drawing. The artist of this early fourteenth-century manuscript shows some awareness of living plants, although it is obvious he still used existing drawings and his illustrations conform to an accepted pattern. This enduring link with a long tradition in plant portraiture that had persisted for centuries was finally broken with the appearance of a herbal, made about 1390–1400 for Francesco Carrara the Younger, the last Lord of Padua. Its anonymous artist disdained the pattern books that had been indispensable props for his predecessors and actually examined the flowers themselves. In the fifty or so drawings we have the first modern corpus of botanical art in the West, a thrusting but sensitive spread of flowers, fruits and leaves across its vellum pages.

Medical students needed access not only to manuscripts with authentic drawings but also to collections of plants to familiarise themselves with their structure and habits. Botanical and physic gardens had been established at the medical schools of Padua and Pisa by the mid-sixteenth century and other countries soon emulated the Italian model. These gardens became the obvious destination for the floral curiosities brought back from the New World, Africa or the Orient. There they were studied, named and classified according to what appeared to be significant characters of the flower, fruit and

leaf. This investigation of the structure of plants was gradually superseding a more circumscribed interest in their medicinal properties, and the discipline of direct observation, aided by the use of the magnifying glass and later the microscope, was an important advance in the scientific development of botany.

The great mission of naturalists was the discovery and comprehension of the laws of nature, a quest in which the polymath Leonardo da Vinci (1452–1519) inevitably participated. He had an opportunity to become acquainted with plant morphology and anatomy when he worked as a young man in the Semplici Garden in Florence. Amongst his drawings, now part of the royal collections at Windsor, is a rapidly executed sketch of a spray of oak leaves and acorns displaying a confidence based on careful observation: the vitality of growth of the 'Star of Bethlehem' (*Ornithogalum* sp.) is captured in flowing patterns of pen and ink lines. The same scientific accuracy invests the plants in his paintings. Vasari described the now lost *Adam and Eve in the Garden of Eden* as 'a meadow in grisaille, containing much vegetation and some animals unsurpassable for finish and naturalness'. Of all his contemporaries, the only artist who challenged his skill and precision in flower painting was Albrecht Dürer (1471–1528).

Dürer, the son of a Nuremberg goldsmith, from whom he probably inherited his talent for meticulous detail, was the first artist in northern Europe to apply scientific principles to art. The fastidious care with which he drew a clump of grasses, dandelion and plantain was confirmation of his integrity as well as his technical skill – he drew with honesty and analytical detachment, never tempted to distort or to adapt in order to accomplish a more pleasing composition. Irritated no doubt by his loyalty to scientific exactitude, someone once complained that he 'approached life with a compass and a ruler'. His watercolour of a European larch shows that he was capable of painting in a more relaxed manner. The trunk of the tree and its branches are rendered quickly with broad and narrow strokes of the brush. It is no more than a sketch, but Dürer, with his formidable knowledge of natural form, has encapsulated the essence of the tree.

Georg Hoefnagel (1542–1600) was one of a number of artists who perfected their technique by assiduously copying Dürer's work. Born in Antwerp, he travelled in Germany and Italy before entering the service of Albrecht V, Elector of Bavaria, for whom he illustrated a

63

63 Albrecht Dürer (1471–1528):
European larch (*Larix decidua*).
Brush drawing with green and
brown bodycolour and
watercolour, *c.* 1495–7.

[77]

64 Jacob Hoefnagel (*c.* 1515–1630): Fritillary, narcissus and other flowers. From *Archetypa Studiaque Patris Georgii Hoefnagelii*, a book of engravings of flowers, animals and insects, Frankfurt, 1592.

book of prayers. He spent eight years illustrating his greatest work, *Missale Romanum*, for Archduke Ferdinand of Tirol. His motto, 'Natura sola magistra' (Nature the sole master), was aptly chosen by an artist who portrayed flowers, animals and fishes in a prodigious output of exquisite drawings. His son, Jacob, at the precocious age of seventeen engraved a selection of his father's work, mostly taken from the *Missale Romanum*, in a book entitled *Archetypa Studiaque Patris Georgii Hoefnagelii*.

Hans Weiditz of Strasbourg was one of Dürer's pupils and some of his work was later wrongly attributed to his illustrious teacher. The book with which he is associated, *Herbarium Vivae Eicones*, published in 1530, is a landmark in botanical illustration. For the first time in any printed work flowers were drawn with the same scrupulous attention that Leonardo da Vinci and Dürer had bestowed on their drawings. The author, Otto Brunfels, dismissed the illustrations as no more than 'dead lines', believing them to be inferior to the 'right-truthful descriptions' in his accompanying text. But it is Weiditz's contribution that has ensured the book's lasting reputation. With frankness, humility and affection Weiditz drew what he saw, including imperfections – a broken stem, a tattered leaf

or a wilting flower. If he has a fault, it is that he recorded a specific specimen rather than an exemplar of the species. His flower drawings, which have miraculously survived, are now housed in the University of Bern.

Brunfels exercised a loose control over Weiditz, content to allow him and the printer to 'fashion the cuts according to their whims'. No such latitude was granted by Leonard Fuchs to the artists he engaged to illustrate his *De Historia Stirpium* (1542). His prefatory remarks leave one in no doubt that he was firmly in control:

> As far as concerns the pictures themselves, each of which is positively delineated according to the features and likeness of the living plants, we have taken peculiar care that they should be most perfect, and, moreover, we have devoted the greatest diligence to secure that every plant should be depicted with its own roots, stalks, leaves, flowers, seeds and fruits. Furthermore we have purposely and deliberately avoided the obliteration of the natural form of the plants by shadows and other less necessary things by which the delineators sometimes try to win artistic glory: and we have not allowed the craftsmen so to indulge their whims as to cause the drawings not to correspond accurately to the truth.

65 The drawings, compared with Weiditz's assertive lines, are thin, almost wiry outlines, but their clarity was what botanists wanted. Fuchs, for whom botany was a pleasant indulgence, handsomely acknowledged his indebtedness to his artists by including their portraits in his book. Albrecht Meyer is shown drawing a corncockle; Heinrich Fullmaurer carefully transfers a drawing to a woodblock; and below them is Veit Rudolph Speckle, the engraver. Fuchs enjoyed the dubious compliment of having the plates in his book repeatedly pirated: the illustrations were, in fact, copied for more than two centuries.

The traditional beliefs of medieval man were being tested and re-evaluated by this new approach to the physical world through the discipline of scientific observation. His geographical horizons were also being widened during what has been called the Age of Discovery. The medieval cartographer hinted that beyond the vast anonymous ocean surrounding the known world there were perhaps other continents. Portuguese adventurers, cautiously extending their navigation of the west coast of Africa, eventually rounded the Cape of Good Hope. Vasco da Gama reached India in 1498 and established a

65 Albrecht Meyer: Wormwood (*Artemisia absinthium*). Watercolour for Leonard Fuchs' *De Historia Stirpium*, 1542.

'Wysauke.

The herbe wch the Sauages call wysauke wherewth theie cure their wounds wch they receaue by the poysoned arrowes of theire enemyes.

66 John White (*fl.* 1540s–after 1593):
American milkweed (*Asclepias syriaca*).
Watercolour.

lucrative trading route. In 1511 the Portuguese took Malacca and discovered the spice islands of the East Indies. Columbus, seeking a new route to Asia, found America. In a memorable voyage lasting three years Magellan's fleet accomplished the first circumnavigation of the globe.

The floristic discoveries of these new lands were reported back to Europe. Printed herbals illustrated the spices of the East – pepper, nutmeg, cardamom and cloves. Nicholas Monardes's *Joyfull Newes out of the Newfound World,* first published in Spain in 1569 and in English in 1577, and Thomas Harriot's *A Briefe and True Report of the New Found Land of Virginia* (1588) mention the animal and plant life in England's first colony on the North American mainland. Walter Raleigh was the prime mover in this establishment of a British settlement in a New World dominated by Spain. A fleet of small ships that left England on 25 April 1585 took with them a 'good geographer to make description of the lands discovered and with him an exilent paynter'. Thomas Harriot, a mathematician who had taught science to Raleigh's children, was the surveyor and scientific observer, and John White the artist. The expedition reached the Outer Banks, the islands off the coast of what is now North Carolina, early in July and established a colony on Roanoke Island. This first colony, which was little more than a military garrison, was evacuated in 1586. In April 1587 a second contingent of hopeful colonists sailed from Portsmouth to rebuild and extend the abandoned settlement. John White, now its governor, returned to England a few weeks after their arrival for more supplies. On his return to Roanoke in 1590 he found that all the colonists, including his daughter, granddaughter and son-in-law, had disappeared, believed massacred by hostile Indians.

John White's early life is a matter for speculation. Almost certainly he had trained as a miniature painter and was, most likely, a member of the Painter-Stainers' Company. Drawings of Eskimos by him lead to the conjecture that he may have been a member of Martin Frobisher's second voyage to the north-west of America in 1577, presumably as an artist. The inclusion of an artist on expeditions was not new. Francisco Hernandez, physician to Philip II of Spain, supervised a team of artists and trained observers to record the native life and natural history of Mexico in the 1570s. Humphrey Gilbert, Walter Raleigh's step-brother, enlisted the artistic talents of Thomas Bavin on his voyage in 1583 when he added Newfoundland to

Britain's infant empire. Bavin's duties as an artist were not, one imagines, very different from those presumably drawn up for White. Bavin was instructed to 'drawe to lief one of each kinde of thing that is strange to us in England … all strange birdes beastes fishes plantes hearbes trees and fruictes … also the figures & shapes of men and woemen in their apparell as well as also their manner of wepons in every place as you shall finde them differing.' At Roanoke, White mapped the neighbourhood, drew Indians in their villages and specimens of the local fauna and flora.

About fifty of White's drawings of the New World have survived and about forty-five others in the form of early copies. His reputation rests on these watercolours of Indians and of reptiles, birds, fishes, insects and plants, and his maps in the same medium. He was a competent artist who could suggest form and texture with a fluent economy of brush-stroke. The few botanical drawings include a sabatia, banana, pineapple, mammee apple and milkweed. The milkweed drawing is inscribed by White, 'Wysauke. The hearbe which the Sauages call Wysauke wherewth theie cure their wounds wch they receaue by the poysoned arroes of theire enemyes.' John Gerard's *Herball* (1597) has a woodcut based upon a drawing of the milkweed given to Gerard by White, but unfortunately few of the drawings were known to White's contemporaries. Nevertheless they are the survivors from a pioneer attempt to record scientifically the fauna and flora of a region of North America.

At some stage – probably before he went to Roanoke – John White met the Huguenot artist Jacques le Moyne de Morgues (*c.* 1533–88). Le Moyne's early life is as obscure as that of White. Born in France about 1533, nothing is known of his professional career until 1564 when he was appointed artist and cartographer on René de Laudonniere's ill-fated expedition to relieve a French Huguenot colony in Florida. The expedition failed through weak leadership, a subsequent mutiny and a massacre by treacherous Spanish troops. Le Moyne escaped, making his way back to France with few, if any, of his drawings, though some may have been sent back to France by ship. Le Moyne had settled in Blackfriars in London 'for religion' by 1581. He enjoyed the patronage of Sir Walter Raleigh and Lady Mary Sidney and published in 1586 his *La Clef des Champs*, with woodcuts of flowers, fruit and a few animals. His original flower paintings were not discovered or appreciated until this century. The British Museum acquired an album of fifty watercolours in 1962. He

67 Jacques le Moyne de Morgues (*c.* 1533–88): Grapevine (*Vitis vinifera*). Watercolour and bodycolour.

68 Jacques le Moyne de Morgues
(*c.* 1533–88): Hautbois
strawberry (*Fragraria
moschata*). Watercolour.

drew flowers with botanical precision combined with an artist's perception of their elegance and fragile beauty, and his flower miniatures on vellum disclose his indebtedness to the naturalistic tradition of Flemish and French illuminators. He was, without question, one of the most distinguished flower painters of his age.

John Gerard, who adapted White's milkweed for publication in his *Herball*, was a barber-surgeon and also gardener to Lord Burghley. Today he is chiefly remembered for his celebrated *Herball* whose frontispiece shows the author holding a spray of the potato flower, one of the earliest published illustrations of this South American vegetable. By the time Gerard's book was published, the New World had already given European gardeners the French and African marigolds, the sunflower, the Marvel of Peru and the nasturtium.

Medieval gardens were square in shape and divided into compartments by paths, with turf seats and arbours and tunnels of trellis-work. By Elizabeth's reign the flower garden had become a desirable addition to any house of distinction. A central feaure was the knot garden, wrought in complicated patterns by lines of small plants such as dwarf box and herbs. The interstices were filled with coloured earths, gravel or flowers, and viewed from the upper windows of the house the knot resembled some brightly-coloured floral carpet.

The first book on gardening to be published in England was Thomas Hill's *A Most Briefe and Pleasaunte Treatise, Teachyng how to Dresse, Sowe and Set a Garden* (c. 1558). It is essentially an anthology culled from classical authors rather than a practical manual, but its publication confirms that there was now a public wanting advice on gardening techniques. The gardens of Renaissance Italy also turned to classical texts for guidance and inspiration, and their influence eventually infiltrated the Jacobean garden with fountains, grottoes and antique sculpture. The medieval garden was capitulating to the Italian taste of the architect and the ingenious waterworks of the engineer.

Tudor prosperity, founded largely on sheep-farming, required houses that proclaimed the new wealth of the squire and the lord of the manor. The Elizabethan love of flowers penetrated the house in a summer abundance of floral patterns on bed valances and carpets, on tapestries and on small domestic items like trenchers for the table. The glory of houses like Hardwick and Speke was their superb plasterwork on walls and ceilings: friezes and canopies of country scenes and interlacing scrolls of roses and vines. The flower that

69 Carnations on one of a set of twelve Tudor trenchers made of painted wood, *c.* 1600. A trencher was a platter used for serving sweetmeats, cakes or fruits at the end of meals or entertainments.

69

70 The 'Phoenix Jewel', a gold pendant with a bust of Queen Elizabeth. English, c. 1575–80.

dominated interiors was the Tudor rose. Cardinal Wolsey had table carpets, some 'wrought with roses of divers colours' and others 'with roses and pomegranates, the utter border being of yellow and sad tawny'.

With a dextrous ease embroiderers of the early Middle Ages composed formal designs of thistles, fleurs-de-lis and other flowers on copes and chasubles. When the Reformation reduced the demand for ecclesiastical embroidery, domestic needlework came into its own and flowers, now naturalistic, decorated clothes, curtains, cushions and pillow-cases. Pansies, columbines, cornflowers, honeysuckle and all the other favourites of the garden were popular subjects, especially the fruit and leaf of the strawberry. They were neatly copied from herbals, not even omitting the roots which these botanical works usually depicted. Le Moyne wrote that he hoped that his *La Clef des Champs* would provide suitable floral subjects for 'embroidery, tapestry and also all kinds of needlework'. An embroidered sprig of oak-leaves and acorns and a bunch of grapes on

68

a large cushion cover at Hardwick Hall in Derbyshire bear more than a passing resemblance to the relevant woodcuts in Le Moyne's book.

Flowers embroidered in black thread on white linen, known as blackwork, intertwined over collars, sleeves, smocks and bodices. An inventory of Queen Elizabeth's possessions records dresses 'embroidered alover with workes of silver, like pomegranetts, roses, honiesocles and acorns'.

Jewellery in the Middle Ages was essentially a badge of rank, a visible symbol of a person's status in society or their religious devotion. The restraint with which it was worn was abandoned in Elizabethan times when women decked themselves with a confection of collars, necklaces, bracelets and earrings. Anne of Cleves, in the portrait painted by Holbein on the occasion of her wedding to Henry VIII, wears a necklace of gem-encrusted flowers of white enamel with a generous sprinkling of more jewelled flowers on the border of her décolletage. Floral motifs had now entered the standard repertoire of the jeweller's art. The Earl of Warwick's New Year's gift to Queen Elizabeth in 1572 was a jewelled branch of bay-leaves on which were set in gold six red roses and a solitary white rose.

A wreath of enamelled red and white roses, symbolising the union of the Houses of York and Lancaster, frames the 'Phoenix Jewel', a gold pendant containing a silhouette bust of Queen Elizabeth. The reverse of the bust is engraved with the royal crown and cypher, with the device of a phoenix in flames in relief below. The phoenix is frequently encountered in Renaissance iconography as a symbol of chastity, and is said to have been adopted by the Queen as her emblem. The 'Phoenix Portrait', attributed to Nicholas Hilliard, is so called from the jewel in the shape of a phoenix which the Queen is wearing at her breast. Her dress, with its bold patterning of embroidered leaves, royally proclaims the affection for nature she shared with her subjects.

71 The 'Phoenix Portrait' of Queen Elizabeth, attributed to Nicholas Hilliard, c.1575. It is so called from the phoenix pendant the Queen is wearing. Her dress is richly embroidered with stylised foliage. London, National Portrait Gallery.

Classical Elegance

In the seventeenth century the rich spared no expense in obtaining the showiest or the rarest plants for their gardens of 'pleasure and delight', the villager was content with his modest cottage garden, and the town dweller coaxed florists' flowers to bloom in tubs and pots. The constricted knot garden was yielding to the expansive patterns of the parterre, fashioned, according to Sir Thomas Hanmer, 'curiously into embroidery of flowers and shapes of arabesques, animals or birds, or *feuillages*'. After the Restoration in 1660 the French style predominated: the French gardener André Mollet become Royal Gardener to Charles II, British gardeners were trained in France and French gardening books were translated into English. The Long Water and radiating avenues of lime trees at Hampton Court emulated André le Nôtre's grand vistas. Ornamental canals and avenues cutting through woods extended estates far into the surrounding countryside. William III introduced a Dutch flavour, with lead statuary and extravagantly contrived topiary.

William Lawson, a gardener in the north of England for almost half a century, sensing a potential clientele for a sound manual of gardening, wrote *A New Orchard and Garden* (1618). Obviously with Thomas Hill's *A Most Briefe and Pleasaunte Treatise* in mind, he announced he had left classical authors 'to their times, manner and several countries', preferring to rely on his 'mere and sole experience'. The book deserved its modest success, enjoying nine reprints, the last in 1683. John Parkinson, an apothecary on Ludgate Hill in London, illustrated in his *Paradisi in Sole, Paradisus Terrestris* (1629) many of the plants he grew in his garden in Long Acre. The thousand or so varieties he describes give a good idea of the range of plants now available to the early seventeenth-century gardener: campanula, carnation, colchicum, crocus, daffodil (more than a hundred varieties), hyacinth, iris, lily and tulip besides many

72 S. Holzbecker (*fl.* 1660s): Crown Imperial (*Fritillaria imperialis*) and Martagon lily (*Lilium bulbiferum*). One of a series of watercolours on vellum depicting garden flowers.

flowering shrubs. Here at last was a horticultural writer who really understood the decorative value of plants. He himself grew five different varieties of the Martagon lily and considered that the Crown Imperial, 'for his stately beautifulness, deserveth the first place in this our garden of delight'.

72

The best flower book of the second half of the seventeenth century is unquestionably John Rea's *Flora* (1665). So many new plants were being introduced into cultivation that Parkinson's book was now out of date. The lupin, evening primrose, Rudbeckia, morning glory and golden rod poured from the North American cornucopia. Alexander Marshall drew some of the New World plants in the well-stocked

nursery in South Lambeth belonging to the Tradescants, father and son, who may also have been the first to raise the Virginia Creeper in this country. James Harlow went to Virginia in 1686 to collect plants for the newly formed Chelsea Physic Garden, and Henry Compton, Bishop of London, with the assistance of one of his botanist missionaries in Virginia, created a little patch of America in his garden at Fulham Palace.

British territorial interests were still confined to North America. The Dutch, through the agency of the Dutch West India Company, started colonising north-eastern Brazil in 1624, and in 1636 the enlightened and cultured Count Johann Moritz of Nassau-Siegen was appointed Governor-General and Commander-in-Chief of the colony. During the seven years he was Governor a team of scientists and

73 Frans Post (*c.* 1612–80). Part of a drawing in pen and ink and grey wash, depicting littoral vegetation in Brazil.

artists was engaged in recording the topography, ethnology and natural history of the country. Frans Post (*c.* 1612–80) painted landscapes, while his companion, Albert Eckhout, concentrated on the native Indians, the wild-life and luxuriant vegetation. Post's notes and sketches served as a basis for further paintings when he returned to Holland.

Another artist who was attracted by the fauna and flora of the Dutch outposts in South America was Maria Sibylla Merian (1647–1717). She was born in Germany, the daughter of a Swiss engraver and topographical artist who died when she was only four years old. Her mother married Jacob Marrel, a German active in the Dutch school of flower painters. He encouraged Maria's artistic talents, sending her to the flower painter Abraham Mignon to complete her training. She married another flower painter, Johann Graff, and with that background it is not at all surprising that she became addicted to natural history. While rearing insects she studied their metamorphosis. In 1679 she published the first of three volumes on the metamorphosis of European insects, *Der Raupen wunderbare Verwandelung und sonderbare Blumennahrung*. She drew and engraved the plates herself and her daughter, Dorothea, helped to colour them. Although now a competent entomologist, her next book had nothing to do with insects. The plates of garden flowers in *Neues Blumenbuch* (1680) were adapted from the engravings in Nicolas Robert's *Diverses Fleurs*. This work, like Robert's, was intended as a pattern book for embroiderers.

In June 1699, now middle-aged, Maria left Amsterdam with Dorothea for Dutch Surinam. There she collected and drew tropical insects until ill-health forced her to return to Holland in 1701. The results of her labours appeared in *Metamorphosis Insectorum Surinamensium* (1705), a work which, though primarily depicting insects, marked the beginning of the great era of illustrated botanical books. She applied her meticulous attention to the host plants as well as to the insects. Breaking free of the traditions of the Dutch and German painters, for whom insects had only a symbolic role, she was the first artist to draw insects and their associated plants in a scientific manner. She was also the first of a distinguished line of women flower painters: her flowers, drawn with fine lines and transparent colours, stand comparison with those of her notable contemporary Nicolas Robert.

Ships plying the ocean routes were returning to Europe with seeds

and plants to excite the curiosity and envy of botanists and gardeners. It was a prosperous time for the nursery trade and by the end of the century there were about fifteen nurseries in London alone.

The flower that dominated the horticultural scene in Europe for many years was the tulip. While journeying from Adrianople to Constantinople in 1554, Busbecq, the envoy of the German Emperor Ferdinand I to the Turkish court of Süleyman the Magnificent, was struck by the richness of the flora, especially the 'tulipams', which the Turks, he reported, 'admired for the beauty and variety of their colours'. Busbecq brought seeds and possibly bulbs to Vienna and in 1561 the first published engraving of the tulip appeared in Valerius Cordus's *Annotationes*. The following year a consignment of bulbs from Constantinople was unloaded at Antwerp. The tulip reached England about 1578, and Gerard's *Herball* listed fourteen varieties. Parkinson's *Paradisi* had well over a hundred varieties with explicit notes on colour gradations. One variety, 'Duchess', Parkinson described as 'more yellow than red with great yellow edges, and the red more or less circling the middle of the flower in the inside, with a large yellow bottome'. The tulip had pride of place in Sir Thomas Hanmer's seventeenth-century garden at Bettisfield in Flintshire. 'The Queen of bulbous plants', he called it, 'whose flower is beautiful in its figure, and most rich and admirable in colour and wonderful in variety of markings.' These colour variations – although it was not known at the time – were caused by a virus carried by aphides and their unpredictability encouraged the speculation in Holland in new and more spectacular varieties. Anyone with any spare land, from the nobility to the working class, grew tulips. Thousands of florins were sometimes paid for a single bulb of a so-called 'broken tulip', that is with striped, flamed or spotted petals; single-colour tulips were disdained. In this fever of gambling on the instability of a flower's colour, businesses and savings were lost and families ruined. Tulipomania finally collapsed in the spring of 1637 when the market was glutted with bulbs no one wanted.

This obsession with the tulip had reverberations in the decorative arts. Blue Delft vases or 'tulip pagodas' were made to display them indoors. William III and his consort, Queen Mary, made them popular in England: some specially made for them, now in the Long Gallery in Hampton Court, are almost four feet tall. Not only tulips but any cut flowers were placed in the spouts or nozzles up their sides. Chatsworth and Dyrham have some fine specimens of these

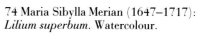

74 Maria Sibylla Merian (1647–1717):
Lilium superbum. Watercolour.

[91]

'pyramids', as they were sometimes called. The ubiquitous tulip appeared on Dutch glazed tiles, in embroidery and marquetry designs, and even watches masqueraded as tulips. They dominated the bouquets in Dutch flower paintings.

Tulips were also favourite flowers with Alexander Marshall, who 75 recorded several striped varieties in the album of his watercolours in the Royal Library at Windsor and in a set of his drawings in the British Museum. Little is known about Marshall, but at some period of his life he may have lived in France. He grew florists' flowers and clearly was a talented flower painter. He was a friend of the Earl of Northampton and passed his last years living with the Earl's brother, Henry Compton, Bishop of London, at Fulham Palace, where he died in 1682.

Marshall's watercolours belong to a category known as 'florilegia', that is, paintings done for patrons who appreciated flowers more for their beauty than for their utility. They were pictorial records of favourite flowers and spectacular new introductions from abroad. The sinewy and supple lines of copper engraving, admirably suited to plant portraiture, encouraged the publication of superior picture books of flowers aimed more at the garden-lover than the botanist. Adrian Collaert's *Florilegium* (*c.* 1590) was a pioneering effort in this genre. Basil Besler's *Hortus Eystettensis* (1613) – a record of the plants in the garden of the Bishop of Eichstatt – is a demonstration of the rhythmic flexibility of copper engraving.

Besler's two substantial folio volumes may dwarf the small *Hortus Floridus* (1614) but their plates do not surpass its exquisite engravings by Crispin de Passe the Younger. De Passe's flowers, all familiar inhabitants of a Dutch garden, are drawn at worm's-eye level, with perhaps a solitary bee or butterfly hovering above. De Passe drew one of the earliest illustrations of a 'broken' tulip. The book was well received at the time and an English edition was published in 1615. Parkinson borrowed a few of its figures for his *Paradisi*. It also served as a pattern book for embroiderers. Some of its flowers feature in the glass-painted windows at Lydiard Tregoze in Wiltshire and Gorhambury House near St Albans.

One wonders whether Alexander Marshall during his residence in France encountered Nicolas Robert (1614–85), the finest botanical artist of his day. About 1646 Robert was commissioned to paint the plants and animals in the botanical garden and menagerie at Blois belonging to a younger brother of Louis XIII, Gaston d'Orléans.

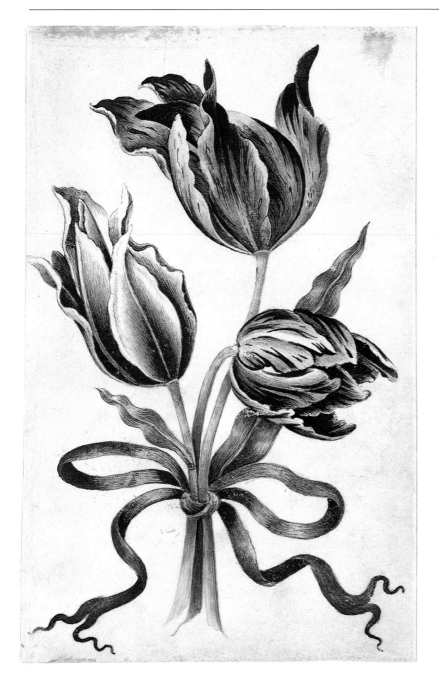

75 Alexander Marshall (*d.* 1682): Tulips.
Watercolour over metalpoint on vellum.

Gaston began a collection of natural history drawings which, on his death in 1660, passed to his nephew, Louis XIV. A few years later Robert was appointed 'peintre ordinaire de sa Majesté pour la miniature'. One of his official duties was to add every year twenty-four paintings to Gaston's original collection of watercolours on vellum. When he died in 1685 he had exceeded this minimum requirement by enlarging the royal collection by 727 paintings, more than half of which were of flowers.

Robert's merits as a flower painter were already recognised when Gaston d'Orléans enticed him to Blois. As a birthday gift for the fiancée of the Baron de Sainte-Maure, Julie d'Angennes, he had painted a charming album of garden flowers, *Guirlande de Julie*, arguably the finest of all florilegia. The cultivated flowers in the 76 collection of his drawings in the British Museum parade his dexterity and delicacy of touch – also apparent in the plates he etched in *Diverses Fleurs* (c. 1660) – and the precision of his brush-strokes, especially his technique of conveying texture and tone through fine parallel lines of colour. These rare skills harnessed to botanical integrity persuaded the newly formed Académie Royale des Sciences that he was the ideal botanical artist to illustrate their projected history of the plant kingdom. Robert was responsible for many of the life-size flower drawings which were engraved in the *Recueil des Plantes* (1701). The Dutch artist and Professor of Natural History Iconography at the Musée National d'Histoire Naturelle in Paris, Gerard van Spaendonck, proclaimed it the most beautiful flower book ever published.

The homes of some of the wealthy would possibly boast a florilegium or a printed flower book illustrated by Nicolas Robert or one of his contemporaries; on their walls there would perhaps hang a flower painting or two by the fashionable artists from the Low Countries who made this genre a lucrative speciality. By the opening years of the seventeenth century, flowers were ceasing to be an incidental decoration or a symbolic comment within the context of a religious painting. By the end of the century oil paintings of flowers were being produced as desirable accessories to the décor of a room. Everything about these fashionable flower studies was artificial: the grouping together of flowers from different seasons of the year and the immaculate perfection of each bloom. They were masterpieces of contrived symmetry: flowers arranged in all manner of containers – baskets, glass bowls, ceramic and stone vases – on plinths and tables

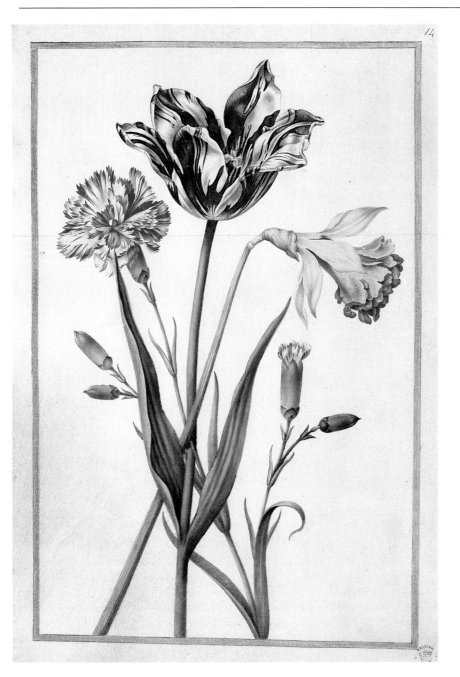

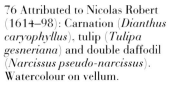

76 Attributed to Nicolas Robert (1614–98): Carnation (*Dianthus caryophyllus*), tulip (*Tulipa gesneriana*) and double daffodil (*Narcissus pseudo-narcissus*). Watercolour on vellum.

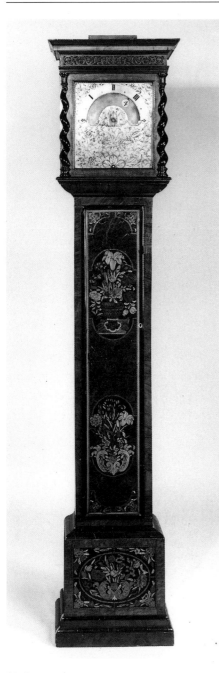

flanked by an exotic shell, a nest of eggs or some precious *objet d'art*. At first artists displayed their flowers in containers in an almost haphazard fashion and no one flower dominated or obscured another. With progressive sophistication the presentation became a baroque bouquet; the lines of stems served as unifying elements in the composition and colour harmonies were subtly orchestrated.

Jean-Baptiste Monnoyer decorated Versailles and other French royal residences with such flower studies, which were shaped to fit above doors and mantelpieces. He designed floral borders for Beauvais and Gobelins tapestries, and well into the next century designers of textiles and wallpapers consulted his book, *Le Livre de Toutes Sortes de Fleurs d'après Nature*. The Duke of Montagu invited him to London in the 1680s to add floral panels to Montagu House, which later became the first home of the British Museum.

Flowers had now assumed a greater prominence in interior decoration. Dutch culture was already a presence in British homes when William of Orange ascended the throne in 1688. Grinling Gibbons, born and trained in Holland, came to England in the early years of Charles II's reign. Cassiobury Park in Hertfordshire was the first house he embellished with carved swags and garlands of flowers and fruits. His astonishing virtuosity in sculpting petal and leaf in lime-wood or oak brought him many commissions to decorate houses, churches and colleges. He was appointed Master Carver to Charles II, and for William III he added floral festoons to Christopher Wren's state apartments at Hampton Court. That discerning dilettante, Horace Walpole, was one of his many admirers. 'There is no instance of man before Gibbons', asserted Walpole, 'who gave to wood the loose and airy lightness of flowers, and chained together the various productions of the elements with the free disorder natural to each species.' His success encouraged imitators; they, too, could carve the pea-pod, once thought to be Gibbon's exclusive 'signature', with all the panache of the master.

Increasing use of textiles was made during the Stuart era: silk fabrics for walls and windows, linen damasks for napkins and table-cloths, chintz for dresses. A factory for tapestry-weaving which opened at Mortlake near London in 1619 briefly challenged the supremacy of Flemish tapestries. The devotees of domestic needle-work had a fondness for the animal and plant motifs in the pattern books published by Johnson, Overton, Sharleyker and Stent. Indian painted quilts, richly decorated with flowers, were imported in great

quantities by the East India Company which through its trading links with China also introduced the decorative motifs known as chinoiseries, which were incorporated in western textile designs. Exuberantly coloured floral patterns distinguished Turkish carpets. An inventory of 1622 lists 'My Turkey carpet of cowcumbers. My cabbage carpet of Turkey-work.'

Although the chests and headboards of beds of Elizabethan and Jacobean furniture were often decorated with simple inlaid floral patterns, marquetry as it is known today was not introduced into this country from the Continent until after the Restoration. The early designs of Dutch and French cabinet-makers who specialised in floral marquetry copied paintings of flowers together with their vases. Comparatively few coloured woods were used, and occasionally ivory and bone stained green simulated foliage. As the craft developed, more woods were employed to interpret floral structure with increasing confidence and competence. Oyster veneers exploited the decorative grain of certain woods. Seaweed marquetry, which vaguely resembled seaweed or endive leaves, enjoyed a brief vogue during the reign of William and Mary. Marquetry was applied to long-case clocks from the 1670s and the level of excellence to which it attained can be seen on the oak case housing the clock by Edward East. Tulips, lilies and pinks appear in both the marquetry and the engraved dial. The topmost marquetry panel was inspired by the familiar formula of painters in the Low Countries; that is, the flowers are in a vase and there is a poised butterfly and an inquisitive snail. Edward East (c. 1602–97) was a founder member of the Clockmakers' Company and its Master in 1645 and 1652. He also became Chief Clockmaker to Charles II.

Floral ornament was not confined to long-case clocks: enamelled and jewelled flowers transformed watches into *objets d'art*, cherished as much for their beauty as for their timekeeping qualities. A new technique of miniature painting in enamel on a white enamel ground was discovered by French goldsmiths about 1630 and Jean Toutin of Blois was an outstanding craftsman in the medium. His son Henri is remembered today for his gold enamelled watch cases. Naturalistic flowers which were stock items in the enameller's repertoire were applied to watches with the fastidious care of a miniature painter. Jean Vauquer, employed at Blois during the last quarter of the seventeenth century, was an enamel painter renowned for his floral designs, a selection of which was published for the benefit of

77 (opposite) English long-case night clock, c. 1675, made by Edward East (c. 1602–98). The oak case is veneered with walnut oyster pieces and with floral marquetry.

78 Floral engraving on the dial of East's night clock (Fig. 77). The numerals are pierced on the dial so that a lamp behind the movement could illuminate it at night.

[97]

goldsmiths and engravers in *Livre de Fleurs Propres pour Orfèvres et Graveurs* (1680). The early watchmakers indulged in lapses of levity when they delighted in unusual and decidedly bizarre shapes — shells, skulls, crucifixes, and plants such as olives, pears, tulips and 80 fritillaries.

Enamelling was an art in which Continental jewellers excelled, and a superb example of their dexterity and instinct for congruous design is a mid-seventeenth century necklace made in France or 81 perhaps Holland or Scandinavia. The twenty-eight plaques are enamelled with tulips, fritillaries, daisies and other garden flowers, drawn with a beguiling simplicity. Such restraint is a far cry from the Grenville jewel, made perhaps in the court workshop of Charles I. It 82 is in the form of a small gold locket, carpeted with rubies, opals, diamonds, emeralds and a solitary sapphire. Inside is a miniature by David Des Granges of Sir Bevil Grenville, the Cornish Royalist general who was killed during the Civil War. The case is enamelled with four violas, a vibrant blue against a black background dense with a symmetrical pattern of white flowers linked by the curving lines of stylised foliage. The English goldsmith at his best was a match for his Continental colleagues.

79 Verge watch signed Isaac Pluvier, London. The case and dial are decorated with painted enamel flowers. On the inside of the lid is a landscape. This style of decoration was common on watches of the mid-17th century and was influenced by Dutch landscape paintings of the period. About 1630.

80 Verge watch by Edward Bysse with a silver niello case in the shape of a fritillary flower. Watch cases in the shape of crosses, shells, tulips etc. were popular in the 1625–40 period and are known as form watches. London, *c.* 1630.

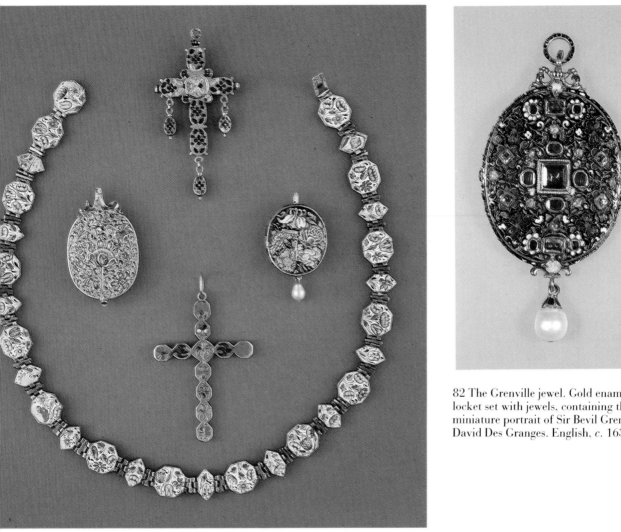

82 The Grenville jewel. Gold enamelled
locket set with jewels, containing the
miniature portrait of Sir Bevil Grenville by
David Des Granges. English, *c.* 1635–40.

81 Jewellery with enamelled floral motifs. Necklace of enamel plaques in gold
mounts. French, or possibly Dutch or Scandinavian, mid-17th century. (*Left*)
Gold locket or pendant miniature case. French, mid-17th century. (*Right*)
Gold devotional locket. French, late 17th century. (*Top*) Gold pendant cross.
English, late 16th century. (*Bottom*) Gold pendant cross. German or possibly
French, first half of 17th century.

The Golden Age of
Floral Art

The rigid geometry of the formal garden of the Restoration and William and Mary was viewed with distaste by Joseph Addison and Alexander Pope, who preferred a more relaxed and naturalistic design. The authority of literature and painting was invoked to justify Pope's dictum that 'all gardening is landscape painting'. The elimination of boundary walls assisted the fusion of the garden with the surrounding countryside and its contours of distant hills. When Mrs Delany visited Longleat in 1760 she discovered that its parterres and clipped alleys had been replaced by 'a fine lawn, a serpentine river, gravel paths meandering round a shrubbery, all modernised by the ingenious and much sought after Mr Brown'. The Mr Brown in question was Lancelot or 'Capability' Brown who ruthlessly uprooted avenues of mature trees on countless estates to impose his formula of gently undulating pastures grazed by contented cattle and sheep, clumps of carefully placed trees and a stretch of glistening water.

Flowers were hidden behind the high walls of an enclosed garden or confined to narrow borders, beds and wildernesses. There were still those 'curious delighters in flowers', as the Curator of the Chelsea Physic Garden fondly called them, who ignored fashionable trends and carried on growing their flowers in the modest gardens of cottages, vicarages and town houses. Quakers were especially attracted to flower gardening; prominent among them were Peter Collinson at Peckham and Mill Hill, John Fothergill at Upton and John Lettsom at Camberwell. The new plants from abroad received their devoted attention – alyssum, aubrietia, fuchsia, hydrangea, lobelia, magnolia, phlox, to name but a few. It was Brown's disciple and successor, Humphry Repton, who gradually modified the Brownian

83 Jan van Huysum (1682–1749): *Iris germanica*. Watercolour.

[101]

landscape by introducing terraces, raised flower-beds and trellis-walks near the house, a preparation for the floral flood that was to overwhelm the gardens of the nineteenth century.

The multiplication of nurseries throughout the country was encouraged by the profitable trade in trees, shrubs and herbaceous plants. In London the leading nursery at Brompton Park was joined by James Gordon at Mile End, Thomas Fairchild at Hoxton, Lee and Kennedy at Hammersmith and Robert Furber at Kensington. Furber engaged the Flemish flower painter Pieter Casteels, who also provided floral motifs for English textile printers, to paint a vase of flowers in the Dutch manner for each month of the year. These flower studies, which depicted some of the flowers in bloom during each month, were reproduced in Furber's *Twelve Months of Flowers* (1730), which was intended as a catalogue for his clients. *Twelve Months of Fruits*, also illustrated by Casteels, followed two years later. These sumptuous catalogues advertised nearly 800 varieties of flowers and fruits which were obtainable from Furber's nursery. The success of *Twelve Months of Flowers* with his customers led to a rather inferior reproduction of the plates in *The Flower Garden Display'd* (1732), aimed at a much wider audience. Its title-page recommended it as 'very useful, not only for the *Curious* in Gardening, but the *Prints* likewise for *Painters, Carvers, Japaners*, etc. also for the *Ladies*, as Patterns for Working and Painting in Water-Colours or Furniture for the Closet'.

Robert Furber was a member of the Society of Gardeners, a trade association of some twenty nurserymen formed in the 1720s. Desirous of establishing some conformity in plant names and descriptions, the Society embarked on the publication of an illustrated catalogue of trees, shrubs, flowers and fruits. Only the first part of the projected *Catalogus Plantarum* (1730) was published. The artist was Jacob van Huysum (*c.* 1687–1740), brother of the last of the great Dutch masters of the flower piece, Jan van Huysum (1682–1749). Jan van Huysum's canvases of flowers, painted with rococo *élan*, compositions of expertly controlled complexity, were promptly bought by the rulers of Europe and by the English Prime Minister, Sir Robert Walpole. It was Walpole who gave employment to Jacob van Huysum when he came to England in 1721. For two years he copied old masters at Houghton for Walpole before being dismissed for drunkenness. He, too, executed a series of twelve canvases, representing the months of the year. The British Museum possesses two

55, 83

84 volumes of his flower and fruit drawings, presumably all made for the *Catalogus Plantarum*, but only twenty-one were engraved and published.

Philip Miller, who as Secretary of the Society of Gardeners was very much involved in the preparation of the *Catalogus Plantarum*, was also Gardener at the Chelsea Physic Garden. Miller worked at Chelsea for almost half a century, making the garden's few acres a national centre for the cultivation and distribution of new plants. To illustrate his monumental *Gardeners Dictionary*, which went through eight editions, he compiled *Figures of the most Beautiful, Useful, and Uncommon Plants* (1755–6). Its 300 plates were consulted and adapted by decorators of Chelsea porcelain. When the great Swedish naturalist, Carl Linnaeus, came to England in 1736, the Chelsea Physic Garden was one of the places he visited. He tried to convince Miller of the superiority of his concise names for plants over the lengthy descriptive phrases then currently in use. Eventually Miller was converted and adopted Linnaeus's simplified system in the eighth edition of his *Gardeners Dictionary* (1768). The rate at which the world's flora was being discovered demanded a more convenient method of classifying plants. Linnaeus provided a solution with an artificial system based upon the number of stamens and styles flowers possessed. This sexual classification combined with his binomial naming of plants offered the professional and amateur botanist a delightfully easy means of plant identification.

The resurgence of botanical and horticultural interest in the eighteenth century created a need for professional illustrators of plants from both the serious botanist and the enthusiastic gardener. Georg Dionysius Ehret (1710–70), a native of Heidelberg, was outstanding among a group of artists willing to conform to the discipline of botanical art. He had the good fortune to meet Linnaeus in Haarlem, where he was writing an account of the plants in the garden of an Anglo-Dutch merchant, George Clifford. Ehret was invited to illustrate the book and *Hortus Cliffortianus* (1738) marked a promising beginning to his career as a botanical artist. He settled in England in 1736, married Philip Miller's sister-in-law and earned his living illustrating books and teaching the 'English noblesse flower painting and botanique'. Peter Collinson remarked in 1755 that Ehret 'has more business than he can do in teaching the young Nobility to draw and paint Flowers etc. which is now the great fashion with us'.

84 Jacob van Huysum (*c.* 1687–1740): 'Striped White Lily' (*Lilium candidum*). Watercolour, subsequently engraved in Philip Miller, *Catalogus Plantarum*, 1730, pl. 14.

While he was giving lessons to the daughters of the Duchess of Portland at Bulstrode Ehret met Mrs Delany, a close friend of the Duchess. Mrs Delany confided to her sister that Lady Betty Bentinck, one of the Duchess's daughters, was making such good progress in her flower painting that 'she comes very near Ehret'. Ehret augmented his income by drawing for private patrons such as John Fothergill and Philip Miller, who used some of his work in *Figures of the most Beautiful, Useful, and Uncommon Plants*. His election as a Fellow of the Royal Society was public acclamation of the scientific value of his drawings. Their scrupulous botanical accuracy in no way diminished the elegance of their composition, whose decorative appeal he often enhanced by the addition of butterflies and moths, also drawn with the same delicate precision. His partiality for bodycolour never robs his watercolours of the freshness and spontaneity associated with that medium.

85

When the German writer and philosopher Goethe saw a copy of A. B. Lambert's *Genus Pinus* (1803) (which included a drawing by Ehret) he said that the new breed of botanical artist, 'if he feels the same inspiration as the great Dutch flower-painters, must always be at a disadvantage. For they had only to satisfy the lover of superficial beauty; but he has to render beauty in its true form and through the medium of truth. And while they found themselves at home in the narrow circle of the amateur gardeners, he must allow himself to be controlled in his treatment of Nature by a crowd of experts, scientists, classifiers and critics.'

Ehret was not alone in teaching flower drawing to the wives and daughters of the gentry. Queen Charlotte and her daughter sought instruction from Francis Bauer, the resident botanical artist at the royal garden at Kew. Under his critical eye they coloured engravings of Cape heaths in his *Delineations of Exotic Plants … in the Royal Garden at Kew* (1796–1805), a masterpiece of fastidious draughtsmanship. Robert Thornton, the author of the ambitious but ill-fated *Temple of Flora*, confirmed with perhaps more than a suggestion of flattery and hyperbole that 'there is not a plant in the gardens of Kew but has either been drawn by their Gracious Majesty or some of the Princesses with a grace and skill which reflects in these personages the highest honours'. Princess Elizabeth is believed to have painted the convolvulus and other climbing plants on the walls of the upstairs room in the Queen's Cottage in Kew Gardens. In 1788 Queen Charlotte sent Lord Bute, a competent amateur botanist and former

PINUS. Americana paluftris.

85 Georg Dionysius Ehret
(1710–70): Longleaf pine
(*Pinus palustris*). Bodycolour
on vellum.

Solanum Dulcamara

adviser to Princess Augusta on the planting of her garden at Kew, 'a sight of the beginning of an Herbal from Impressions on Black Paper'. These floral cut-outs must surely have been inspired by similar work executed by her acquaintance, Mrs Delany.

86 Mary Delany (1700–88), widowed for the second time, took up flower collage or 'paper mosaic', as she always called it, at the age of 73. When failing eyesight some ten years later forced her to give up the hobby, she had created nearly a thousand flower portraits, now kept together in the Prints and Drawings Department of the British Museum. She had all the qualities necessary for this exacting work: infinite patience, nimble fingers, artistic talent and a love of flowers. She could dissect a flower and counterfeit almost miraculously, life-size, every leaf, petal, stamen, style, calyx, thorn and stem in matching coloured paper. Normally she rendered shading by mounting slivers of paper, layer upon layer. Occasionally she dyed or lightly touched up the paper with a brush. She produced her convincing replicas, carefully observing texture and highlights, effectively mounted on a background of black paper. The Duchess of Portland's garden at Bulstrode provided her with many of her subjects; the King had specimens sent from his garden at Kew; the Chelsea Physic Garden was a generous donor, and friends' conservatories – Lord Bute's at Luton and John Fothergill's at Upton – yielded more floral treasures.

Mrs Delany's life-long apprenticeship to fine needlework was excellent training for this exacting work. And, not surprisingy, her taste was decidedly horticultural. She embroidered floral themes on chair covers and cushions; seats in a chapel rejoiced in 'a border of *oak-leaves and all sorts of roses* (except yellow), which I work without any pattern, just as they come into my head'; her quilts resembled flower gardens; and her friends received handkerchiefs stitched with her favourite poppy. But she really excelled herself in designing her court dress with an unstinted scattering of field and garden flowers on petticoat, bodice, overskirt and sleeves. In choosing such an emphatic floral pattern she was not only indulging in a personal preference but also reflecting contemporary fashion in dress, which favoured massive flowers and fruits. The Princess Royal's wedding dress in 1734, reported Mrs Delany, had 'the finest embroidery of rich embossed gold and festoons of flowers intermixed in their natural colours'. It was, however, the uncurbed luxuriance of vegetation on the dress worn by the Duchess of Queensbury at a court

86 Mary Delany (1700–88): Paper collage of woody nightshade (*Solanum dulcamara*).

held by the Prince of Wales that evoked her admiration and envy and lyrical response:

> The Duchess of Queensbury's clothes pleased me best: they were white satin embroidered, the bottom of the petticoat *brown hills* covered with all sorts of weeds, and *every breadth* had an old *stump of a tree* that run up almost to the top of the petticoat, broken and ragged and marked with brown chenille, round which twined nastersians, evy, honeysuckles, periwinkles, convolvuluses and all sorts of twining flowers which spread and covered the petticoat, vines with the leaves variegated as you have seen them by the sun, all rather smaller than nature, which made them look very light; the robings and facings were little green banks with all sorts of weeds, and the sleeves and the rest of the gown loose twining branches of the same sort as those on the petticoat: many of the leaves were finished with gold, and part of the stumps of the trees looked like the golding of the sun. I never saw a work so prettily fancied, and am quite angry with myself for not having the same thought, for it is infinitely handsomer than mine, and could not have cost *much more*.

Jewellers put the finishing touches to these herbaceous affectations with flower sprays in coloured stones or sparkling diamond flowers, pinned all over the hair and corsage. To add to the effect the flowers might be set on 'trembler' springs so that they moved with the wearer. The Duchess of Northumberland reported that Queen Charlotte on her wedding day wore 'Diamond sprigs of Flowers in her Sleeves and to clasp back her Robe'. The Queen in her coronation portrait by Allan Ramsay wears a large stomacher or corsage ornament made of silver flowers set with diamonds, valued at £275,000.

It would not be an exaggeration to claim that the decorative arts during the eighteenth century were a glorious celebration of flowers. Chairs, settees and fire screens were embroidered with excessively large blooms, which were also strewn in dense patterns on carpets. Fewer tapestries were hung on walls, but they, too, portrayed horticultural themes and landscapes. The two charming Stoke Edith hangings which five ladies worked in tent stitch (now at Montacute House) show an unidentified garden of the first half of the century. Its formal elements of statuary, fountains, balustrades and steps are softened by trees paraded in tubs and by regiments of tulips lining

87 Plate of hard paste porcelain, painted in overglaze colours, and gilt. Paris, Dihl and Guerhard factory, early 19th century.

88 Bowl, cover and lobed stand, of hard paste porcelain decorated in overglaze colours on a gold ground. Germany, Furstenberg factory, 1760–80.

the grass plots. Spitalfields, the centre of the English silk industry, passed through phases of designing with semi-naturalistic, stylised and naturalistic flowers. Festoons and swags were the stock-in-trade of the silversmith. Roses entwined the stems of candlesticks, soup tureens bore a crest of cauliflowers or other bulky vegetables wrought in silver, dishes pretended to be leaves, their veins ingeniously integrated into the pattern. Glass goblets and decanters were engraved with fruiting vines and ambiguous leaves.

Chinese textiles were known to Italian weavers as early as the fourteenth century. Silk, porcelain and lacquerware began reaching Europe in significant quantities after the Portuguese and the Dutch had established trading posts in China during the seventeenth

century. By the later seventeenth century European art had absorbed aspects of Chinese design. John Evelyn was proud of his waistcoat embroidered with dragons and chrysanthemums. In the eighteenth century chinoiserie became a cult. Mrs Delany, visiting Lord Cornbury's estate in 1746, admired a room 'hung with the finest Indian paper of flowers and all sorts of birds' ('Indian' frequently meant Chinese). Chinese wallpapers were painted with birds and butterflies in tall flowering trees. When Joseph Banks was in the East Indies in 1770 on board Captain Cook's *Endeavour*, he recalled that 'some of the plants which are common to China and Java, as bamboo, are better figured there [i.e. on Chinese wallpapers] than in the best botanical authors that I have seen'. The French painter and designer Jean-Baptiste Pillement, one of the leading exponents of chinoiserie, created a form of rococo-chinoiserie wallpaper with cartouches of oriental scenes amidst trailing flowering branches. In 1760 his *Recueil de Différentes Fleurs de Fantaisie dans le Goût Chinois* was published in London as a pattern book for designers of silk fabrics, wallpapers, porcelain, marquetry and japanned furniture.

In the Middle Ages those few pieces of Chinese porcelain which reached Europe were treated as precious objects and often set in gold or silver mounts. They ceased to be so rare following the expansion of Portuguese and Dutch trade in the Far East, but were still highly prized, and European factories produced imitations in 'soft paste' porcelain. It was not until the early eighteenth century that the secret of Chinese 'hard paste' porcelain containing china clay and china stone was discovered and the Meissen factory in Saxony began manufacturing it. At first Meissen adhered to oriental prototypes, mechanically copying Chinese chrysanthemums, peonies and plum blossom, the so-called 'Indische Blumen'. By the 1740s Meissen had substituted European flowers – 'deutsche Blumen' – for the oriental, establishing a floral style which became a model for other European factories.

English factories such as Bow, Chelsea, Coalport, Derby, Spode, Swansea and Worcester treated flowers in a completely naturalistic fashion. It has been aptly said that the 'Meissen flowers and fruits ripened at Chelsea but were harvested at Worcester'. Factories evolved their own distinctive styles. Bow, for instance, liked delicately painted compact bunches of large blooms flanked by sprays of smaller flowers. Chelsea replaced the semi-naturalistic flowers of

87. 88

89

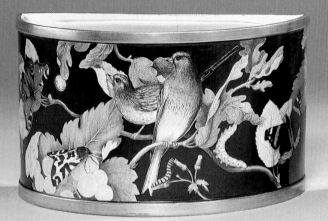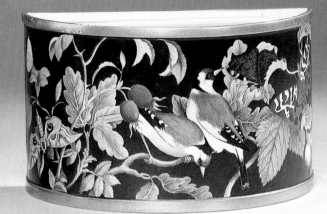

89 Pair of earthenware flower vases (bough pots), decorated in overglaze colours on a dark brown ground and gilt. Swansea, Cambrian pottery, signed *Young pinx^t* for William Weston Young, employed 1803–6.

Meissen with boldly painted flowers, typical of their 'red anchor' period. Porcelain painters who took their subjects from living plants and botanical prints perfected their own styles and preferences. One Worcester decorator made a speciality of filberts, berries and pea-pods. Another always depicted large florid roses and tulips with drooping outer petals. Plates and dishes were painted with neat posies or smothered with generous sprays.

An exhibition at the Victoria and Albert Museum in 1987 of the work of the artists employed by the Derby factory in the early nineteenth century made it clear that they were no mere painters of pots. William Billingsley, William Pegg and Moses Webster excelled in floral decoration. Pink roses in the full flush of their bloom were Billingsley's favourite flower; 'Quaker' Pegg, who found it difficult to reconcile his artistic activity with his religious beliefs, covered porcelain with life-size flowers.

Flowers were modelled in porcelain as well as painted on its surface. Fine pieces were produced by Bow, Chelsea and Derby and in particular by Longton Hall, whose vases were encrusted with floral opulence. For many years a huge vase decorated with painted and modelled flowers stood in the hall at Wentworth Woodhouse

90

proclaiming the skills of the nearby Rockingham factory, whose painters were allowed to copy the flowers and fruits on the estate. At the other extreme in size were Chelsea's dainty split pea-pods exposing a row of deliciously rounded peas. Chinese lotus-leaf dishes, bamboo teapots and pineapple jugs inspired European designers to make lemon-shaped pots for dried sweetmeats, dishes disguised as tied bundles of asparagus, melon tureens, lettuce sauce-boats and globe artichoke cups. Chelsea had a fondness for crinkled savoys.

Georgian homes displayed their garden flowers in jardinières made in stoneware and earthenware as well as in porcelain. Josiah Wedgwood, seeing a profitable market in flower pots, produced in 1770 the first English-made pyramid flower pot 'with spouts, much as the old Delph ones'.

Tableware probably attracted the most decoration. The Swedish naturalist Linnaeus had the Chinese paint a tea-set with his own little pink flower, *Linnaea borealis*. One of Linnaeus's pupils, Theodor Holmskjold, when he became Director of the Copenhagen porcelain factory, persuaded the Crown Prince of Denmark to order a table-service decorated with plants copied from Georg Oeder's *Flora Danica* (1762–1883), an outstanding national flora which before it ceased publication had depicted more than 3,000 Scandinavian plants in seventeen folio volumes. Plants of appropriate size were copied from this work on 2,300 separate pieces of porcelain before production was discontinued in 1802. It was resumed in 1862 to provide a wedding present for the Danish Princess Alexandra on the occasion of her marriage to the Prince of Wales the following year. The factory still produces a few pieces today, painted with the same exquisite attention to botanical accuracy.

The botanist Lewis Weston Dillwyn, who managed a porcelain works in Swansea, had a series of plates decorated with flowers taken from illustrations in *Curtis's Botanical Magazine*. William Curtis had launched his monthly magazine in February 1787 for 'such ladies, gentlemen and gardeners, as wish to become scientifically acquainted with the plants they cultivate'. Each issue had three hand-coloured engravings of plants from the tropical and temperate regions of the world, many of them recent introductions. These floral novelties proved irresistible to porcelain painters. In the 1790s the Derby factory subscribed to nineteen copies of the magazine. When John Sims became editor in 1801, he was pleased to draw attention to

90 Vase of soft paste porcelain, decorated in overglaze colours. England, Longton Hall factory, *c.* 1755.

the fact that 'a large proportion of the ornaments of our most expensive porcelain and cabinet ware' was copied from plates in it. A porcelain set manufactured in Berlin between 1817 and 1823 used *Curtis's Botanical Magazine* and another English horticultural periodical, H. C. Andrews's *Botanists' Repository*, as the principal sources for its floral decoration.

Certain Chelsea plants of the 'red anchor' period in the 1750s are decorated with 'Sir Hans Sloane Plants'. The attribution originates 91 with an advertisement in the *Dublin Journal* for 1 July 1758 announcing the auction of Chelsea china 'with table plates, soup plates & desart plates enamelled from Sir Hans Sloane's Plants'. Sir Hans Sloane (1660–1753) was an eminent physician who served in that capacity to the Governor of Jamaica in 1687 and 1688. Like so many of his professional colleagues, he was a competent naturalist, and while he was in the West Indies collected plants, animals and minerals. His purchase of the Manor of Chelsea in 1721 included the Chelsea Physic Garden administered by the Society of Apothecaries. He reduced the Society's financial difficulties by granting a lease in perpetuity to the Society for a nominal annual rent of five pounds. He was an enthusiastic collector of books, manuscripts, antiquities, works of art and natural history specimens: on his death in 1753 an Act of Parliament authorised their purchase to form a foundation collection of the new British Museum. The 'Phoenix Jewel' and the drawings of Albrecht Meyer, Nicolas Robert and Jacob van Huysum illustrated in this book were part of the Sloane acquisition.

For a long time it was accepted that the link between Sloane and the plates decorated with 'Sir Hans Sloane's Plants' was the Chelsea Physic Garden. The putative connection, the first volume of *Figures of the most Beautiful, Useful, and Uncommon Plants* by Philip Miller, gardener at Chelsea, was, in fact, published two years after Sloane's death. A number of 'Sir Hans Sloane's Plants' have since been traced to an entirely different source – two works illustrated by Ehret: *Plantae et Papiliones Rariores* (1748–62) and Christoph Trew's *Plantae Selectae* (1750–73). Usually the 92 Chelsea porcelain painters abstracted a leaf, a flower or a twig, adding a butterfly, a moth or some other insect to balance the pattern and fill the plate. Occasionally the entire engraving would be copied with minimal modification, as in the example selected from the four plates now in the British Museum. The porcelain made at Tournai in Belgium during the 1770s also featured engravings

CORALLODENDRON triphyllum Americanum non spinosum, foliis magis acuminatis, flore pallide rubente. Houstoun Cat. MSS. Mill. Gard. dict.

from *Plantae Selectae*, but seldom modified Ehret's original drawings.

93 This erroneous attribution to Sir Hans Sloane has a parallel in the Wedgwood 'Water Lily' service, also known as the 'Erasmus Darwin' service. It was once believed that the service had been made by Josiah Wedgwood for Erasmus Darwin. It was, however, John Wedgwood, Josiah Wedgwood's son, who chose the 'Water Lily' pattern for the service which was purchased by Erasmus Darwin's son, Robert. Wedgwood decorated breakfast, dinner and dessert services with the brown 'Water Lily' pattern from 1808 to 1811. Another version in blue proved more popular, and at the end of the century it was revived as the 'Old Water Lily' pattern. The pattern combined

94–7 elements from two engravings in *Curtis's Botanical Magazine* and two in the *Botanist's Repository*.

91 'Sir Hans Sloane Plate.' The floral design is based on *Erythrina carnea* in C.-J. Trew. *Plantae Selectae*. 1750–73 (see Fig. 92). Spaces on the plate have been filled by the painter with insects and a scattering of seeds. Made at the Chelsea factory. England, mid-18th century.

92 *Erythrina carnea*, from C.-J. Trew. *Plantae Selectae*. 1750–73, pl. 8.

[115]

93–7 Earthenware plate (*left*) with 'Water Lily' pattern, painted in brown under the glaze and overglaze in orange, and gilt. Wedgwood, 1806–11. The pattern is composed of leaves and flowers copied from engravings in *Curtis's Botanical Magazine* (*above left and right*), vol. 23 (1806), pl. 903, and vol. 21 (1804), pl. 797, and H. C. Andrews, *Botanist's Repository* (*below*), vol. 6 (1804), pl. 391, and (*right*) vol. 5 (1803), pl. 330.

Garden Mallows

A Surfeit of Nature

The production of the 'Water Lily' service was an agreeable project for John Wedgwood, for whom gardening was a principal relaxation. In June 1801 he wrote to William Forsyth, royal gardener at Kensington and St James's Palaces, proposing the formation of a horticultural society. The idea was favourably received, and in March 1804 Wedgwood and six other like-minded men met in the house of the bookseller Mr Hatchard in Piccadilly for the 'purpose of instituting a Society for the Improvement of Horticulture'. From this inaugural meeting the Horticultural Society of London was born. By the time it became the Royal Horticultural Society in 1861 it had attained a position of pre-eminence in British horticultural affairs. Nurserymen, impressed by the success of its plant collectors, recruited their own collectors. The Wardian case, a tightly sealed glass case invented in the 1830s, protected the plants these collectors despatched from all over the world. The repeal of the tax on glass in 1845 made the construction of glasshouses cheaper, and improvements in heating systems provided a more congenial environment for delicate tropical flowers. No large house was complete without its ornamental conservatory to display the latest offerings of the nursery trade. Tree peonies from China, rhododendrons from the Himalayas and orchids from South America and Asia were cherished status symbols. Tender and half-hardy plants were bedded out in the appropriate season in colour combinations that were bold, emphatic and often insensitive. Flowers were cultivated with an assiduous devotion in country mansions, suburban villas and terrace houses. 'It is difficult to conceive of either an elegant or happy home, which has not, at least, some amount of garden attached', declared Shirley Hibberd, author of *Rustic Adornments for Homes of Taste* (1856).

98 James Sillett (1764–1840): Garden mallows (*Lavatera*). Watercolour, 1803.

[119]

Flowers invaded the house: cut flowers in vases, trailing plants in hanging baskets and ivy rampant over furniture and picture frames. Screens were covered with dried ferns or variegated ivies; seaweed pictures hung on walls. Oriental silks, pale-tinted gauzes and velvets, feathers, wool or tinted shells were used to create flimsy bouquets which were then protected under glass domes. The eye could be deceived by flowers expertly fabricated in wax. Queen Victoria, impressed by the deceptive fragility and freshness of Mrs Emma Peachey's models, showed her approval by appointing her 'Artist in Wax Flowers to Her Majesty'.

Then, of course, there were endless flower studies, frequently painted by ladies with ample leisure. Miss A. A. Young's drawings in *Studies of Trees* (c. 1834) were made 'to beguile the tediousness of a lingering indisposition'. 'I do not know of any accomplishment I would more earnestly recommend to my young friends than that of flower-painting.' This recommendation came from the novelist Mary Mitford, who thought it 'a most quiet, unpretending womanly employment'. The first quarter of the nineteenth century witnessed a spate of flower-painting manuals, many aimed specifically at women who had that 'fine and delicate feeling' which some art critics believed flower painting needed. Mrs Clara Pope came to flower painting late in her artistic career, and her first attempts were in the Dutch still-life tradition. She drew with impressive assurance and bravura in Samuel Curtis's *Beauties of Flora* (1806–20) and *Monograph of Genus Camellia* (1819). Vitality and scrupulous accuracy were abundantly evident in the work of Mrs Augusta Withers, who was appointed 'Painter in Flowers' to Queen Adelaide. She and the nebulous Miss S. A. Drake were the main contributors to that most spectacular of all flower books, the elephant folio *Orchidaceae of Mexico and Guatemala* (1837–43).

But women had not yet dislodged men from their dominant role in this field. The Austrian brothers Ferdinand and Francis Bauer maintained the highest traditions of Georgian sensibility, faultless in technique and faithful to nature. Pierre-Joseph Redouté, the 'Raphael of Roses', enjoyed the patronage of all the French queens from Marie Antoinette in the 1780s to Marie Amélie in the 1830s. Overshadowed by these giants were many obscure flower painters like James Sillett (1764–1840), who would competently turn out on request contrived bouquets in the Dutch manner or a modest spray of flowers.

98

There was now a preoccupation with decoration, and the flower became a popular component in the ornamentation of buildings and their furnishings. At one stage, design was subservient to Gothic Revival principles. The love of medievalism which had always lingered in English taste was manifest in sham castles and artificial ruins set in Augustan landscapes. Horace Walpole's pinnacled Strawberry Hill was dismissed as a puny effort, a 'Gothic Mousetrap' by William Beckford, who riposted with soaring but unstable Fonthill Abbey, the epitome of Romantic medievalism.

Augustus Welby Northmore Pugin (1812–52), a prolific architect and designer, was the Gothic Revival's most articulate and persuasive spokesman. Medieval art, he was convinced, owed its vigour and inspiration to the Christian Church. The medieval artist realised it was 'impossible to improve on the works of God'. Pugin saw plant forms as the source of all Gothic ornamentation. 'The natural outlines of leaves, flowers, etc. must be more beautiful than any invention of man.' But he rejected servile imitation of natural forms. 'It is absurd,' he wrote in *Floriated Ornament* (1849), one of the most influential pattern books of its time, 'to talk of Gothic foliage. The foliage is natural, and it is the adaptation and disposition of it which stamps the style.... Nature supplied the mediaeval artists with all their forms and ideas; the same inexhaustible source is open to us ...; if we go to the fountain head, we shall produce a multitude of beautiful designs in the same spirit as the old, but new in form.' The success of his interpretation of the adaptation of natural shapes can be judged in the formal and geometrical patterns in his book and in the wallpapers and textiles he designed.

Illuminated medieval manuscripts were studied by designers and the craft of illumination offered yet another agreeable pastime for Victorian ladies. Disraeli in his novel *Lothair* described a household 'where the mistress of the mansion sat surrounded by her daughters, all occupied in various works. One knitted a purse, another adorned a slipper, a third emblazoned a page.' Illuminated gift-books were the coffee-table books of the Victorian era, discreetly displayed in the drawing room for the admiration of guests. Noel Humphreys, who illuminated many such gift-books, counselled the illuminator to be 'acquainted with Botany and also possess a knowledge of what may be termed the poetry of flowers, that is to say, their associations, their symbolism, and their properties'.

This obsession with flowers found its most varied and ebullient

99 An example of the floral extravagance displayed on many of the exibits in the Great Exhibition, 1851. From the *Crystal Palace Exhibition. Illustrated Catalogue*, 1851, p. 26.

expression in the Great Exhibition held in Hyde Park in London in 1851. The Exhibition was the nation's shop window for manufacturers and designers, who displayed a remarkable but undisciplined talent for surface enrichment. Floral motifs were exploited in tortured curves and convolutions. Heavy fabrics were covered with blowzy blossoms, rococo roses and all the exotic flora of the tropics. Dense patterns were formed out of rampant foliage and carpets were 'ornamented with water-lilies floating on their natural bed, with fruits and flowers poured forth in overwhelming abundance in all the glory of their shades and hues'. 99

The abandonment of Regency restraint for this sensual naturalism can perhaps be best seen in Berlin wool-work, which from the 1830s supplanted traditional embroidery. It was popular because little skill was required to copy the patterns imported from Berlin in brightly coloured wool on upholstery and screens. By 1850 the designs had degenerated into bold floral groups standing out against black backgrounds. A clergyman who presented a paper on 'Church work for Ladies' to the Architectural Society of the Archdeaconry of Northampton in 1855 was probably remembering the fine pale silks of Georgian needlework when he denounced the grossness of Berlin wool-work designs. He cited with revulsion 'a group of gigantic flowers, with pansies as big as pennies, cabbage roses which deserve the name suggesting pickle rather than perfume; gracefully falling fuchsia as big as a hand-bell.'

The ingenuity of Victorian designers could introduce a floral theme into practically any object. In the Great Exhibition there was a gaslight bracket smothered in vine leaves and pendulous bunches of grapes, and anemones and fuchsias serving as curtain hooks. An inkstand disguised as a thistle was not considered 'a very happy idea' by a contributor to the *Crystal Palace and its Contents* (1852), who solemnly observed that the 'introduction of hooks or rests for the pen upon the stalk is decidedly an addition not to be found in nature'. When the giant South American water-lily, *Victoria amazonica*, flowered for the first time in this country – a horticultural sensation – designers welcomed it as a challenge to their innovative skills. They made it a motif for mantelpieces and light fittings and even created a papier-mâché cradle out of it. Such distortions, which substituted 'the ornament itself for the thing to be ornamented', were deplored by Ralph N. Wornum, the winner of a hundred-guineas prize offered by the *Art Journal* for his essay on 'the Exhibition as a Lesson in

100 John Ruskin (1819–1900):
Ivy (*Hedera helix*). Watercolour.

[123]

Taste'. A dessert service made for the Duke of Roxburgh was one example he gave of 'natural objects performing impossibilities; the fuchsia, the lily, the thistle, and the vine, are, respectively, without any artificial or mechanical aid, made to support dishes upon their delicate flowers or tendrils.' Excessively floriated carpets repelled him: 'if natural foliage or flowers are essential to some taste, they should perhaps be rather dispersed with a more studied carelessness.'

Alarmed by the ascendancy of the 'naturalistic' or 'horticultual school of ornament', Wornum came to the conclusion that 'a conventionality of arrangement' was necessary to curb its worst excesses. His disquiet was shared by a number of eminent participants in the Great Exhibition, in particular Henry Cole, whose phenomenal energy and organisational genius had contributed so much to its success. A number of the items shown in the Crystal Palace were selected by Cole in 1852 for an exhibition illustrating the 'False Principles of Design' at the Department of Practical Art at Marlborough House. Distinguished designers like Pugin and Owen Jones were uneasy about this slavish copying of nature rather than seeking principles of form and shape.

When the Great Exhibition closed and the Crystal Palace was re-erected at Sydenham in South London, Owen Jones, architect and illuminator of gift-books, designed some of the new galleries along historical lines. From all the research necessary to ensure their historical authenticity emerged Jones's *Grammar of Ornament* (1856), a seminal work for the new school of modern designers. The floral trends in carpets, papers and carvings had convinced him that no work of art was likely to come out of a close imitation of nature. Dogmatic and assertive, the *Grammar of Ornament* enumerates 37 'Propositions' for the construction and colouring of ornament. Proposition 13 states that 'Flowers and other natural objects should not be used as ornaments, but conventional representations founded upon them sufficiently suggestive to convey the intended image to the mind, without destroying the unity of the object they are employed to decorate.' Geometry was the basis of all form, and Owen's flat, stylised interpretation of plants sought to demonstrate nature's inherent symmetry and rhythm.

A knowledge of plant form and structure was considered an essential part of the education of any serious designer. In that respect Christopher Dresser, who lectured in botany at the Department of

101 English 'Naturalistic Style' jewellery of the 19th century: (*top left*) orange-blossom spray; (*top centre, bottom left and right*) matching brooch and earrings of sprays of violets with tinted ivory flowers; (*top right*) spray of flowers; (*centre*) gold brooch of a rose-spray with tinted ivory petals; (*bottom*) convulvulus comb-mount.

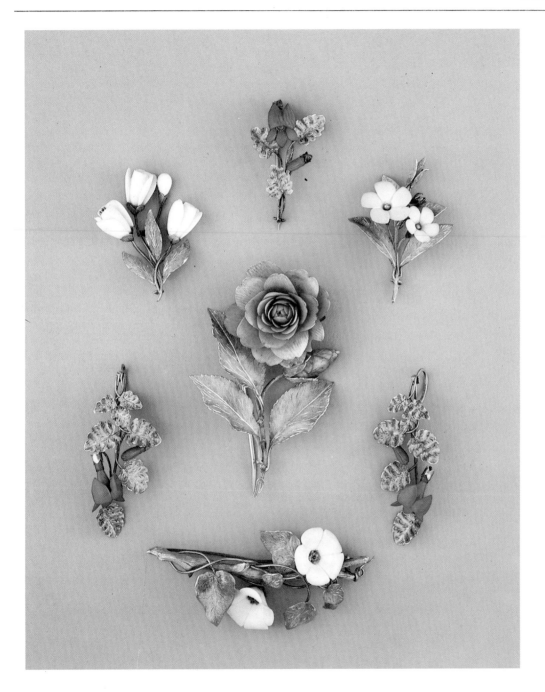

Science and Art in London, was eminently well-qualified for his new career as a commercial designer. Also a botanical artist, he had contributed a plate 'exhibiting the geometrical arrangement of natural flowers' to the *Grammar of Ornament*. His own researches in plant morphology convinced him that 'all plants of a highly organized character … are built upon a geometric plan'. His *Art of Decorative Design* (1862) was a reaffirmation of Jones's dictum that floral ornament must be conventionalised. Frederick Hulme, art teacher and amateur botanist and the author of *Plants, their Natural Growth and Ornamental Treatment* (1874), thought that an acquaintance with plant structure was just as important for the designer as anatomical studies were for the painter and sculptor.

John Ruskin (1819–1900) opposed the stylisation of natural form. 'Nature,' he said, 'was far too holy to be subjected to such barbaric treatment.' He himself painted plants in delicate watercolours with humility and devotion. He persuaded the craftsmen building the new Oxford Science Museum to carve its sandstone capitals with naturalistic flowers and foliage. He was instinctively in sympathy with the Pre-Raphaelite Brotherhood, who sought truth through a reverence for nature. The Pre-Raphaelites recorded the physical world about them in obsessive detail. William Holman Hunt hauled his huge canvas *Rienzi* to a friend's garden in Lambeth in order to paint in a fig-tree with absolute botanical fidelity. John Everett Millais, who used a magnifying glass to ensure accuracy in floral details, observed similar meticulous standards in rendering the flowers in his *Death of Ophelia* (London, Tate Gallery). 101

One wonders whether the naturalistic style of nineteenth-century jewellery, with shell and ivory petals, gold and silver leaves and occasionally diamond dew-drops, met with the approval of the Pre-Raphaelites. Jewellery, especially influenced by fashions in dress and hair-styles, also reflected trends in artistic taste. The Gothic Revival gave necklaces and pendants an architectural flavour. Archaeological discoveries in Egypt inspired pseudo-Egyptian jewels with lotus motifs, while Italian craftsmen copied formalised Etruscan laurel wreaths. By contrast, the imitation of Roman mosaics, using tiny glass fragments, produced astonishingly lifelike flower bouquets. A new vitality pervaded Florentine *pietra dura* work in inlaid hard stones, where the natural markings of the stones suggested the veins of petals and leaves. But it was the naturalistic movement in

100

102

102 (*Top*) English silver-gilt patch-box with Italian glass mosaic panel of flowers. Early 19th century. (*Left*) Gold brooch-pendant with *pietra dura* pansies. Florentine, *c.* 1850–70. (*Right*) Gold brooch with glass mosaic of fruit inlaid in white opaline glass. Italian, *c.* 1850.

decoration that from about the second decade made the greatest impact on jewellery. Society ladies were bedecked with horticultural motifs: tiaras of gold ivy-leaves, turquoise-set forget-me-not hair-combs, earrings in the form of strawberries or acorns, sprays of orange-blossom with shell petals or pearl-set lily-of-the-valley, tight

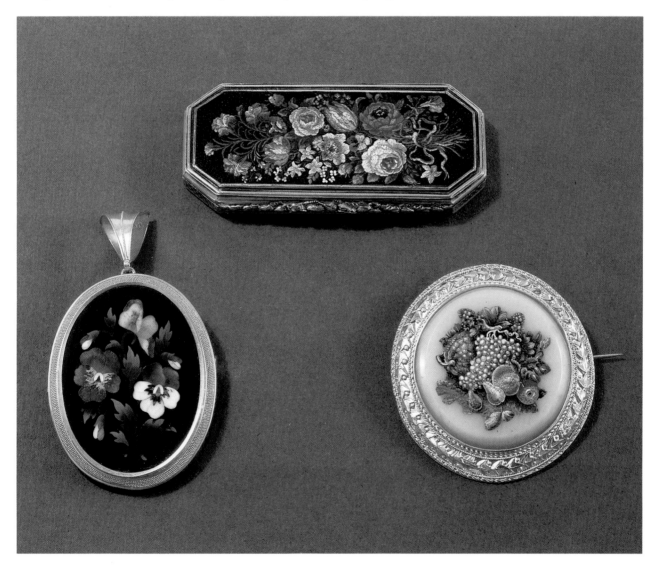

rose-buds of carved coral, seed-pearl grapes, fuchsias and violets in carved and tinted ivory.

Such floral proclivities were encouraged by the symbolism of flowers. In medieval times plants had religious connotations; in the nineteenth century symbolism was sweetened with sentiment. 'Flowers do speak a language, clear and intelligible', enthused Elizabeth Kent, author of *Flora Domestica* (1823): 'observe them reader, love them, linger over them, and ask your own heart if they do not speak affection, benevolence, and piety.' Young ladies employed the language of flowers in coy flirtations. 'Many a bright nosegay may exchange hands, and tell, in its fitting and intelligible language, a welcome message to a fair lady's ear.' To instruct them were numerous handbooks illustrating the subtleties of floral language. But a mastery of its syntax was no easy accomplishment. Ivy, a Victorian favourite, signified 'fidelity', and with tendrils added, 'assiduous to please'; orange blossom ingratiatingly declared 'your purity equals your loveliness'; flowering almond offered 'hope'; the buttercup expressed 'ingratitude'; colour permutations of the carnations could be confusing: deep-red 'alas ... for my poor heart', striped 'refusal', yellow. 'disdain'; colchicum or meadow saffron conveyed a message of despair, 'for my best days are past'.

No one loved jewellery more than Queen Victoria herself, who was lavish in her gifts of bracelets, brooches and other pieces. Prince Albert commemorated their wedding anniversary in 1845 by designing a tiara for her of orange blossom with porcelain flowers, complete with slender porcelain stamens, leaves of frosted gold and four oranges — representing the royal children — in enamel.

Leaves were often convincingly executed by engraving the veins on the gold, which was either frosted or covered with translucent green enamel. They received the endorsement of the *Art Journal* in its catalogue of the Great Exhibition: 'the brilliant colouring of an enamelled leaf or floret is an excellent foil to a sparkling stone.' By the 1860s London jewellers enjoyed a brisk business in earrings, brooches and pendants of enamelled flowers and insects. The Swiss enamellers of the nineteenth century offered serious competition with their enamelled watches.

John Ruskin stipulated enamelled flowers of hawthorn on a gold cross for presentation at a 'Queen of the May' ceremony which he initiated at Whitelands College, Chelsea, in 1881. The recipient was to be the most popular student at this teachers' training college.

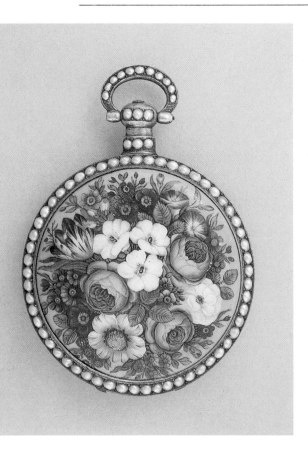

103 Duplex watch by Bovet of Fleurier in Switzerland. The silver-gilt case is decorated with painted enamels of flowers and surrounded with borders of split pearls. The watch dates from about 1830 and is one of a type made for export to China, where they were highly prized objects.

104 (*opposite, top and centre*) Gold Whitelands 'May Queen' crosses of flowering hawthorn, designed by Edward Burne-Jones (1883) and Arthur Severn (1884). (*Bottom*) Gold Cork 'Rose Queen' cross of flowering wild rose, designed by Arthur Severn in 1885.

103

104

Arthur Severn, the husband of his favourite cousin, Joan Agnew, designed the cross with a spray of hawthorn blossom, though enamel was not used. In 1883 Ruskin's friend the painter Edward Burne-Jones designed a new cross, which was used only once because it was, according to Ruskin, 'not hawthorny enough'. Severn obliged with a new design for the following year and this, with slight modifications, remained in use until Ruskin's death in 1900. The headmistress at the High School for Girls in Cork, a former teacher at Whitelands, instituted a Rose Queen festival in 1885 and every June Ruskin presented a gold cross of flowering wild roses, again designed by Arthur Severn.

William Morris (1834–96), perhaps the greatest decorator of the nineteenth century, whose fertile genius created patterns for wood-work, fabrics, wallpapers, tiles, stained glass and fine books, never, so far as is known, designed any jewellery. He was a medievalist like Pugin and joined Ruskin in acknowledging the supremacy of nature, not in reverence but as one who took pleasure in 'the simple joys of the lovely earth'. As a young man he had visited the Great Exhibition and disliked its mechanical sterility and ornamental excesses. Ten years later the firm of Morris, Marshall, Faulkner and Company was established as 'Fine Art workmen in painting, carving, furniture and the metals'. Morris soon became the dominant partner and its products reflected his thesis that 'beauty mingled with invention, founded on the observation of nature, is the mainspring of decorative design'. The enthusiasm which permeated his early naturalistic designs was a defiant response to the geometrical severities and intellectualism of Pugin, Jones and Dresser. But his patterns needed an overall structure and order, and so he imposed on them a formal framework without diminishing the vitality of the flowing lines of his vegetation. He eschewed flamboyant, overblown flowers, the pride of garden and glasshouse, preferring old-fashioned flowers like the daisy, wallflower, larkspur and jasmine, and cautioned his fellow designers 'to be shy of double flowers'. Many late Victorian middle-class homes were tastefully decorated with William Morris wall-papers and chintzes, distinctive in their bold but subtle floral patterns.

William de Morgan (1839–1917) was introduced as a young aspiring painter to the Pre-Raphaelite Brethren; in 1863 he met Morris, who persuaded him to work for his firm as a designer, initially of stained glass. Before long his talents were redirected to

105 Central ornament from a dog-collar necklace, of carved horn set with opals in the form of sycamore 'keys'. Probably designed by René Lalique (1860–1945). French, *c.* 1900.

tiles, then considered indispensable to good interior decoration. The fashion had started when Victorian architects such as Pugin laid encaustic tiles, imitating medieval designs, on the floors of the churches they were building or restoring. Within a few decades they had become mandatory ornamentation. The walls of the royal residences at Windsor and Osborne were clad with them; they adorned new public buildings such as the Houses of Parliament and the Foreign Office; they formed a common bond between aristocrat and artisan, from Lord Leighton's house in Kensington to modest dwellings with tiled porches and fireplaces. De Morgan's tiles could not escape Morris's pervasive influence. The flowers he chose would have met with Morris's approval – circular daisies and sunflowers and fan-shaped carnations. His repeating pattern of flowers resem- 107
bled a ceramic version of a Morris wallpaper. De Morgan's tiling of Debenham's house in Addison Road, Kensington, is a virtuoso performance; his other prestigious commissions included the P & O liners and the Czar of Russia's yacht.

In the 1880s craftsmen and designers like De Morgan who were attentive disciples of Ruskin and Morris formed craft guilds with truth to nature and to materials as sacred principles of faith. One of the first, the Century Guild, was founded by Arthur Mackmurdo in whose book *Wren's City Churches* (1883) can be detected the first intimations of Art Nouveau in Britain. Its title-page is composed of heavy, swirling lines of stylised leaves and flowers. Art Nouveau, which enjoyed a far greater following on the Continent, exploited the rhythmic qualities of sinuous line and organic growth. The flexible stems of grasses, irises, lilies and tulips and the curving tendrils of the

106 Charles Rennie Mackintosh (1868–1929): 'Mixed Flowers'. Watercolour and pencil study painted in France in 1925.

MONT
LOUIS.
JULY 1925
MMM
CRM

107 William de Morgan (1839–1917):
Ceramic tile with carnation design,
reminiscent of Islamic designs like the
Syrian tile, Fig. 139. Sands End Pottery,
Fulham, 1898–1907.

grape vine were converted into dynamic, undulating forms and patterns. Water-lily pedestals, side-boards with carved ears of corn and chairs and stools with cow-parsley motifs came from the workshop of Emile Gallé. Lamps offered a challenge to the inventive: there were desk lamps disguised as mushrooms and irises; wall lamps with stems terminating in flowering light fittings, and standard lamps with long curving stems and leafy appendages. The jewellery of Georges Fouquet created glistening orchids and fuchsias in fragile and transparent enamels, while René Lalique indulged his sometimes macabre fantasies with writhing organic forms and sensuous overripe blooms – anemones, wistaria, thistle flowers and sycamore fruit were especial favourites. Flowers were an essential component of the decorative vocabulary of Charles Rennie Mackintosh, the leader of the Glasgow school of Art Nouveau. They embellish his chairs, cabinets, doors, leaded glass panels and textile designs. His watercolours of wild and cultivated plants are confident linear compositions filled in with washes of bold colours. The thrusting lines of plants frame the entrances to the Paris Métro and flourish in contorted metalwork on the balconies of Antonio Gaudí's Casa Milá in Barcelona. In its search for a new concept of decoration, Art Nouveau absorbed the curves of rococo, the linear forms of Arts and Crafts and the interlacing patterns of the Celtic Revival. But paramount was the influence of nature, always a potent source of infinite inspiration for all designers throughout the whole of the nineteenth century.

Twentieth-century architects and craftsmen under the influence of the Modern Movement renounced decoration or reduced it to geometric and abstract patterns which did not conflict with functional design. Stylised flowers in festoons and garlands persisted, however, in textiles. Raoul Dufy, for instance, adeptly interpreted plant form in simplified or abstract patterns. The French Art Deco designer Paul Iribe, with a penchant for including tight rose-buds in his creations, conceded that 'for thousands, the flower is as necessary as the machine – shall we sacrifice the flower on the altar of cubism and the machine?' Despite the magisterial pronouncements of exponents of the Modern Movement, the vitality of popular art, having firm links with traditional decoration, has survived undiminished. After several decades of reticent treatment, flowers have now returned to textiles, wallpapers, jewellery and ceramics, portrayed with affection and even panache.

3
Oriental Art

Frances Wood

108 Detail of a scrolled floral border from
an album painting. India, Mughal school,
late 17th–early 18th century.

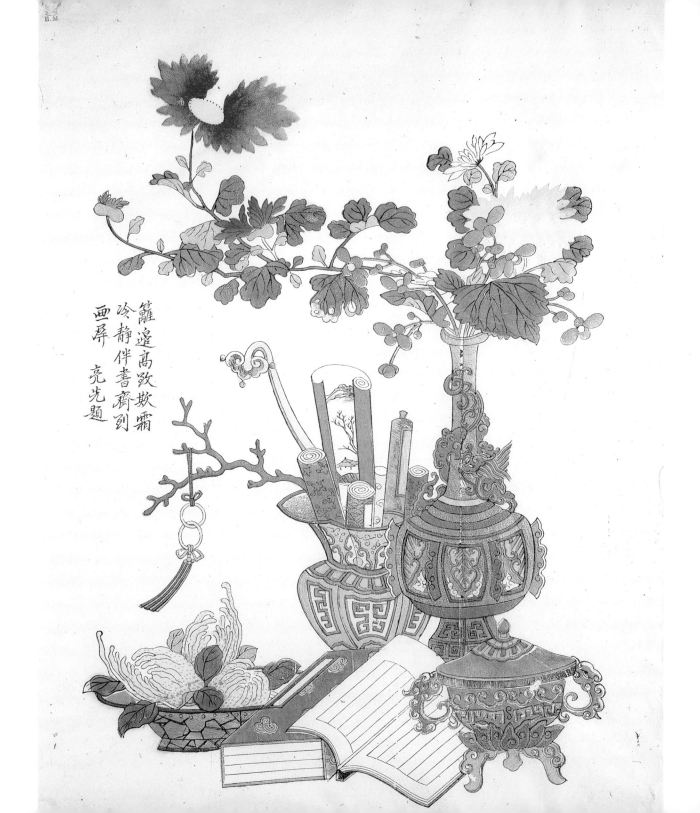

籬邊高致欺霜
冷靜伴書齋到
畫屏　亮光題

China and Japan

T he vast continent of Asia comprises a wide range of climatic regions, each with its characteristic flora, as well as a wide range of distinctive cultures. Owing to the existence of routes of trade and communications, established as early as the Neolithic period, when Siberian jade reached northern China, mutual influence and borrowing affected all of the great Asian cultures. One example of such cross-continental communication is the movement of the floral scroll motif across Asia. Palmette scrolls used in architectural decoration in the third and second centuries BC in Hellenistic Turkey and in Roman Syria in the first century BC were copied in Chinese cave temples of the fifth century AD. Overall floral scrolling decoration on Near Eastern metalwork had some influence on the decoration of Chinese blue and white porcelain of the fourteenth century, and, in turn, Chinese porcelain with scrolling floral designs became immensely popular in seventeenth-century Turkey, where copies of Chinese styles kept pace with changing Chinese fashions.

The lotus, a symbolic flower in both Hinduism and Buddhism, was a favourite decorative emblem in India and travelled, with the Buddhist faith, into Central Asia and thence to China, Korea and Japan. But it was not just the motifs that moved: actual flowers and plants also travelled across the great landmass, notably grapes and pomegranates (which occur as decorative motifs on Tang and later Chinese ceramics), which reached China from Ferghana and Bactria in Central Asia by the second century AD. For European plant-hunters, Asia was a treasure-house. The floral traffic was, in the end, a two-way affair, for the herbals of Europe and botanical drawings of the explorers had a strong effect on floral painting in Persia, where accurate 'portraits' of flowers combined local tradition with the foreign style. China and, to a lesser extent, Japan provided a wealth

110

110 Jade belt ornament in the shape of two lotus leaves with intertwining stalks. China, late Ming dynasty, 16th to 17th century.

109 (*opposite*) Archaistic vessels with flowers, books and paintings. Woodcut in ink and colour on paper. China, second half of the 17th century.

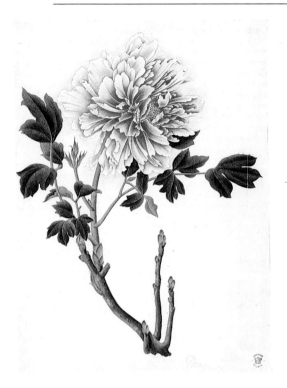

111 Specimens of the Chinese peony first reached Britain in the 1780s, and became immensely popular with gardeners. This botanical watercolour by an anonymous Chinese artist was painted for the East India Company, *c.* 1800.

of specimens, and it has been estimated that some 80 per cent of the garden flowers of Europe today come from China. E. H. Wilson (1876–1930) called China 'the mother of gardens' and, apart from actual specimens, local artists in India and China began to produce botanical drawings for servants of the East India Company as early as the late seventeenth century. 111

Two major cultural areas in which flowers and plants formed a great part of the artistic repertoire were the Islamic countries (including Turkey, Persia and Mughal India) and the Far East, dominated by Chinese culture but including strong local traditions. For Islamic rulers, especially those living on the dry highlands with brief springs when grasses and wild flowers carpeted the ground only to wither in the baking heat of summer, the construction of gardens was a major pastime. The Islamic garden, a man-made oasis, centred on water and geometry. Inside a walled enclosure, water-channels divided the garden into regular geometric plots with a pool or fountain at the centre. Within these, flowers and trees were grown for their colour and scent. Garden design was also a major passion in the Far East, but the starting point was quite different. For the Chinese, the garden was a retreat from city life into a miniature version of a grand mountain scene. Piled rocks, hollowed pools and strategically placed pavilions for viewing the artificial landscape took pride of place; plants, especially flowers, came second. Yet flowers themselves were appreciated, according to their season. In Peking's cold late winter, the back slopes of the Summer Palace are lightened by the sparse flowers of dark-limbed prunus, and cherry-blossom time in Japan sees parks and gardens with alleys of trees heavy with flowers, crowded with visitors. In April and May in Peking, lovers of lilac troop off to the courtyards of the Fayuan si (Temple of the Source of the Law), and May is the time to visit Luoyang for the flowering of the tree peonies. The autumn displays of chrysanthemum in parks throughout China are a tribute to the extraordinary variety of the species (from pom-pom to spider) as well as to the art of the topiarist, for plants are trained through split bamboo and over wire into the shapes of horses, deer, aeroplanes and elephants. 112

Floral decoration became prominent in China with the arrival of Buddhism and the stimulus of non-Chinese motifs. In the early Buddhist cave-temple complex at Yungang in North China (constructed between AD 460 and 494), North Indian, Central Asian and Hellenistic influences are apparent. The leaf and floral scrolls found

dividing scenes in niches and in haloes surrounding icons were based on Central Asian versions of Hellenistic motifs. Petals, vine-scrolls and simplified acanthus or half-palmette scrolls, first found here at Yungang, were to have a long history in China, through Tang silver and stone-carvings to flower scrolls on Cizhou wares of the Song dynasty, and culminating in the decoration of blue and white porcelain of the Yuan and Ming periods. Classical half-palmette scrolls were adapted into lotus scrolls for Buddhist decoration, for example in borders around lotus ceilings in the caves at Dunhuang (fifth to tenth centuries AD); combinations that also occur on seventh-century Korean tiles, as Jessica Rawson has demonstrated.

112 Tang Yifen (1778–1853): 'The Garden of Delight' with pavilions, lily pools, willows and pines. China, 1826.

[137]

CHINESE DYNASTIES

Han	206 BC–AD 220
Three Kingdoms	220–265
Jin	265–420
Northern and Southern Dynasties	420–589
Sui	581–618
Tang	618–907
Five Dynasties	907–960
Ten Kingdoms	902–979
Song { *Northern Song*	960–1127
{ *Southern Song*	1127–1279
Liao	907–1125
Jin	1115–1234
Yuan	1279–1368
Ming	1368–1644
Qing	1644–1911

The most notable motif associated with Buddhist decoration is the lotus, which rises in beauty out of mud. It therefore symbolises man's aspiration to a state of purity despite the quagmire of desire in which human beings wallow. Though the lotus is paramount, in much Far Eastern Buddhist art simple floral motifs with no symbolic meaning also appear: Bodhisattvas wear ropes of pearls with jewelled floral plaques; their head-dresses of filigree are twisted in leafy forms, with more floral plaques entwined, and they stand or sit on lotus thrones, the latter directly inherited from Indian Buddhist images. An early Japanese example of the floral filigree head-dress can be seen on a sculpture of the Guze Kannon in the Hōryūji Temple (early seventh century). Above the heads of Buddhas in ninth- and tenth-century silken banners from Dunhuang, rich silken canopies are hung with ropes of pearls terminating in floral plaques of semi-precious coloured stones, and before them altars with vases of flowers are covered with cloths richly embroidered with yet more flowers. In the woodblock-printed frontispiece to a scroll of the Diamond *sūtra* of 868 (the world's earliest printed book), all these floral decorations are seen, as well as a depiction of a floor covered with tiles impressed with a floral design in relief. Temples of the Tang dynasty (AD 618–907) often had such floors, which cannot have been very hard-wearing or comfortable to walk on; excavated examples can be seen in Chinese museums. In another Tang dynasty banner from Dunhuang, painted on silk, the Buddha is depicted preaching from a lotus throne, further embellished with floral scrolling, and above him, the pearl and jewel canopy is entwined with flowers and fruit; *apsarases* (Buddhist 'angels') fly above, scattering flowers. Banners and wall-paintings of the same period depicting the Western paradise of Amitābha Buddha usually include a lotus pond at the base, with naturalistic lotus flowers rising from the water where fat children sit on round lotus leaves.

In Japanese Buddhist art, the same stylised floral motifs are frequently found, from the patterned floor to the lotus throne and woven, printed and embroidered fabrics. Sometimes the flame mandorla (or 'halo') surrounding the Buddha incorporates floral scrolling, as in a ninth-century standing Shaka Nyorai at Nara. In many temples, very fine canopies were suspended above the Buddhas. These were made of wood, either painted or carved, edged with metal, with a central lotus flower surrounded by lotus borders and floral scrolls, and were hung with crystal and semi-precious stone

113

pendants, in a three-dimensional version of the canopies also seen in paintings.

Though in Buddhist art the lotus was frequently reduced to a decorative motif, there are also many examples of realistic depiction. In the Buddhist caves at Dazu in Sichuan province (south-western China), a niche depicting the Buddha of Medicine has a wonderful frieze of lotuses at the base. Slender stalks support the open, spike-petalled flowers, which stand beside broken-stemmed leaves. The niche was carved in AD 955, but the naturalistic lotus pond theme persisted and is seen in a fine thirteenth-century Chinese hanging scroll painted in ink and colours on silk, now in the Museum of East

113 Part of a Buddhist votive patchwork including flowered silk embroideries. From Dunhuang, China, Tang dynasty.

Asian Art in Berlin. Buds, pink and white open flowers and seed pods sway above the water, their leaves open or half-closed, whilst a pair of ducks swim amongst water-weed beneath. Though there is no overt religious content, this cannot be seen as a simple flower painting, for the lotus is so strongly associated with Buddhism and its symbolism so strongly felt that the religious message would be overpowering. The symbolism persists to this day: just at the end of the oppressive Cultural Revolution in China (1966–76), one of China's foremost painters commemorated the death of Premier Zhou Enlai in a painting of a single bright red lotus flower. At the time, an outspoken statement of support for the 'good Premier' Zhou Enlai would have been seen as a criticism of the current 'bad' regime, hence the use of the lotus as a symbol.

In genre painting, both in China and Japan, the emphasis is on figures and architecture: flowers have a small part to play and no symbolic value. They appear in scenes where a garden setting is required, as in the many Chinese paintings of the Ming dynasty (1368–1644) depicting the hundred children at play or in Japanese handscrolls illustrating the classic novel 'Tale of Genji'. Later Japanese genre painting of the seventeenth century anticipated the perfection of the coloured woodblock print in the eighteenth, and, like the woodblock print, concentrated on figures, occupations and events, some of which were associated with flowers, such as the spring viewing of cherry blossom.

In both China and Japan, monochrome ink and wash painting carried the highest artistic status. One of the reasons for this was its close link with calligraphy. It is interesting to note that many Asian cultures held calligraphy in higher esteem than any other art form. In India, the tradition of passing on texts through copying was extremely important and well developed from an early period, and in Islam the religious significance of calligraphy in conveying the message of the Prophet helped to enhance its status, but in the Far East the position was more complex. Certainly China, in particular, has always been obsessed with words, from the point of view of both form and content. The obsession with form meant that in the Ming period (and probably at all other times) a good piece of calligraphy could sell for perhaps ten times as much as an equally good painting. The Chinese writing system (also adopted in Japan and Korea, though subsequently modified in both places) is unique: to some extent based on pictograms and ideograms representing objects or

114 Dai Mingyue (*fl. c.*1619–56): Bamboo. Hanging scroll in ink on satin. China, mid-17th century.

ideas graphically, from about 1500 BC it was a fully developed writing system based on a series of graphic images recording the roots of words. Though the pictorial aspect of characters is now down-played, the graphic elements of the language have long formed part of the fascination of a script in which it is possible to make visual links or even puns at the same time as links or puns relating to meaning. The significance of the written word was such that many Daoist medicinal prescriptions consisted of ornamental characters written on paper. The paper with its text was burnt and made into a 'medicinal' tea to be drunk by the patient.

The tools used in writing – the brush and ink (used from the Neolithic period) and silk or paper (the latter, a Chinese invention, was in fairly widespread use by the fourth century AD, well over 600 years before it appeared in Europe) – were also the tools of painters. The strokes used in writing the complex characters of the script were similar to those used in painting, particularly in the depiction of a plant of great significance to the Chinese and Japanese, the bamboo. Symbolising modesty in its drooping leaves, with its regularly segmented stems and graceful line (and, in some cases, beautiful patterning of the stem), it is also a living example of the innate patterning of natural things (*li*), which man must study in order to help attune himself to nature and her ways. Different painters saw bamboo in different ways: as explosions of ink, swayed by winds (yet not breaking), or as forceful and sturdy clumps. Just as the bamboo deserved study for its innate qualities, an ink and wash painter had to study and practise bamboo painting in order to achieve success in grouping the calligraphic strokes: light but firm lines finished with a twist for the stem and darker, stabbing strokes for the leaves.

The principle of representation in Chinese art has long differed from Western ideas. From the sixth century AD, when Xie He laid down the six principles in his *Gu hua pin lu* (Classification of ancient paintings), the first principle of 'spirit resonance' has always been far more important than use of the brush, correspondence to the object (accurate depiction), suitability to type (accurate use of colour), placing and arranging of composition and transmission by copying ancient models. 'Spirit resonance' is perhaps best understood with reference to bamboo painting, where it was popularly said that a painter had to become a bamboo before he could paint it. Conveying the 'spirit' of a subject, whether it be bamboo or mountain, on silk or paper in dark ink which left no possible room for error or overpaint-

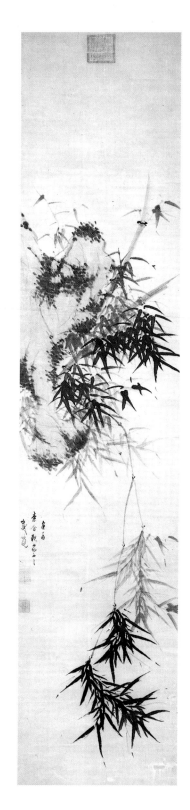

ing, meant doing more than merely depicting. It was necessary to convey 'mountain-ness' or 'bamboo-ness', and part of the process was the mastery of ancient models. Though Chinese painters travelled to beauty spots and looked at bamboos and mountains, they did not sit in front of an object to depict it. Having practised for years the method of painting a subject such as bamboo in the style of different masters of the past, having looked at bamboo to try and understand its patterning, the artist in his studio would contemplate the paper, 'become the bamboo' and then paint it.

A problem of the study of painting in the Far East is the fragility of the medium. Few paintings on silk or paper survive, even from the Song dynasty. Where paintings by great masters of the past do survive, it is often in the form of copies by later painters, part of whose training was to copy their predecessors, mastering their methods, before making their 'own' paintings, compositions which owed enormously to tradition but which yet required an individual input to be of value in their own right. One of the most famous masters of bamboo painting of the Song dynasty, Su Shi (or Su Dongbo) (1036–1101), none of whose paintings survive, described how a friend of his approached bamboo painting. He dismissed those who simply drew one joint after another of the stem and the 'piled leaf upon leaf', for how could this grouping of strokes become a bamboo? It was essential to visualise the bamboo in the mind, transfer this vision to the paper and, seizing the brush, with the accuracy of a buzzard swooping on a hare paint the bamboo as you saw it before you on the paper. A moment of hesitation, a break in concentration, and all would be lost. Su Shi's passion for bamboo painting and calligraphy (stone-carved examples of his calligraphy, traced from paper originals, do survive), combined with his official career, during which he served for a period as Governor of the lakeside town of Hangzhou, exemplifies the Chinese ideal of the amateur scholar-painter. Though the ideal was rarely realised, for not all officials were skilled painters, Su Shi did combine a successful career as a government servant with the production of bamboo paintings, calligraphy and many poems. In one of these, he describes how he hears the official bugle calling him to duty. He pulls on his official hat and sets out, with a longing backward glance at the quiet garden and the wide open landscape beyond.

In a pure bamboo painting by Dai Mingyue (*fl.* mid-seventeenth century) in the British Museum, the calligraphic effect of bamboo

114

leaves is combined with a mastery of ink quality. The composition is unusual, for the bamboo, clinging to a softly outlined rock at the top left-hand corner of the hanging scroll, hangs down in a void. This downward composition, which runs down as a calligraphic inscription would, emphasises the calligraphic quality of bamboo. Soft, watery grey-toned ink is used to paint the rock and its smooth surface, dotted with darker spots of lichen. The bamboo itself, dangling in the mist, is also painted in varying ink-tones. Stems vanishing into the mist are light grey, whilst those in the foreground are dark, the leaves painted in quick, firm stabbing strokes.

The great age of monochrome ink painting with the bamboo as its 'highest' subject was the Song, when the art-loving Huizong emperor (reigned 1101–26), despite a personal painting style that was markedly different, had 148 monochrome ink paintings of bamboo in the imperial collection. Though the tradition in its pure form continued, exemplified by the Dai Mingyue painting, in later periods, the monochrome ink style was modified.

The Yuan dynasty, when the Mongols ruled China, was a time of

115 Bamboo and birds. Part of a wall scroll in ink and colour on silk by Dao Zhao and Zhu Sheng (*fl. c.* 1680–1735). China, late 17th to early 18th century.

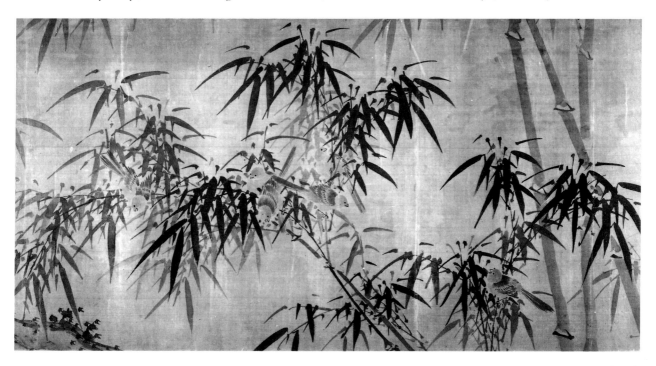

innovation within the narrow canons already established. Artists like Ni Zan (1301–74) explored textures of ink and brush, often using a very dry brush, and expanding the previously rather narrow composition of the hanging scroll, spreading the elements of the landscape horizontally. There was a greater interest in widening the painters' scope, which led to a broadening of the elements of composition in monochrome paintings of flowers and trees. A new grouping (also commonly found on slightly later blue and white porcelain vessels) was the 'three friends of winter', bamboo, pine and prunus, a grouping that was interesting for the painter because it allowed a greater range of brush-strokes than the pure bamboo. It was not a purely technical exercise, for the 'three friends' also symbolised scholarly virtues. The pine and the bamboo are evergreen, withstanding the difficulties of winter, the pine through its rugged strength, the bamboo's slippery green leaves and flexible stems bending gracefully under the weight of snow, whilst the prunus symbolises hope and regeneration since its tiny flowers open when the ground is still hard and cold.

The grouping was interpreted both on hanging scrolls and handscrolls. Both formats, owing perhaps to the fragility of the paper or silk, mounted between dark wood rollers, were intended for temporary viewing. Hanging scrolls were stored in scented camphor-wood boxes against the damp and brought out and hung up on special occasions: birthdays, family celebrations, visits from honoured friends, or perhaps to coincide with the first opening of the prunus blossoms marking the end of winter. A long horizontal wallscroll by Zhu Sheng (*fl.* 1680–1735) and Dao Zhao reveals the possibilities of the format. Painted by two artists, part of the fun of viewing the scroll would have been trying to spot the different hands, but the painting also includes tiny sparrows amongst the bamboo which appear suddenly, flying into the field of vision and disappearing just as fast. Handscrolls which unrolled horizontally, bit by bit, revealing part of the painting for contemplation, were an almost narrative form, allowing for different groupings of subjects or different treatments. They were also brought out when great friends arrived, as study or conversation pieces.

One of the 'three friends of winter', the plum blossom, was particularly favoured by the Japanese: garden pavilions were sometimes constructed in the form of prunus blossom (in plan), and the tiny regular flowers appear frequently on Japanese textiles. In

115

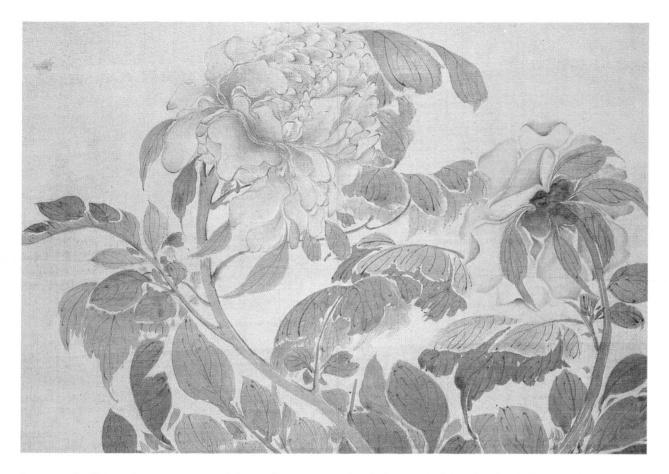

Japan, as in China, the prunus was celebrated in poetry and painting, and a plum blossom handscroll of about 1820 by Tani Bunchō in the British Museum perfectly illustrates the possibilities of the subject. In parts, he paints the thick, dark gnarled boughs of the tree with thick, wet brush-strokes which do not quite meet and in the vigour of the strokes leaves small blank spaces, conveying the nature of the bark. This technique was known as 'flying white', the white streaks being the bare paper. Bunchō's strong branches are offset by lightly delineated buds and flowers, a stroke or two outlining the form. The speed with which he must have painted can still be felt, though the end of the scroll tapers more restfully to lighter, thinner branches dotted with dark spots of buds yet to open.

If the prunus was depicted with special delicacy by Japanese artists, the pine was, like the bamboo, perhaps more essentially

116 Gao Fenghan (1683–1743): Chinese peonies, from an album of twelve leaves after the *Ten Bamboo Studio Manual of Calligraphy and painting.*

Chinese than Japanese for, like the bamboo, the short sharp strokes of the needles are essentially calligraphic. The texture of the trunk, however, allows for variety of brush-strokes and ink quality and presents a more painterly challenge. An extraordinary example in the British Museum is Shen Zhou's long handscroll 'portrait' of a single pine, stretched out horizontally over many metres in defiance of nature.

Other plants that could be perfectly depicted in ink wash, with no need for colour, and which held significant places in Chinese, Korean and Japanese culture were the epidendrum, chrysanthemum, lotus and magnolia. The lotus appears a different flower when depicted in ink and wash. The flowers and buds, the most significant part of the plant in Buddhist depictions, become almost of less interest than the leaves and seed-pods. In a painting on a fan by Gao Fenghan of about 1730, in the British Museum, a lotus bud about to open peeps out from behind a large flat leaf, its soft contours washed in pale ink, the ribs picked out in thinner, darker strokes. This leaf is balanced by another huge leaf with curling edges and a bent stem which covers half the fan surface. The decay of the plants, the way that the leaves, first smooth and fresh, gradually break up, their edges curling and stems snapping as the summer passes, is lovingly depicted in a different view of the proud symbolic flowers of Buddhist iconography.

The epidendrum, an orchid, was one of another grouping of flowers favoured by painters. During the Ming, the 'three friends of winter' were joined by a new grouping, the 'four noble plants': bamboo, plum, chrysanthemum and orchid. Numbering groups, whether flowers, painters or, as in today's China, political movements and groups (the 'Gang of Four', the 'Four modernisations') is an eternal linguistic habit in China, probably, in the early period, reinforced by Indian traditions, both Hindu and Buddhist, whose texts often mention numerical groupings such as the 'eight guardians of the directions of space', the 'ten incarnations of Vishnu' and so on. Chinese Buddhism includes a similar array of numbers: the 'four noble truths', the 'five improper ways of livelihood for a monk', the 'five vices', the 'six perfections', and hundreds more. The 'four noble plants' symbolise the four seasons (the evergreen bamboo for winter, the plum for spring, the orchid for summer and the chrysanthemum for autumn); but the epidendrum, its grass-like stems and green flowers camouflaging it amongst other plants, also symbolises the

117 Epidendrum with calligraphy from an album leaf painted in ink by Kōun. Japan, 1870.

quiet, hidden life of the scholar. Though it is not rated quite as highly as the bamboo as a 'calligraphic' plant, its sparsely petalled flowers and long, slender brush-stroke leaves do approach the pure line of calligraphy. It has been suggested by Lawrence Smith that, since it is softer than the spiky bamboo, its forms are closer to the softer, running calligraphy of the Japanese syllabary and Japanese calligraphic styles and are therefore particularly attractive to Japanese painters. An album leaf of 1870 by Kōun depicts a rather wild clump of epidendrum with long leaves trailing through a long calligraphic passage (in soft cursive Chinese characters), blurring the distinction between writing and painting. The leaf strokes mirror the characters, especially the simple character for 'man' which occurs twice, open and wide, crossing the page in the same direction as the trailing leaves. A more classic version of orchid painting by a Buddhist priest, Chō Gessen, of the late eighteenth century shows three clumps of epidendrum beautifully placed diagonally across the paper. The placing of the clumps, separated yet linked by the over-arching line of the long slender leaves, reveals Japanese flower painting at its best – the unerring sense of space and design developed from Chinese styles but sometimes surpassing them. Chō Gessen's orchids represent a tradition of Japanese Buddhist painting seen first in the work of another priest, Bompo, of the fifteenth century, who also favoured the epidendrum. Though this flower was less favoured amongst Chinese artists, it has remained a very popular motif, still

[147]

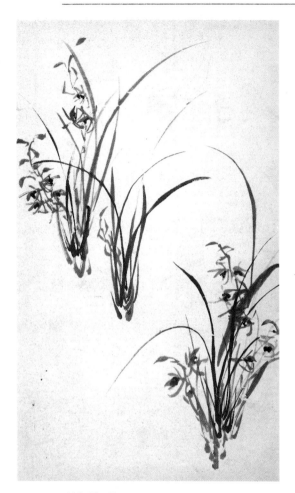

118 Chō Gessen (1721–1809):
Epidendrum. Detail from a monochrome
ink handscroll. Japan, late 18th century.

found today trailing over covered porcelain tea-mugs and even enamel washing-up basins.

A flower of related appearance, whose long leaves are not quite as calligraphic as those of the epidendrum, is the narcissus. Native to Fujian province on China's south-eastern coast, the *Narcissus tazetta* is a favourite winter house-plant throughout China. Grown in elegant, flattish ceramic bowls filled with pebbles and constantly renewed water, the slender leaves and stems topped with a cluster of small, strongly scented flowers, it brightens window-sills and perfumes rooms in winter. A painting of a narcissus 'after Zhu Da' in the British Museum epitomises the barest ink monochrome style. The leaves are sketched with the absolute minimum number of rough, strong strokes, the flower-heads almost scratched on the paper. The positioning of the flower is equally free. Zhu Da (1626–1705) was a reclusive painter, a descendant of the ruling house of the Ming dynasty who was forced into seclusion when the Manchus overthrew the Ming in 1644. His best-known paintings, well represented (though, owing to their rarity and the general fragility of Chinese paintings, rarely exhibited) in the Shanghai Museum, are of fish beneath rocks or brooding birds with rather wildly rolling eyes, painted in the same rough, minimal style of surprising modernity.

The chrysanthemum, whose subtle colours are so much part of the flower, was painted both in monochrome and in colour, perhaps more successfully in the latter form. One of the forms which did lend itself to monochrome ink depiction was the 'spider' chrysanthemum with its long narrow curled petals. An album leaf by Tani Bunchō (1817) in the British Museum combines the dry spiky strokes of the flower with leaves painted with a dark, ink-loaded brush. His brief calligraphic inscription also manages to combined the two different strokes, dark and wet, thin and dry, unifying the painting.

Other, less calligraphic plants were also successfully depicted by Japanese artists. An early nineteenth-century handscroll by Matsumura Keibun which includes a magnolia shows his masterly sense of placing: a long narrow stem with soft buds stretches out across the paper, with an open flower in the bottom left corner. The petals of the open flower are depicted with fine strokes, whilst the stem and buds are softer and mistily depicted with a wet brush. The same very wet brush is used most successfully in a hanging scroll of a grape-vine by Tenryū Dōjin (1718–1810), also in the British Museum, where the leaves and grapes are softly washed. The ribbing of the leaves is

119

indicated by darker veining which runs into the ground wash, and the bloom of the grapes is also achieved by the same combination of dark and light washes. The style is used by artists still working in Sichuan province in China who, though using colour, depict grapes in the same wet washes.

The Japanese favoured the use of very wet washes in flower paintings in both monochrome and colour. The technique known as *tarashikomi*, where wet colours were used together, running into one another, was also used in monochrome, as in Tenryū Dōjin's grape-vine: a wet, light wash was immediately overpainted in a darker tone so that edges were blurred. This wet blurring effect was used on screens by the Kanō school from the sixteenth century and in the seventeenth century by the school of Sōtatsu, and marked a development away from the dry calligraphic styles of some Chinese schools, being most suited to the depiction of 'non-calligraphic' plants with broad, dark leaves and soft outlines.

Much has been written about the distinction between monochrome ink painting and painting with colour – the former elevated and esteemed as the art of the scholar-official, the latter a despised courtly form, appreciated by those who lacked imagination. In Japan, however, the coloured style always retained its prestige as the vehicle for the narrative handscroll form, which is one of the glories of that country's art. Tradition also has it that while coloured painting was a commodity to be bought and sold, monochrome ink painting and calligraphy were exchanged between cultivated friends. However, the fact that records of prices exist (in the early Ming period at least) shows that this distinction is inaccurate. It is also clear that from the Ming period, in particular, the borderline was blurred, with light colour washes being used on essentially mono-chrome ink paintings – a mixing of styles that was to be continually developed and which is still to be seen today.

It was during the Song period that the two styles of monochrome ink and colour painting were most clearly distinguished. Colour had apparently been widely used in the preceding Tang period (618–907), and though few examples on paper or silk have survived (with the exception of the Buddhist paintings of Dunhuang, already mentioned), a landscape style which used cobalt blue and copper green (known as 'blue and green') was later associated with the Tang. The use of flowers as a subject was most marked in the Song, when 'bird and flower' painting first flourished. The Song style of

119 Narcissus. Painting in ink on paper after Zhu Da (1626–1705). China.

detailed representation of birds and flowers, involving colour and creating a more naturalistic effect than the monochrome ink scrolls, had a long influence and also affected later textile and ceramic decoration. It coexisted with the monochrome ink style for many centuries, though, as already mentioned, there was an increasing tendency to combine the two from the Ming period onwards.

The beginning of Chinese bird and flower painting was associated with the establishment of an Imperial Academy of painters, which had its roots in the Tang dynasty. The imperial household with its fabulous wealth was naturally a major patron of the arts: recent excavations in the vicinity of the Tang capital Chang'an (today's Xi'an) have revealed a wealth of treasures donated by the imperial house to the Famen temple in the ninth century. Imperial tombs were filled with treasures, their doors carved, their walls painted with scenes of hunting, polo-playing and courtly processions. Literary accounts describe how painters at the Imperial Academy were skilled in the depiction of birds or animals. One scroll, said to be the work of Han Huang (723–87), is occasionally displayed in the Palace Museum in Peking in the autumn exhibition of early paintings from the old imperial collection.

In the period between the fall of the Tang and the beginning of the Song, when China was broken up into various separate states, imperial academies persisted, though on a smaller scale. Nothing survives of the work of a number of artists who were described as producing coloured flower paintings in two major styles: ink outline with brilliantly coloured infills, or soft washes of ink and colour. These techniques were continued in the work of the artists appointed to the imperial court of the Song, and some of the greatest bird and flower paintings have traditionally been associated with the reign of the Huizong emperor (1101–26). Huizong founded a school of painting which soon came under the direction of the Hanlin Academy. This academy (whose name in translation is often given as the 'forest of pens') had its roots in the eighth century and evolved to become an imperial academy of the most outstanding graduates, who performed academic services for the court such as compiling the official history or producing commentaries on the classics. The emperor himself set competitions for his painters, as if he were setting examinations for classical scholars, suggesting a line from a poem for illustration. He was known to be a competent painter himself, though it is unlikely that many of the surviving paintings

120 Tani Bunchō (1763–1840): Hibiscus. Album painting in ink and pigment. Japan. 1796.

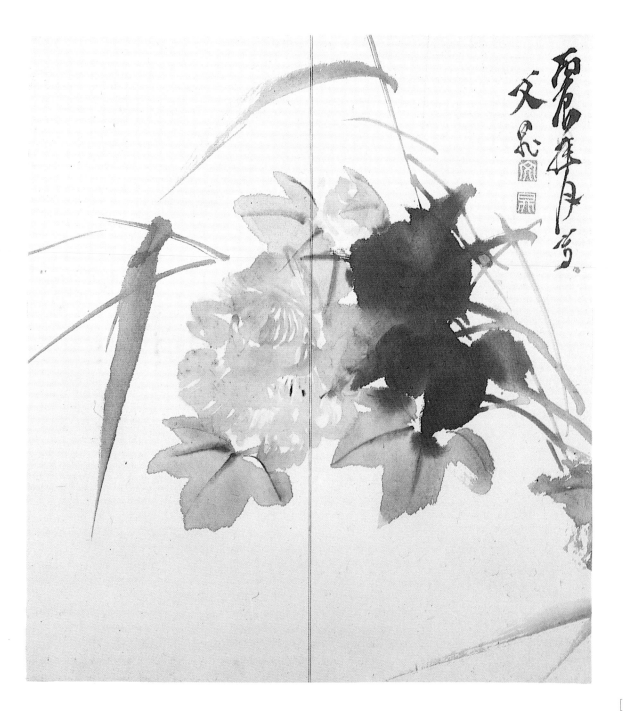

[151]

attributed to him were his own works: and in later periods such an attribution, where credible, would add to the value of a painting. Similarly, a later ruler, the Qianlong emperor (1736–96), who prided himself on his cultural achievements, had 42,000 poems attributed to him. Had he written them all, he would have been the most prolific poet in Chinese (not to say world) history and have had little time for the administration of empire. Nevertheless, it is known that the Huizong emperor had more than 2,700 bird and flower paintings in his own collection.

One of the most charming examples of bird and flower paintings in the British Museum was attributed to the Huizong emperor but in fact dates from a later period. A long handscroll painted on yellow silk, it depicts green-breasted, white-throated birds singing amongst flowering gardenia and lychee branches laden with red fruits. Some gardenias do flower as late as July so the combination is just possible, and as a composition it is a convincing and successful example of the type. The loving detail with which the little birds are painted, their beaks open in song, is delightful, as are the flowers, stems and fruit, painted in a detailed and naturalistic style. The larger, glossy leaves of the white-blossomed gardenia are varied, their paler undersides often visible, some beginning to yellow and spot along the edges before they fall. The fat red lychee fruits with their rough skin and slight furrowing would do credit to a European botanical work. The birds' colouring, the fading of the breast feathers from a rich green to a paler tone on the lower part, their scaly legs and claws, the patterning of the neatly folded wings, each feather tipped with black, are equally graphic, but it is the composition, the movement as the handscroll is gradually unrolled, that lifts the painting above mere scientific recording. The technique used, whereby the subjects are drawn in outline and the colours filled in, is said to have been 'invented' by Huang Quan of the ninth century and was described, quite appropriately, by a Song critic as 'sketching from life'. In its richness this painting anticipates another medium in which birds and flowers were long to flourish as subject matter: embroidery.

Partly because the Huizong emperor was more concerned with painting than military affairs, the Song dynasty was gradually extinguished as a result of a series of invasions by northern peoples, culminating in the Mongol domination of China. The Mongols took the name Yuan ('beginning') for their dynasty, which lasted from 1279 to 1368, and, despite the fact that many painters, in particular,

121

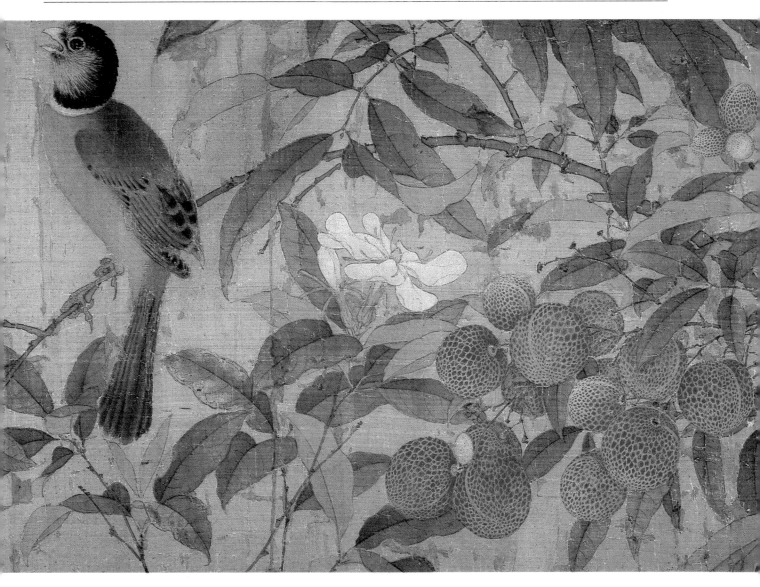

found their loyalties divided and refused to work for the alien court, the Yuan was a period of considerable innovation. The work of Qian Xuan (1235–1301), a scholar who never took office, stands out for its softer style, often without the carefully drawn 'bones' or outlines

121 Attributed to Emperor Huizong (r. 1101–26): Birds, lychees and gardenias. Handscroll in ink and colours on silk. China, probably Ming dynasty (1368–1644).

seen in the work of Huang Quan or the paintings attributed to the Huizong emperor.

The bird and flower paintings of the Song were a major source of inspiration for the Japanese Tosa school, which painted for the imperial family from the fifteenth to the nineteenth centuries. Sometimes they used dark silk (to suggest that the painting was ancient), and their subjects included tranquil hanging scrolls of birds and flowers (the bird frequently a fat quail) in the outline style. A hanging scroll in the British Museum by Tosa Mitsuoki (1617–91), leader of the Tosa school, shows two quail, one standing on a rock, the other hiding in a clump of small chrysanthemum and grasses. 122 Though the rock is painted in a soft, non-outline style, the birds and plants are carefully outlined.

At the same time, individual Chinese artists, not working for imperial patrons, were beginning to abolish the strict dividing lines between monochrome and coloured ink-wash paintings. One of the most influential, particularly in Japan, was Chen Shun (1483–1544). That he was master of the monochrome floral handscroll is obvious from an example in the British Museum depicting mixed flowers and bamboo, in which his bamboo has broader single-stroke leaves and Michaelmas daisies are calligraphically sharp, while narcissus flowers are more softly outlined. A copy by the Japanese artist Tsubaki Chinzan (1801–54) of another handscroll by Chen Shun has tiger-lilies painted in a non-outlined colour wash, their stamens delicately picked out. Even the dragonflies beside the lilies have been painted in a light wash, as has the mossy rock in the background. Chinzan's own album painting of a blue tree peony and crab apple, also in the British Museum, combines boned and boneless styles: the peony's rather unusually coloured petals are rendered in broad brush-strokes shading from white to blue.

Chen Hongshou (1599–1652), an eccentric artist known for his often archaic style and for his figure painting, combined the more important art of calligraphy with a form of flower painting that was to grow in popularity in China: paintings of flowers in vases or assemblages of objects including vases of flowers. A copy in the British Museum of a hanging scroll by Chen Hongshou includes a 123 glass vase of chrysanthemum and brightly-coloured autumn leaves beside a smaller ceramic vase with chrysanthemum and roses, set beside a long calligraphic inscription. The gnarled and knotted stems are clearly visible through the glass, and the leaves themselves,

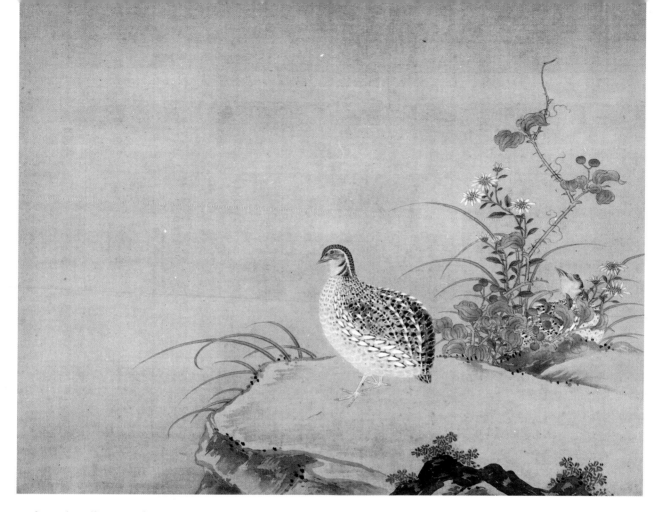

122 Quail, rock and autumn plants. Detail
from a hanging scroll by Tosa Mitsuoki
(1617–91). Japan.

perhaps in tribute to the insect-eaten leaves of many Song bird and
flower paintings, are curled and pitted with caterpillar bites.

The linking of monochrome ink styles and content with the
hitherto despised colour continued to flourish in China, and in the
late nineteenth and early twentieth century came to dominate. The
work of Qi Baishi (1863–1957), which combines a strong sense of
calligraphic balance with the well-judged use of colour, often
includes floral subjects: tea-flowers, wistaria, grapes and vine or
lotus. He also continued the type of grouping seen in Chen Hong-
shou's scroll: one of his paintings combines brushes, an ink-slab, a
teapot-shaped water-dropper and a simple glass with two epiden-
drum blooms; another has a jar of wine, a basket of ripe persimmons
and a basket of flowers. In all of these, strong dashes of colour are
combined with his immensely solid and sure black brushwork.

123 After Chen Hongshou (1599–1652): *Chrysanthemum × morifolium* and Joseph's coat (*Amaranthus tricolor*). Detail from a hanging scroll in ink and colours on silk. China, 1635.

In Japan, colour paintings of flowers took a rather different route from that of their Chinese predecessors, as Japanese society itself was never in the Chinese mould. A major vehicle for decorative floral painting was the screen, an integral part of the Japanese house. Sliding screens of paper stretched over a wooden frame were used to divide living spaces, and free-standing folding screens were used in the same way. The Japanese habit, developed particularly from the ninth century, of sitting on the floor meant that these great areas of movable wall presented decorative potential which, particularly from the sixteenth century, was seized upon. On gold- and silver-leaf backgrounds, artists of the official Kanō school painted bold blossoms in thickly laid colours. The school of Tawaraya Sōtatsu in the seventeenth century continued and developed the tradition. A pair of screens in the British Museum by Nakamura Hōchū (*fl.* 1795–1817) depicting the flowers of the four seasons on gold illustrates the richness of screen paintings. Aubergines, gourds with their vine-like leaves and curling tendrils, brilliant red poppies, bulrushes and grasses, long dangling seed-pods and huge taro leaves combine with smaller border plants, all 'growing' from the textured gold background. There are examples of the work of one well-known screen painter, Watanabe Shikō (1683–1755) in the Ashmolean Museum in Oxford, and whilst he, like Hōchū, makes no attempt to suggest earth or ground for his plants, they are beautifully observed and convincing: indeed a sketchbook of Shikō's survives, in which his drawings from nature can still be seen.

Shikō was a forerunner of the Maruyama-Shijō school (late eighteenth to early nineteenth century), whose artists frequently painted 'ordinary' flowers such as persimmon, flowering cherry, wistaria, willow, maple and wild rose, rather than the conventional 'three friends', and whose concern, like that of the Chinese Song dynasty bird and flower painters, was to reproduce the colours and forms of nature as well as the 'essence' of the plant depicted. In rare examples, the paintings involve no black or grey ink at all, only colours. Like Shikō, many of the Maruyama-Shijō artists worked from nature to produce both accurate and graphically very pleasing flower paintings, like Kyōho's album leaf of a gourd in the British Museum. Whilst the strong, confident ink and colour paintings of Qi Baishi represent the twentieth-century culmination of the Chinese flower-painting tradition, in Japan, the Nihonga school (meaning 'Japanese paintings') which since 1880 has resisted the influence of

124 Flowering ginkgo and rocks.
Woodblock print from the *Ten Bamboo
Studio Manual of Calligraphy and Painting*.
China, 1622–33.

western techniques, uses gentler, more delicate methods to depict a wide range of subjects, including floral scenes.

Woodblock printing, which reached maturity in China by the middle of the ninth century, was closely associated with the regular-style calligraphy of written texts, but in a later development also became associated with flower painting. From the beginning, woodblock printing facilitated the combination of text and illustrations, either on separate blocks or carved on the same block. As the blocks were cut directly from handwritten (or hand-drawn) originals on very fine paper which was pasted face-down on the block and cut through, the reproduction was absolutely faithful to the original. The first evidence of colour printing in illustration is found in a twelfth-century fragment, but the major development of the technique came in the late sixteenth and early seventeenth century. The albums of the *Ten Bamboo Studio Manual of Painting and Calligraphy*, printed between 1622 and 1633, were named after a house in Nanjing where the scholar-painter friends of Hu Zhengyan, an amateur painter, calligrapher and seal-carver, used to gather. They include a wide variety of floral subjects treated in a variety of painterly styles and printed from a number of blocks, separate blocks being used for each colour. The printing was a craft operation, for some shaded colours such as the pink fading to white in a plum blossom or the yellow fading to white of a ginkgo fruit, were brushed, with all their gradations, onto the blocks. The prints were both decorative and instructive, intended partly for use as copybooks for amateur painters. Yet each was a finished image, usually completed with brief calligraphic inscription and red seal. 124

A more strictly didactic version was produced by the painter Wang Gai in 1679 with two later supplements. His colour prints from the *Mustard Seed Garden Manual*, also produced in Nanjing, took the amateur painter through the stages of construction of a painting, with different types of bamboo, plum-blossom or rocks to copy and master, before achieving a complete painting. Whilst the *Ten Bamboo Studio Manual* was largely restricted to bird and flower groupings (though it included small landscape scenes), the *Mustard Seed Garden Manual* included more landscape scenes and was more consistent in the addition of inscription and seal. It was the *Mustard Seed Garden Manual* that had the strongest effect in Japan after the repeal in 1720 of an edict forbidding the import of foreign books to the country.

125 Plum blossom, from the Japanese stencil-printed book *Saishiki Gasen* by Sekkōsai, 1767.

As the separate registration of different colours was difficult to achieve, some early Japanese printers used stencils rather than separate woodblocks, as in Sekkōsai's *Saishiki Gasen*, 1767, where the simple depiction of plum blossom and the placing of the design on the page seems as strikingly modern as Zhu Da's *Narcissus*. The renowned print artist Utamaro (1753–1806) designed a book containing floral prints, *Ehon Mushi Erabi* (1787), where the colour registration is perfectly controlled by the then widespread use of the *kentō*. *Kentō* were two raised marks on the first outline printing block, copied exactly onto each succeeding colour block. The use of the *kentō* was part of the massive development of multi-colour printing in Japan in the mid-eighteenth century, best known through the Ukiyoe prints of actors, courtesans and the entertainment quarters of Japan's cities.

Though ony one of the great Ukiyoe artists, Hokusai (1760–1849), devoted time to the production of floral prints, it was in Japan, rather than its country of origin, China, that colour printing was developed to the most exquisite degree. In both China and Japan, despite an early interest in herbal medicine and very early compilations of illustrated pharmacopoeia (the first printed herbal in China was produced in 1108), the illustrations to the herbals were usually not very useful – symbolic rather than botanically accurate – though the accompanying texts were precise. One late botanical work

126 Aspidistra, liriope and other plants, from the Japanese woodblock-printed botanical work. *Sōmoku Kinyōshū* (1829) by Ōoka Umpō (1765–1848) and Sekine Untei (1803–77). British Library.

produced in Japan in 1829, *Sōmoku Kinyōshū*, is an exception, for the illustrations are accurate, beautifully placed on the page and combined with textual information in a variety of written styles, creating an extremely attractive, yet botanically valid whole. 126

The earliest ceramics and the artefacts of the Bronze Age in China and Japan are bare of floral designs. Animal forms were turned into geometric patterns on the earliest decorated Neolithic pottery, and Chinese bronzes were similarly decorated with animal and geometric or geometric animal forms. Flowering trees and trees as a part of landscapes behind hunting scenes appear first on the stamped clay bricks that lined tombs of the Han dynasty (206 BC–AD 220). Landscapes and floral scrolling, as well as various lotus designs, played an important part in Buddhist iconography and can be seen in the great Buddhist cave-temple complexes in China which were constructed from the third century AD. It was, however, during the Tang dynasty that floral designs began to spread over silver, gold, silks, ceramics and any other available surface. The early eighth-century tomb of the princess Yongtai contains a stone sarcophagus incised with designs of young women strolling amongst tall flowering plants, the whole framed by floral scrolling. Tang silver, often 127 embellished with chased and gilt decoration, frequently bears floral scroll designs. Bronze mirrors were inlaid with mother-of-pearl

flowers and birds set in coloured lacquer or cast with designs of floral scrolls or grapes and vine leaves. Near Eastern designs influenced Chinese decoration and can also be seen in Japan, for instance in the intricate floral scrolling on the silver scabbards on two eighth-century knives in the Shosoin Museum in Nara. Tang ceramics, particularly the mainly funerary *san cai* (three-colour) ware, bore stamped floral designs. All of these were stylised flowers and rarely identifiable, though the lotus gave form to a number of grey-green glazed stoneware bowls and was carved on the sides of stoneware jars from the kilns of the south. Rare finds of silks, usually buried in the dry sand of the Gobi Desert, reveal embroidered and woven floral designs, again of unidentifiable flowers.

During the Song, a period generally praised for restraint in decoration, stylised floral ornament was frequently found on ceramics, but in most cases it was incised beneath the monochrome glaze, forming a light and unobtrusive low-relief pattern that did not detract from the form of the vessel and the colour of the glaze,

127 Silver comb with a bird and flower design, derived from Tang dynasty motifs. China, 10th century.

128 Silver-gilt belt buckle plaque decorated with fruit on a climbing plant. China, 13th to 14th century.

129 (*opposite*) Japanese cabinet, made in a European shape, lacquered and inlaid with mother-of-pearl in a variety of floral forms, *c.* 1625–50.

generally the two most striking aspects of Song ceramics. In the stonewares grouped under the name Cizhou, decorated with *sgraffito* designs cutting through the white slip to the grey body beneath or painted in dark colours on a pale slip, bold all-over floral designs are commonly found, sometimes tentatively identifiable as peony. Scenes from operas and popular stories painted in black and brown on white-slipped Cizhou pillows often feature garden scenes or landscapes with trees, bamboo, banana and flowering shrubs. Cizhou wares with their bright painted designs are sometimes considered to be the heralds of a new form of ceramic decoration that was to gain immense popularity, not only in China but throughout the Near East and eventually the West, underglaze blue or 'blue and white'. The technique of painting designs in cobalt on the unfired porcelain body was developed in China during the Yuan, when it may have been inspired by Near Eastern use of cobalt on earthenware, and flourished during the Ming and the Qing. The decoration of early blue and white vessels often includes a scene of peonies, lotuses with fish and water-weeds or birds on flowering prunus branches painted in the centre of great dishes or the curved sides of vases, with bands of floral scrolling. These scrolls recall the earlier Western-inspired acanthus, half-palmette and lotus scrolls seen at

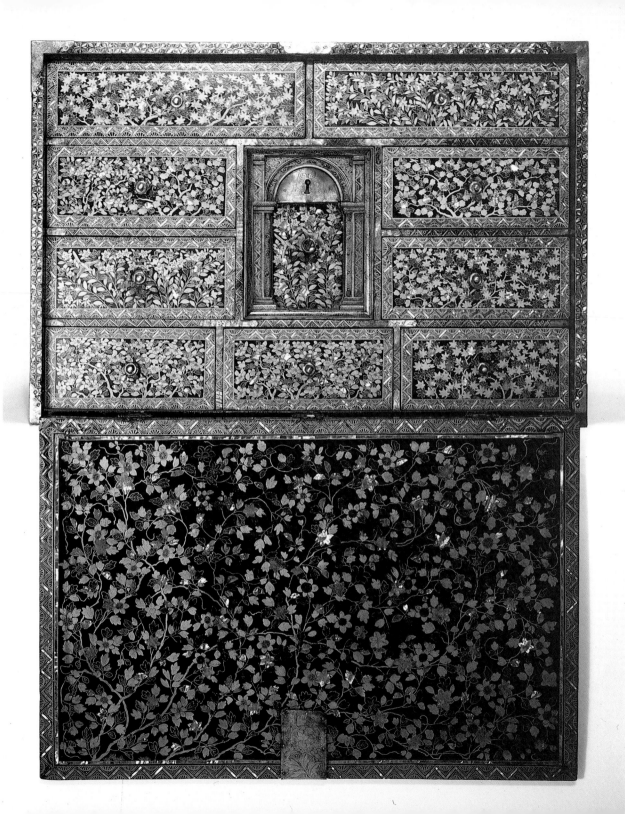

130 Peony in *kesi* woven silk, used for the handscroll *The Admonitions of the Instructions to Court Ladies*. Copy after Gu Kaizhi (344–405?). China, probably mid-19th century.

Yungang; the central flowers are, however, more accurately depicted.

As the techniques of decoration of blue and white porcelain were perfected in the Yuan and Ming, the taste for more lavish decoration in general became apparent. Earlier Song lacquer vessels were usually monochrome dishes with a suggestion of lobing at the rim, though some examples were painted in gold and silver or had mother-of-pearl inlays, usually of a floral spray. Yuan vessels, however, made greater use of intricate mother-of-pearl inlays in multi-layered red lacquer; lacquer of the Ming, usually multi-layered and red in colour, was carved with designs of camellias, soft-petalled peonies, lychees or garden scenes with pools, pavilions, rocks, banana, pine, wistaria and bamboo.

The decoration of lacquer reached a peak of perfection in Japan, rather than China. Red carved lacquer dominated in China and was used in Japan to make, among other things, small *inro* seal-cases with carved chrysanthemums and peonies, but Japanese lacquer artists were above all masters of painted or inlay decoration. Mother-of-pearl inlays were used on the small *inro* boxes, and the larger area

offered by chests was used for the depiction of a variety of floral
129 forms, from closely observed wistaria on a chest in the British
Museum to more stylised floral scrolling with end panels of long-
tailed birds amongst flowers on an eighteenth-century chest in the
Victoria and Albert Museum. The greatest achievements of the
lacquer artists of Japan was the *maki-e* or 'sprinkled picture'
technique, where gold and silver powders were sprinkled onto the
wet lacquer surface to form an element of the decoration. Painted
lacquer vessels, often embellished with gold or silver, bore a vast
variety of designs which included flowers, garden and landscape
scenes.

As fabrics are perishable, the great majority of Chinese textiles
that survive date from the Qing, although occasional excavations,
such as those where Tang textiles have been recovered from the dry
desert or, indeed, later tombs where conditions were favourable,
have preserved a small number of earlier examples. Silks with woven
floral designs were commonly used for garments during the Song and
131 Ming, but by the Qing, when we have far more examples, a great
variety of weaving, dyeing and embroidery techniques were used.
Many embroidered fabric panels reflect the 'bird and flower' designs
found in paintings from the Song to the Qing: an early Qing woman's
robe in the Victoria and Albert Museum is made of bright red silk
embroidered with cranes and phoenix, chrysanthemum, peonies,
roses and plum blossom, and separate embroidered bands at the
wrist incorporate peonies and fish. Another nineteenth-century robe
combines the Buddhist lotus quite realistically depicted with the
traditional 'double happiness' character in silk tapestry (or *kesi*).
Black silk velvet is cut in the form of slender-leaved epidendrum
flowers, and pomegranates (symbols of fertility) and peaches (sym-
bols of longevity) are also found. Poor women wore clothes made of
indigo-printed cloth with wax-resist patterns in white against blue:
the patterns included the same range of flowers found on grander
embroidery and tapestry.

Japanese textiles, particularly those intended for clothing, were
conceived on a grander scale. Viewed as decorative items in their own
right, they were sometimes hung on lacquer stands to form room
dividers, the equivalent of the gloriously painted sliding screen. It
was from the sixteenth century onwards, as Chinese imports declined
in the face of the thriving local industry, that the most stunning
designs were produced. Kimonos, conceived as flat, T-shaped forms,

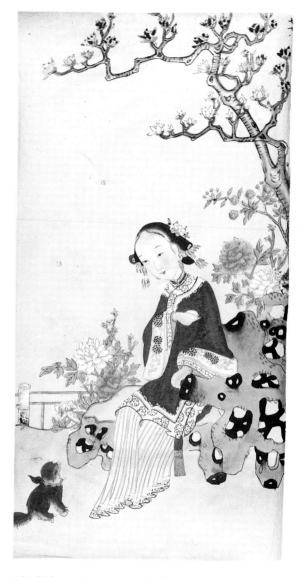

131 Girl wearing a gown with floral
embroidery, in a garden with peonies and
plum blossom. Woodcut in ink and colours
on paper, China, 19th century.

were embroidered, appliquéd, woven, painted or dyed, or decorated in a combination of techniques. The garments were frequently embellished with diagonal designs of wistaria, peonies and chrysanthemum or birds in various settings. As in China, dyed cotton was used by poorer people, but in contrast with the restrained, overall floral scrolling of the Chinese indigo-dyed fabrics, the Japanese took a bolder view, using a broader range of colours and treating the surface of the garment as a whole.

Japanese ceramics from the seventeenth century were strongly influenced by Chinese and Korean techniques and styles. Porcelain wares from Arita were decorated with underglaze blue and overglaze enamels in a very restricted palette of mainly red with blue, and frequently used stylised floral designs with rocks. Botanical realism was not aimed for and would have been difficult with the limited colours used. The Nabeshima kiln (founded in 1628) occasionally produced designs that were closer to the brilliant sense of placing found in other aspects of Japanese art. A nineteenth-century plate has rows of flowering buckwheat placed centrally and towards the outer rim – an unusual subject, imaginatively placed.

Chinese ceramics of the Qing dynasty were also decorated with a wide range of realistically depicted flowers, made possible by the use of overglaze enamels. Painted on porcelain vessels that had already been fired at a high temperature, the enamels were available in a wide range of colours. After the centuries of popularity of blue and white, the jewel-like, multi-coloured vessels made a tremendous impact. Bird and flower subjects were popular: an eighteenth-century dish in the Percival David Foundation (University of London) has a small, brightly-coloured singing bird on a magnolia branch with a rose beneath. Quails and chrysanthemum; plum blossom and rocks; hens, chicks, bamboos and *lingzhi* fungus (supposed to convey longevity); combinations of the 'three friends of winter' with the peach of longevity – all these can be found on enamelled porcelain of the Qing, depicted in exactly the same style as bird and flower painting.

132

132 Chinese porcelain vase decorated with a branch of peaches and peach blossom, symbolising longevity. Qianlong period, mid-18th century.

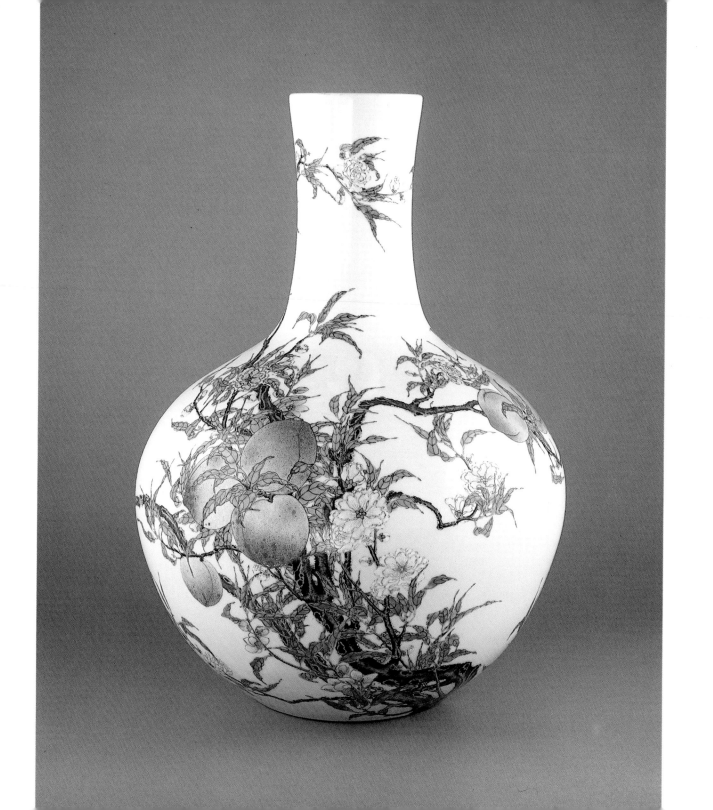

India and
the Near East

I n many areas of decoration, the Near East and South East Asian cultures frequently reveal a far more lavish use of floral motifs than is seen in the Far East. Except in the early Buddhist cave temples, floral motifs are virtually absent from the exterior of Far Eastern architecture, for example, whilst floral and calligraphic scrolling on blue and white tiles covers the Safavid architecture of Isfahan and floral inlays decorate the Taj Mahal and other Mughal buildings in India. Carpets and other textiles are richly covered with flowers, as are furniture and boxes, bookbindings and metalwork. Indian, Persian and Turkish art combine in themes during the Islamic period and draw strongly on Chinese motifs, which were most freely available during the period of Mongol and subsequent Mughal rule. The Mughals who ruled India from the sixteenth to eighteenth centuries were descendants of the Mongols who, a few hundred years before, had controlled Asia from west to east, including China and Persia, creating conditions for art motifs and designs to move freely from Persia to China and back. For instance, the use of Chinese motifs on Ottoman art of the sixteenth century is apparent in large Iznik ware dishes with versions of the lotus or peony scroll at the rim and in the centre. Some examples follow the Chinese prototype closely, while others transform the original by adding extra colours and subtly altering the central scroll design into a flowering plant growing from a leafy base. Individual motifs of Far Eastern origin were sometimes incorporated into local styles, like the flowering prunus that can be found in Deccani painting in India in the late sixteenth and early seventeenth centuries.

In India, the use of flowers in decoration has a history spanning over 5,000 years. Asymmetrical flowering tree-forms were inlaid in

133

133 The Mughal emperor Babur in a garden. India, c. 1610.

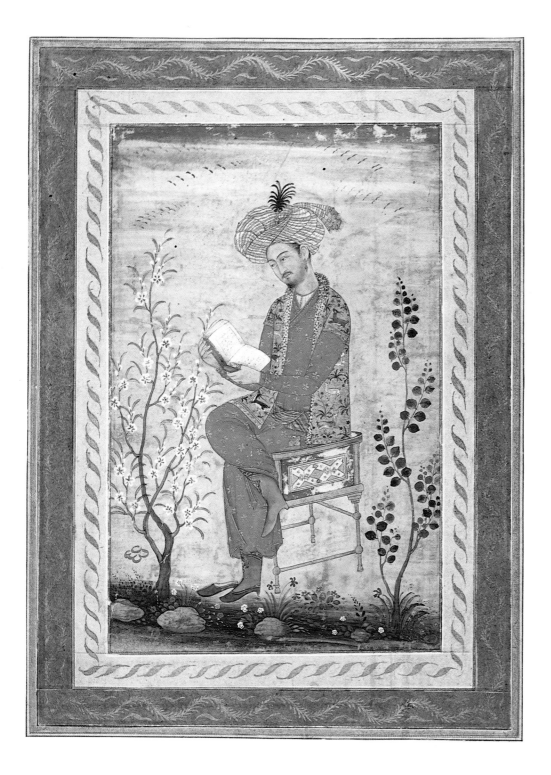

[169]

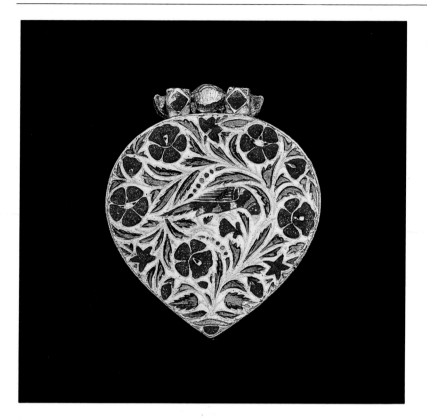

135 Enamelled gold pendant with a parrot amongst flowers. Mughal India, 17th century.

ivory and tortoiseshell on articles of furniture made from sandal-wood; enamelled metal *huqqas* and *pan* sets were covered in filigree floral scrolling; flower scrolls appear on the chased and inlaid handles of Mughal weapons, and leather shields were painted in white, green and gold with floral stems reminiscent of the inlays on the Taj Mahal. Textiles were particularly rich in floral designs: on chintzes, acanthus borders enclosed vases of flowers similar to those on Turkish tile-panels of the sixteenth and seventeenth centuries; woven silks and wools and embroidered velvet shoes were covered with floral designs, as were elephant saddle-cloths in velvet with silver and gold wire embroidery. Even small ivory combs from Sri Lanka were embellished with a central depiction of Hindu deities framed in a floral border.

The earliest floral designs in South Asia are found on ceramics and small steatite seals of the early Indus Valley civilisation. These were

134 (*opposite*) Green glass *huqqa* base, with gilded decoration of poppies. Mughal India, *c.* 1700.

136 Ivory casket decorated with floral
scrollwork. Sri Lanka, *c.* 1700.

decorated with simple floral shapes and stylised trees and leaves.
Earthenware jars of the Harappan culture (*c.* 3000–2000 BC) have
on their sides daisy-like flowers with a dot in the centre surrounded
by leaf-shapes painted in black and red slip, and scenes including
water birds, water plants and stylised trees at the neck. On seals, jars
and small ceramic figures, recognisable plants include the trefoil and
the pipal tree, a tree with sacred connotations from the earliest times
whose significance was to persist in Hindu and Buddhist mythology.
It was recognised as sacred by Chinese Buddhists as late as the
nineteenth century, when pipal leaf skeletons were used for small
paintings of Bodhisattvas and Lohans. Hinduism, the main religious
force in India and South-East Asia before the spread of Buddhism,
had a strong rapport with the natural world. Part of its origins lay in
the earlier Vedic religion of the second millennium BC, whose great
hymns extolled the harmony of the natural world. In the Vedic
system of belief animals personified gods, and plants were also
sacred. Many of the gods of Hinduism appear in images with floral

emblems. Surya, the sun god, one of the old Vedic deities, holds two open lotus flowers; Lakshmi, the consort of Vishnu and goddess of beauty and good fortune, is often portrayed carrying lotus blossoms, and Lajja Gavri's head takes the form of a blossoming lotus. The importance of the lotus persisted in Buddhism, which arose in India in the sixth century BC. Perhaps the most important Buddhist deity in the popular imagination is Avalokitesvara, the Bodhisattva of Mercy, who is also named Padmapani or 'he who carries the lotus' and is usually thus depicted.

Apart from emblematic plants, others are specifically used in the worship of certain deities. The *bilva* or crab-apple leaf is used in the worship of Shiva, the Hindu guardian of the abundance of the earth. Vishnu, like Shiva a composite deity whose origins lie in a number of different gods from varying sources, including Dravidian and Aryan beliefs, is the Hindu 'lord of life', and the *tulsi*, or basil, is used in his worship, especially in his form as Rama. Plantain leaves lashed to buildings, especially temporary shrines, indicate their sacred nature, and brilliant flower garlands of all sorts, from orchids to marigolds, are used in worship.

Lush vegetation with flowering trees and curling creepers symbolises fertility and is often seen in Hindu iconography. Curling leaves issue from the mouths of *makara*, aquatic beasts who represent the unmanifested state of the cosmos and which are found at the base of statues; *yakshas*, 'vegetal' spirits of fertility depicted as women, often embrace a tree. One kick from their feet could make a tree bloom, so the trees that they clasp are often shown bursting into flower.

The lotus, associated with many Hindu deities, became the paramount floral image in Buddhist art, but many Buddhist icons also reflect the garden or natural settings of many of the legends. Queen Maya, the mother of the Buddha, gave birth in the Lumbini garden. In birth scenes she stands clasping a flowering tree as the child emerges painlessly from her side. The Buddha achieved enlightenment under a Bodhi tree at Bodh Gaya, and throughout India and South-East Asia the depiction of the Bodhi tree alone is enough to symbolise the enlightenment. The first sermon was preached at Sarnath, near Benares, in the Deer Garden.

These scenes are depicted in Gandharan sculptures of the second and third centuries AD, which show the strong Hellenistic influence which was to affect later Buddhist art, especially in China. In a frieze

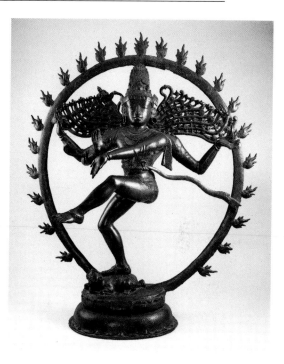

137 Bronze figure of Shiva Nataraja (Lord of the Dance), on a lotus base. South India, *c.* 1100.

from Gandhara, one of many in the British Museum, Queen Maya is depicted giving birth beside a curved tree whose outer branches enclose leaves and flowers, and in a scene of the first sermon, pipal leaves surround the Buddha's head in a rustic halo with a classical leaf frieze above. Another frieze shows the first sermon in a similarly leafy setting, with branches making a canopy over the figure of the Buddha, beneath whose throne two deer sit beside the wheel of the law.

The Graeco-Persian influence so evident in the scenes from the life of the Buddha at Gandhara is also evident in the slightly later stupa at Sanchi (first century BC), where architectural elements (including a bracket in the British Museum collection) are richly covered with low-relief carvings incorporating a variety of flowering lotus medallions, creepers and acanthus scrolls. On the gate, square sections are filled with pots of flowers, some resembling the thickly curled heads of French marigolds, and narrower panels enclose long acanthus leaves. Very similar floral motifs, including massive lotus medallions, are found on carvings from the stupas at Amaravati in the Deccan (third century AD). Drum slabs in the British Museum include 138 undulating floral garlands in the upper register and lotus medallions near the base, filling the background behind figures bearing offerings to the Buddha. Above them is a band of crowded scenes, divided by rows of smaller lotus medallions. Later figures in the Gandharan style include painted terracotta Bodhisattvas, similar to contemporary figures found in China and Japan, adorned with jewelled necklaces in floral forms and wearing head-dresses of leaves and flowers amongst their curled locks. Ceilings at the Ajanta caves of the late Gupta period (late fifth century) are decorated with panels, some painted with frisky elephants among lotus flowers, others with sprays of stylised flowers and fruit, whilst, on the walls below, Bodhisattvas with flowery head-dresses stand in palm groves clasping lotus flowers. Thrones and bases decorated with lotus petals were almost invariably found supporting images of the Buddha and Bodhisattvas, whether in stone or metal. However, this was not restricted to Buddhist images; many bronze Hindu icons of Shiva and other 137 deities are shown seated or standing on scalloped lotus petal bases.

Tibetan Buddhist art shows a mixture of influences from Nepal, Central Asia and China. The influence of Chinese landscape painting is seen in a fourteenth-century painting on cloth of the *arhat* Kanakavatsa, in the British Museum. The bearded sage sits in a

138 Stupa drum slab showing a railing with lotus medallions and a stupa with floral garlands. From Amaravati. 3rd century.

mountainous landscape, a twisted pine-tree filling much of the background. His clothes and those of his attendants, covered with tiny flowers, are suggestive of Chinese brocade, and in fact a variety of Chinese brocade cloths were used to mount Tibetan paintings. An eighteenth-century painting of Samvara, for example (British Library), where the deity stands in a landscape of water, pines, willows and bright flowers, is bordered by two strips of figured silk and a brocade with red and white peonies and pink prunus branches on a dark blue ground.

The vast number of Buddha images in human form that survive today appeared much later than the beginnings of Buddhism and the

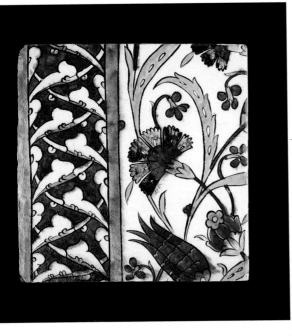

139 Tile decorated with dianthus, tulip and other flowers. Syria, 17th century.

worship of stupas. In the early years of Buddhism, the Buddha himself was represented by symbols, such as the wheel of the law. The form of Buddhism that persisted in South and South-East Asia continued the symbolic tradition, though images in human form became gradually more common. The use of the wheel or the Bodhi tree to represent the Buddha and his enlightenment was frequent, as was the depiction of his footprint, strewn with flowers.

In Islam, whilst the Koran did not specifically forbid the depiction of animate objects, the later 'Traditions of the Prophet' contained condemnations of those who fashion likenesses of living things, as if trying to emulate God himself. It was said they would be called upon to 'breathe life' into their two-dimensional creations on the day of judgement and, in failing, were doomed to Hell. The prohibition on the depiction of living things was strongest in relation to people and animals. Holy buildings were therefore decorated with mainly geometric designs, often incorporating stylised calligraphy, although the domes of many of the mosques in Isfahan in Persia have floral arabesques on their polychrome tilework, while Turkish mosques, such as Rustem Pasha in Istanbul, described as a 'veritable tile museum', have cool interiors covered with lavishly decorated floral Iznik tiles.

In the sixteenth century, cultural developments in Islam lay in the hands of the Safavids, Ottomans and the Mughals, based in Persia, Turkey and North India respectively but each controlling a considerable empire. Commercial contacts continued between these great empires despite wars and official embargoes, for tastes in calligraphy, album leaves, jewellery, textiles and carpets were shared throughout much of Asia.

The decorative repertory of Ottoman Turkey was dominated by a taste for rather abstract floral arabesques incorporating marguerites and pomegranates and cardoons, which may have been borrowed from Venetian painted enamels and Italian textiles. These are found notably on tiles and textiles. Ottoman textiles also incorporate hyacinths, prunus, lotus, campanulas, roses, fritillaries, and in particular dianthus and tulips. Later in the eighteenth century, tulips became a passion of the 'Tulipomane' Sultan Ahmed III (d. 1730). Turkish tulips with their long, pointed petals were planted, together with Dutch and Persian imports, in a special tulip garden in the Topkapi Palace in Istanbul, where archives list the amount of tax payable on tulips as well as providing details of the types of bulb

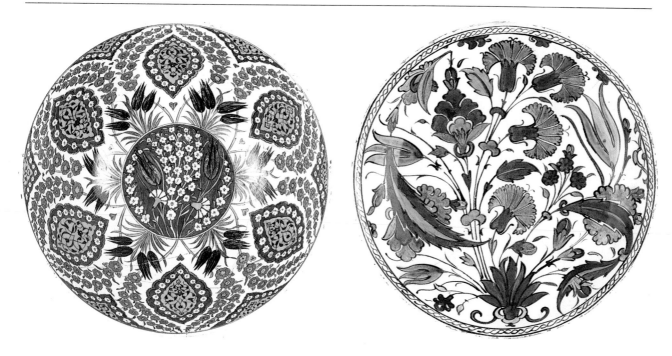

imported and planted. Apparently tulips were the best form of present to the Sultan, who held evening parties when they flowered, light being provided by tortoises with lamps stuck on their shells.

During the Ottoman period, Chinese blue and white porcelain had a considerable influence on the Iznik potteries. Iznik ceramics use a lot of cobalt blue, like the Chinese wares, but frequently in combination with green and red. Chinese motifs such as the lotus and prunus were adopted, to intermingle with the native dianthus, cypress and tulip. Mosque lamps of the early sixteenth century were covered with feathery peony or lotus scrolls which also appeared on dishes: an Iznik jug in the British Museum is decorated with marguerites impaled with feathery *saz* leaves, and a covered bowl from the Godman Bequest has similar leaves combined with prunus blossoms. Plain white porcelain and jade vessels were imported from China and embellished in Turkey with jewels set in gold, the gold mounts almost invariably shaped like tiny petalled flowers with a bright green or red stone centre.

Marginal illustrations to Ottoman manuscripts and, above all, paper-cuts depict flowers with great naturalism. Despite the limi-

140 (*left*) The inside of a footed basin lavishly decorated with pointed-lobed medallions filled with arabesques wreathed with prunus blossoms and branches. In the centre are prunus flowers, carnations and speckled tulips or fritillaries with sharply pointed petals. Turkey, Iznik, *c.* 1550–70.

141 Dish decorated with tulips, dianthus and *saz* leaves. Turkey, Iznik, *c.* 1550.

tations of the format, which was a form of silhouette, flowers in paper-cuts are often models of botanical illustration. In tiles and textiles, flowers are hybridised and treated with some degree of fantasy although still identifiable; paper-cuts accurately illustrate species such as cyclamen and columbine, narcissus and violets, as well as the florists's flowers of the Iznik repertory – roses, carnations, tulips and lilac.

A similar Chinese influence is apparent in Safavid Persian metal-work and ceramics, which were covered with peony and lotus scrolls in imitation of Chinese models, as potters followed changing styles in Chinese porcelain. In Safavid bookbinding, Chinese and local styles mix in panels of animals in natural landscapes. Worked in stamped and tooled leather, flowering prunus trees in the Chinese style, with small birds in their branches, hang down over deer drinking from a stream, the deer depicted with no reference to Chinese decoration.

It was in illustrated albums, bound in richly tooled leather, that floral art reached its greatest heights in all three great empires of the Islamic world. The starting-point, the Islamic garden itself, could hardly have been more remote from the Chinese and Japanese garden, just as the detailed illustrations are as far removed as possible from the ideals of the monochrome ink painters of China and Japan. As the Chinese garden was intended to be a miniature mountain scene, designers eschewed the straight line as unnatural; everything was curved, twisted and sinuous, branch-like, rock-like. The Islamic garden, by contrast, was characteristically a regular walled enclosure, divided into four or more rectangular sections by water-channels meeting in a central pool, often with a fountain in the middle. One of the great conqueror-gardeners, the first Mughal emperor, Babur (1508–30), said of a stream that flowed irregularly through a garden he acquired near Kabul, that 'the place became very beautiful' when he had the stream straightened. A Mughal miniature of about 1590, depicting a feast celebrating the birth of Babur's son Humayun, shows almost as a map might the layout of a walled garden with a square tank in the centre and a multi-spouted fountain. The ground is thick with bright flowering plants, amongst which musicians sit. The feast is laid out on a floral carpet beneath a canopy suspended from a great oriental plane tree. A painting by Bichitr (Chester Beatty Library, Dublin) of Mughal Shah Jahan (1628–58) shows the emperor sitting on a terrace spread with a floral carpet, looking out over a quadrangular garden thickly planted

133

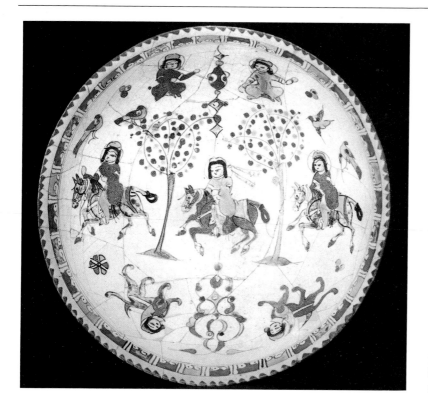

142 Ceramic bowl with figures on horseback and stylised fruit-trees. Persia, *c.* 1200

with irises and marigolds. The garden was intended to be viewed from a fixed spot, often a cool, shaded terrace above the water, not wandered through like the Chinese garden, where small vistas unfolded as one walked, like an unrolling handscroll. The vista was one of geometry, in the form of the regular water-channels, bordering organic form, a design principle that is also seen in the framed inlays of plants in semi-precious stones set in the walls of Shah Jahan's Taj Mahal at Agra.

142 The quadrangular form was one of the symbolic aspects of the Persian and Mughal garden: early Persian ceramics depict the world divided into four by the four 'rivers of life', with a central pool, 'the spring of life'. Cypresses represented immortality and fruit trees rebirth. With the advent of Islam, paradise was described in the Koran as a garden with 'fruits and fountains and pomegranates', and believers that did good were promised that they would 'inherit gardens through which water will flow', certainly an idea of paradise

143 Bilqis, Queen of Sheba, with the hoopoe which carried her love-letters to Solomon. Persia, c. 1590.

based on the oasis of desert peoples. Beyond that, gardens were simply to be enjoyed for their beauty and scent and the haven they offered from the dry, hot world outside. The planting was also practical: fruit trees, cypresses and, in Kashmir, oriental planes offered shade for smaller plants and, planted along waterways, reduced evaporation. Flowers were scattered across grass or formally planted in parterres, and were particularly valued for their scent, hence the frequent appearance of jasmine and, above all, roses. Omar Khayyam, who regretted that 'spring should vanish with the rose', wanted to be buried where the wind would scatter rose-petals. Nizami's late twelfth-century epic poems describing the battles of Alexander the Great also include long stanzas on the glory of gardens filled with dark red roses with amber fragrance, violets, narcissi, cypress and pomegranate; the flowers covering the ground 'like the figured damask of China'.

Illustrated manuscripts of Persian literature reflect this love of 143

gardens and flowers, whether in descriptions of events that took place in gardens or celebrations of natural and man-made beauty. Persian artists worked in Turkey for the Ottomans, influencing Turkish miniature painting, and illustrated manuscripts of Persian legends and romances were written in Persian for the Mughal emperors of India. Scenes from the *Shahnama* (Book of Kings, completed in 1010 by Firdawsi) were illustrated in a manuscript prepared for Nusrat Shah in Bengal in 1532. The *Shahnama* includes bloody descriptions of wars between Iranians and Turanians, but also love stories like that of Zal and Rudaba, illustrated by the scene of Zal climbing up to Rudaba's balcony. Leaving his horse by two tall cypresses, he crosses a garden carpeted with irises and narcissus, where a tiny pool of open lotuses is dominated by small willows and the twisted trunk of a plane-tree entwined with a grape-vine. The scene is surrounded by a marginal design of peony scrolls in gold.

Illustrated albums were cased in decorated bookbindings, further enhancing the contents. Most Islamic bindings include a triangular flap attached to the back cover which folds over and tucks into the front cover, to keep dust out and protect the edges of the leaves. The outside of the flap and covers were often stamped with floral arabesques and frequently gilded. The insides, too, were often decorated with arabesques. In Safavid Persia, painted papier-mâché lacquered covers were used for fine manuscript bindings. These were painted with scenes – often of gardens – similar to those on the

144 Book cover depicting women attendants in flowered dresses beside a pavilion. Eastern India, 1647.

145 Papier-mâché pen-case decorated with
flowers and birds in gilt and lacquer.
Persia, mid-19th century.

manuscript within. Later covers of the eighteenth and nineteenth
centuries are frequently decorated with elaborate paintings of sprays
of roses, peonies, dark purple irises, tulips and violets, bordered with
narrow floral scrolls and gilded strips, with further sprays of iris or
narcissus (their upright form fitting the rectangular book format) on
the inside. Such covers were also used for Mughal manuscripts, but
Turkish binders continued to favour leather, with arabesques
stamped or painted in gold.

The Mughal emperor Babur was a keen naturalist, and his
memoirs, the *Babur Nama*, contain descriptions of plants as well as
of garden-building. The Gardens of Fidelity which he created at
Kabul in 1504 were illustrated in later manuscripts of the *Babur
Nama*, produced in India. It is unusual, however, for a real garden to
be depicted: most albums set scenes from folklore, history and legend
in imaginary flower-filled gardens. In a Turkish work filled with
generally bloodthirsty scenes, the *Suleymanname*, or Life of Suley-
man (1558), the emperor is shown standing before the city of
Belgrade, which is engulfed in flames, while the foreground is
charmingly filled with a variety of lovingly painted trees in a flower-
strewn grassy border.

That the rulers of Persia, Turkey and Mughal India were intensely

144

interested in flowers is well documented. The Turkish passion for the tulip is known from literary accounts, particularly from the seventeenth and eighteenth century, and there is a detailed work on hyacinths in the Topkapi Museum library. This interest in botany led to the development of a new tradition in Turkey and Persia of accurate plant drawing, partly fostered by European travellers. The flowers found in Persian gardens and miniatures are listed and illustrated in Arabic editions of Dioscorides' *Herbal* and other encyclopedias, but are also known from poetic accounts. Shah Abbas II, for example, ordered the poet Ramzi to record his garden in Isfahan in verse. One of the fullest lists of garden plants is gathered from Babur's memoirs. A particularly charming album is that assembled by the prince Dara Shikoh in about 1633–42 as a present for his wife (India Office Library and Records). The album contains sixty-eight miniatures of bird, flower and figure studies set in margins painted in gold. The broad outer marginal illustrations are of tall flowers in natural clumps, while the narrower inner borders contain gold floral scrolls on coloured grounds. The miniatures themselves include mixed groups, such as the night heron beside a Martagon lily growing amongst decorative grasses, or single flowers such as the Crown Imperial. In some of the miniatures the flowers are reasonably accurate in botanical detail, but the arrangement is more decorative than natural.

Flowers mentioned in the memoirs of Babur's grandson Akbar (1556–1605) include *Hibiscus rosa sinensis*, oleander, citron and jasmine. Other plants found in Mughal paintings, *pietra dura* inlays and murals include, from the plains of Agra, cypress, carnations, coxcomb, heliotrope, hyacinth, jasmine, larkspur, love-lies-bleeding, lotus, marigold, French marigold, narcissus, oleander, tuberoses, violets and zinnias, and from Kashmir and Lahore, oriental plane, carnation, delphinium, hollyhock, jasmine, lilac, lotus, narcissus, saffron, stocks and wallflowers. Akbar effectively founded the Mughal school of painting. He set up an atelier where about a hundred artists, mostly Hindu, worked under the supervision of two Persian artists, Mir Sayyid'Ali and Abd al-Samad, brought to India by Humayun, Akbar's father. When Akbar died, his library contained some 24,000 illustrated manuscripts.

His son Jahangir (1605–27) was also very interested in botany, observing nature and carrying out scientific experiments. He is known to have been fascinated by the way saffron flowers appeared

before the leaves, and cut off the thumbs of a gardener who had spoiled a natural scene by felling some trees by a river in Ahmedabad. Jahangir praised *Michelia champaca* (one tree, he said, was sufficient to perfume a garden), *Pandarus odoratissimus* and *Mimusops elengi*, which was graceful and symmetrical as well as scented. He also commissioned paintings from the artist Mansur, who specialised in animals and plants: on one trip to Kashmir he painted over a hundred flower studies. Mughal artists often copied the engraved plates in European botanical works, and some of Mansur's studies follow the style of these. Jahangir also continued to encourage artists of the imperial atelier and an album leaf in the collection of the India Office Library, produced during his reign and dated to about 1610, shows a fine plane-tree with a light mottled bark and leaves turning from green to red and gold. Smaller shrubs and flowers dot the ground and some marvellously observed squirrels race amongst the branches or pause to groom their tails. A portrait by Bichitr of Jahangir's son, Shah Jahan (Victoria and Albert Museum), shows the ruler at the age of forty standing amongst tiny clumps of flowers with two mallow-like flowering shrubs beside him. Flower sprigs adorn his robes and jewelled flower-heads decorate his belt.

The imperial atelier declined during the reign of Aurangzeb (1658–1707), who seized power from his father Shah Jahan, though the Mughal school saw a revival in the early eighteenth century with miniatures depicting lovers in natural scenes packed with flowers and flowering trees, just like those of the earlier period. The painting of faces, however, began to change to a more romantic style.

Local styles evolved elsewhere in India: Deccani painting developed at about the same time as the Mughal school, and, though many of its sources of influence were similar (including the native Hindu tradition), Turkish, Iranian and European elements appear to have arrived directly in the south rather than through the Mughal empire in the north. Though some of the surviving examples are cruder than contemporary Mughal paintings, with human figures and plant forms depicted with stylised simplicity, they are none the less striking. Rajasthani painting shows similar simplicity: a *ragamala* painting of 1605 (one which through the depiction of human situations reflects a musical form or *raga*, the classical Indian musical mode which itself was intended to convey an emotion or passion) shows a woman plucking petals from a star-like lotus flower. She sits in a courtyard beneath a simple palm-tree: over the courtyard wall is

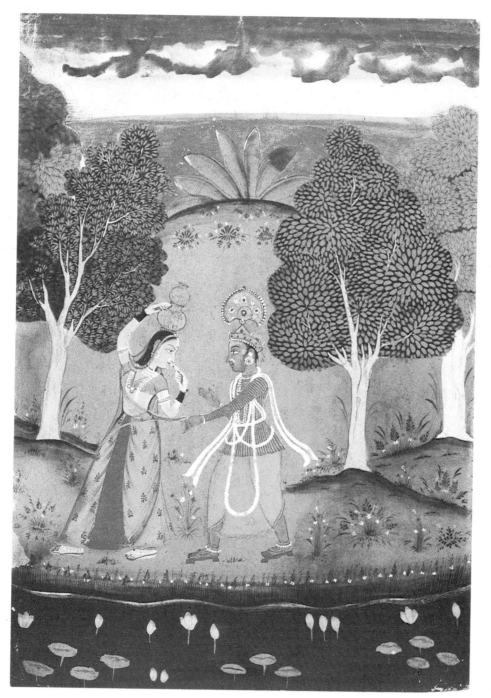

146 Krishna with a
milkmaid. On the water in
the foreground float the
flowers and leaves of the
symbolic lotus. Rajasthan,
early 18th century.

a flowering tree (painted as a mass of dots) and the doors of her room are decorated with stylised flowers made up of four dots (Los Angeles County Museum of Art). The folk-art quality of early Rajasthani painting was somewhat modified by Mughal influence, although this did not extend to its contents. Eighteenth-century depictions of 146 Krishna and Radha are set in more naturalistic gardens, with lotus-leaves and flowers in the pool, bright flowers appearing amongst thickets of banana leaves and upright palm-trees and feathery cypresses in the background (the latter, in particular, based on Persian depictions). The miniature paintings of the Himalayan foothills show something of the same development, from bold, simple paintings of scenes from Hindu mythology with broad areas of bright, plain colours to a more detailed, decorative style, perhaps as the result of the collapse of Mughal power at Delhi in the mid-eighteenth century, when Mughal artists were compelled to seek patronage elsewhere.

In later Indian painting of the eighteenth and nineteenth centuries, 147 portraits of single figures became popular but retained the garden setting and flowered effect. As in the seventeenth-century portrait of Shah Jahan described earlier, single figures dressed in flowered garments stand amongst flowers. They often hold a single blossom, and the painting is frequently surrounded by a flowered border.

In nineteenth-century Ottoman Turkey and Qajar Persia, the tradition of painting flower 'portraits' continued, with added impetus from European botanical drawing. European travellers were interested in acquiring albums of native species, and the combination of this interest and the continuing love of flowers and flower paintings led to the production of semi-botanical flower albums. In India, European interest in local flora and fauna stemmed from two major sources. The primary one was economic. Hendrik Adriaan van Rheede tot Drakenstein (1637–92), Governor of the Dutch possessions in Malabar (South India), organised the collection of local plants by Indians and employed a team of Dutch artists to paint them. His interest was in plant medicines and the work was designed to foster the production of medicinal herbs. The British East India Company was formed in 1599, and from the mid-eighteenth century it encouraged its officers to research into Indian flora and fauna with the aim of discovering the economic potential of 148 both. Indian draughtsmen, employed to depict the plants and animals collected, had to learn how to portray flowers with botanical

147 Portrait of the Mughal emperor Shah Jahan holding a seal, with a border of flowering plants including lilies, irises and tulips. India, 18th century.

[187]

148 This painting on mica of stylised gourds is an example of pictorial souvenirs specifically executed for European residents in India. a genre known as Company drawings. Paintings on small sheets of thin and fragile mica became fashionable in India during the 19th century.

accuracy rather than the decorative exuberance of their own album leaves, and to use European watercolours instead of the thicker pigments to which they were accustomed. Their European masters were more demanding than travellers to Turkey and Persia or the Mughals like Dara Shikoh.

Locally produced thick paper and rich layers of gouache were replaced by pencils and water washes and thinner, European paper. Sometimes European artists were employed to tidy up plant illustrations for publication, as in Hooker's *Illustrations of Himalayan Plants* (1855). The resident botanical artist at Kew, W. H. Fitch, was called upon to correct 'the stiffness and want of botanical knowledge displayed by the native artists who executed most of the originals'.

Though economic interest was the main impetus behind the massive production of plant and animal studies for the East India Company, a love of natural history was another. The wives of high officials who went out to join their husbands found time lying heavily on their hands as a multitude of servants took care of every detail of household management. Some took up natural history to pass the time. The most notable was Lady Impey who, in Calcutta in the mid-eighteenth century, formed her own menagerie and employed three local artists to paint for her. They depicted her birds and animals standing on grassy ground or perched on branches. Accuracy to the subject was important, but both the medium – thickly burnished layers of colour – and the decorative approach to detail, with every feather painted as if it were a pattern rather than a scientific specimen, were closer to the Mughal painting style.

These attractive plant and animal studies became popular amongst Europeans. It was particularly in China, where the East India Company established itself in the late seventeenth century, that local artists in Canton developed the botanical watercolour into a major trade item. Chinoiserie wallpaper of the seventeenth and eighteenth centuries was dominated by the depiction of garden scenes, with partridges and pheasants amongst low-growing flowering shrubs and taller clumps of prunus and bamboo with tiny, brightly-coloured birds in flight. The watercolour leaves and albums produced in Canton for Europeans combined the detailed depiction of natural objects found in the Chinese tradition with the exuberance of wallpaper design and a nod in the direction of European botanical illustration. In both Chinese and Indian examples of floral export watercolours, the decorative effect was paramount.

111

Further Reading

American School of Classical Studies at Athens, *Garden lore of ancient Athens*, Princeton, 1963.

Berrall, Julia S., *The garden: an illustrated history from ancient Egypt to the present day*, London, 1966.

Blunt, Wilfrid, *The art of botanical illustration*, 3rd ed., London, 1955.

Bøe, Alf, *From Gothic revival to functional form: a study of Victorian theories of design*, Oxford, 1957.

Bonavia, Emanuel, *The flora of the Assyrian monuments and its outcomes*, London, 1894.

Craven, Roy C., *Indian art: a concise history*, London, 1976.

Darby, William J. *et al.*, *Food: the gift of Osiris*, vol. 2, London, 1977.

Dawson, Percy G. *et al.*, *Early English clocks: a discussion of domestic clocks up to the beginning of the eighteenth century*, London, 1982.

Desmond, Ray, *Wonders of creation: natural history drawings in the British Library*, London, 1986.

Durant, Stuart, *Ornament: a survey of decoration since 1830*, London, 1986.

Evans, Joan, *A history of jewellery, 1100–1870*, 2nd ed., London, 1970.

Evans, Joan, *Nature in art: a study of naturalism in decorative art from the Bronze Age to the Renaissance*, Oxford, 1933.

Gothein, M. L., *A history of garden art*, 2 vols, New York, 1928.

Hartmann, Fernande, *L'agriculture dans l'ancienne Egypte*, Paris, 1923.

Hayden, Ruth, *Mrs Delany: her life and her flowers*, London, 1980.

Hulton, Paul, and Smith, Lawrence, *Flowers in art from East and West*, London, 1979.

James, T.G.H., *An introduction to ancient Egypt*, London, 1979.

MacDougall, Elizabeth B., and Jashemski, W. (eds), *Ancient Roman gardens*, Washington, 1981.

Masson, Georgina, *Italian gardens*, London, 1966.

Murdoch, John, and Twitchett, John, *Painters and the Derby china works*, London, 1987.

Pevsner, Nikolaus, *The leaves of Southwell*, London, 1945.

Rawson, Jessica, *Chinese ornament: the lotus and the dragon*, London, 1984.

Rogers, J.M., *Islamic art and design*, London, 1983.

Rogers, J.M., and Ward, R.M., *Süleyman the Magnificent*, London, 1988.

Tait, Hugh (ed.), *Seven thousand years of jewellery*, London, 1986.

Titley, Norah M., *Persian miniature painting and its influence on the art of Turkey and India*, London, 1983.

Titley, Norah M., *Plants and gardens in Persian, Mughal and Turkish art*, London, 1979.

Zohary, M., *Plants of the Bible*, Cambridge, 1982.

Zwalf, W. (ed.), *Buddhism: art and faith*, London, 1985.

List of Illustrations

Index